# Shape & Decoration in Japanese Export Ceramics

## Nancy N. Schiffer

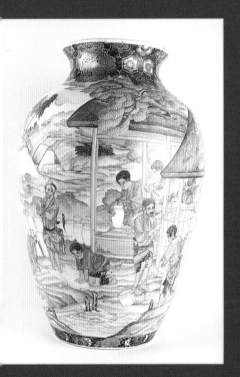
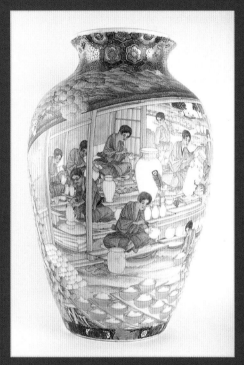
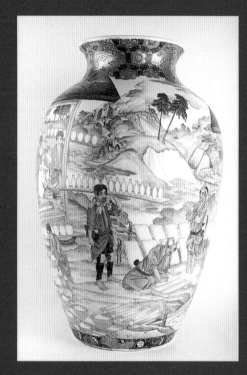

Schiffer Publishing Ltd

4880 Lower Valley Road, Atglen, PA 19310  USA

# Acknowledgments

Marvin Baer brings enthusiasm to life and shares his love of Japanese arts with everyone he meets. I have been enriched through his guidance and thank him for encouraging me to carry on with enthusiasm.

Taishi Shimodaira, ceramics dealer from Nagano, Japan, graciously read many of the makers' and decorators' marks found on the forms in this book. I sincerely appreciate his knowledge of the markings and his willingness to share them with the readers.

I thank each person who has opened their personal collections to this study: those who prefer to remain anonymous, Marvin Baer of The Ivory Tower, Inc., Ridgewood, New Jersey; Bonnie Boerer, Hilda and Neal Cohen, Donna Fuller, Shelley Goldberg, Leila Grossinger, Maxine P. Lynn, Aaron and Virginia Messing, Hal Miller, Helen W. Nowell, Lawrence Robbins, William and JoAnn Van Rooy, Marvin and Nina Vida, Sandra Wasserman, and Harry and Carol Willems.

Library of Congress Cataloging-in-Publication Data

Schiffer, Nancy
Shape & Decoration in Japanese Export Ceramics/by Nancy Schiffer

   p.cm.
ISBN 0-7643-1649-4
1. Pottery, Japanese--1868- I. Title: Shape and decoration in Japanese export ceramics. II. Title
   NK4167.6.S355 2002
   738'.0952--dc21

                    2002008075

Cover and Book Design by: Bruce Waters
Type set in Zurich BT  heading font Dutch 801 RmBT

ISBN: 0-7643-1649-4
Printed in China  1 2 3 4

Published by Schiffer Publishing Ltd.
4880 Lower Valley Road
Atglen, PA 19310
Phone: (610) 593-1777; Fax: (610) 593-2002
E-mail: Schifferbk@aol.com
Please visit our web site catalog at **www.schifferbooks.com**
We are always looking for people to write books on new and related subjects. If you have an idea for a book, please contact us at the above address.

This book may be purchased from the publisher.
Include $3.95 for shipping. Please try your bookstore first.
You may write for a free catalog.

In Europe, Schiffer books are distributed by
Bushwood Books
6 Marksbury Ave. Kew Gardens
Surrey TW9 4JF England
Phone: 44 (0)20 8392-8585; Fax: 44 (0)20 8392-9876
E-mail: Bushwd@aol.com
Free postage in the UK. Europe: air mail at cost.
Please try your bookstore first.

**Title page photos:**
Very large and rare Kutani vase of ovoid shape beautifully painted with an allover landscape scene displaying the handmade pottery industry in Japan. c. 1860-1870. 22" h. $12,000-14,000.

# Contents

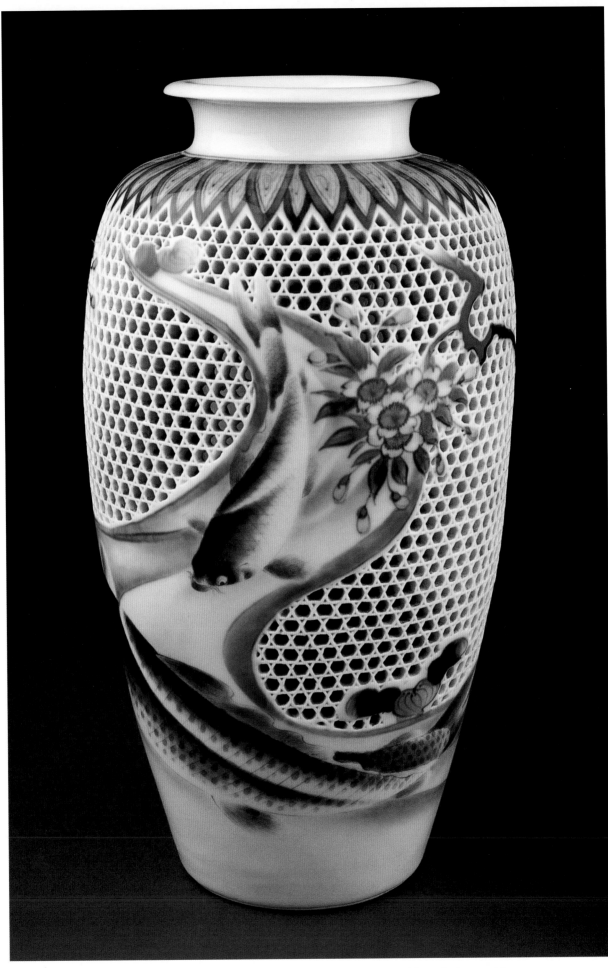

Hirado double walled vase with
reticulated side, 12" h. $3000-3500.

# Rare & Unusual Japanese Export Ceramics

Any study of Japanese arts seems invariably to lead the student through a myriad of variations. Often the workmanship is of the highest order, and the variations of form, imagery, materials, colors, sizes, uses, characters, and so forth is never-ending.

It is the intention of this work to explore the many rare and unusual shapes among various ceramic types, and to see how comparable pieces are varied by their individual decorations. It is therefore a visual study for the most part, with essential descriptions and dimensions provided because we are limited to seeing by means of photographs. Would that we all could hold each piece, turn it over, see the proportions, and look carefully at the marks and clay types.

The ceramics shown here must then be recognized as a mere finite group in a field of unknown proportion, for it is seemingly without boundaries. It is a certainty that the moment the last piece is chosen for photography and analysis, another will appear unexpectedly that cannot be included. The readers must carry on the study in their own personal ways, satisfying their interests and including all that crosses their paths, for they will see varied examples far beyond the confines of this work. Therein is the challenge and the fun of being involved with Japanese arts, and why no one in the field I have ever met has said they are done. Consider this an introduction and feel free to continue the method throughout your own investigations.

# Export Wares From Japan

In the realm of Japanese ceramics, potters in Japan have been producing a variety of earthenware (low temperature fired) for domestic use for thousands of years. Soft-paste porcelain (medium temperature fired) and hard-paste porcelain (high temperature fired) items were developed there within about the last 400 years. Under the old Shogun-dominated political system in Japan, certain potteries made ceramics for general use and others primarily made gifts for the Imperial Household. The manufacture of utilitarian ceramics for the general population as well as exclusive ceramics has a long tradition in Japan.

When Japanese society underwent radical changes politically and economically in the middle of the nineteenth century, entrepreneurs in Japan, for the first time officially, began to exploit world markets. They introduced traditional Japanese products to the West that previously had been available only in limited supply through official trade agreements.

International exhibitions held in the West became staging grounds for many products of distant origins from around the world. Japanese exhibits were installed throughout the late nineteenth century at the international exhibitions held in London (1862), Paris (1867), Vienna (1873), Philadelphia (1876), Paris (1900), St. Louis (1904), and London (1910). They were very popular among visitors and provided important commercial contacts for the development of future mutual trade. A deeper discussion of this topic can be found in the author's book *Japanese Porcelain 1800-1950* and readers are encouraged to study the interesting and complex background for Japanese trade with the West in the second half of the nineteenth century.

Today, one can find in the open world markets old ceramics made for the Japanese domestic market as well as those made for markets outside Japan. The pieces associated with the domestic market are usually sparsely ornamented with images derived from naturally occurring plants, animals, and landscape features. Two Satsuma vases shown here are representative of this type.

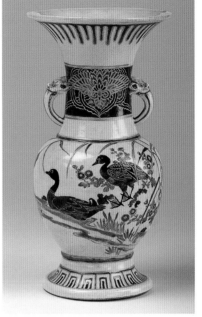

Early period Satsuma bulbous vase with flared rim and base, possibly made for the Japanese domestic market and not the export market. The wide flaring rim tapers to a straight neck painted with red and blue enamel stylized leaf pattern and with two lion mask handles with extended tongues. The body has two ducks and a crane in a floral landscape. 8-1/2" h. Signed Satsuma yaki. *William & Jo-Ann Van Rooy.* $800-1000.

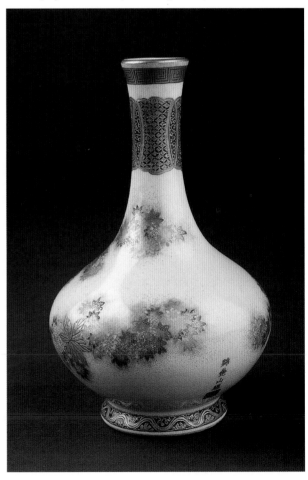

Satsuma vase made for the Japanese market, not the export market. Round baluster shape with floral decoration. 6" h. *Courtesy of Marvin Baer, The Ivory Tower, Inc.* $2200-2400.

When ceramics companies in the mid- and late nineteenth century pursued the foreign markets in earnest, they found that altered decorations sold better abroad. European taste was for more highly decorated pieces including many colors and gold. People, trades, and exotic animals began to appear on Japanese ceramics of the export variety from the mid-nineteenth century onward. A rather extreme example of a vase made only for a foreign market is presented for comparison.

A rather extreme example of a Satsuma vase made for the export market with side scrolled handles and polychrome enamel scenes of people. It is a European silver shape with a cut top rim. 24-1/2" h. *Courtesy of the L. Robbins Collection. $3800-4200.*

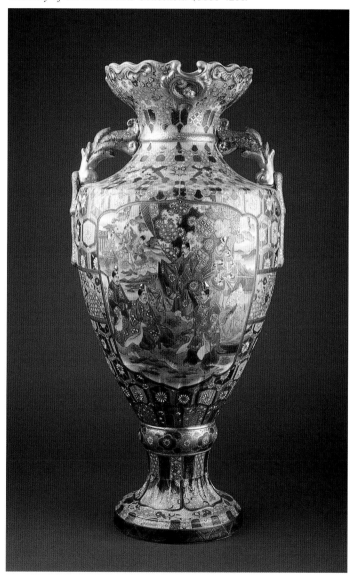

## The time periods referred to with Japanese export ceramics are:

| | | |
|---|---|---|
| Edo Period | 1600 - 1868 |
| Meiji Period | 1868 - 1912 |
| Taisho Period | 1912 - 1926 |
| Showa Period | 1926 - present |

# 1904 Louisiana Purchase Exhibition, St. Louis, Missouri, Japanese Ceramic Collection

A rare opportunity to study a group of superior quality, Japanese export ceramic exhibition pieces, whose approximate date of manufacture can be fairly accurately determined, became known during the course of study for this work. A portion of the contents of the Japanese display at the 1904 Louisiana Purchase Exhibition in St. Louis, Missouri, was preserved by a Canadian doctor, Donald Sutherland, including fine quality bronze figures, furniture, and Kutani and Satsuma ceramics. These were preserved in his collection until an auction sale in 1968, when they were dispersed.

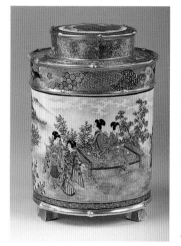

Satsuma canister tea caddy with bamboo shaped rims and raised lid decorated with gold and enamel dragon decoration. The inset brocade decoration around the rim and base is bordered by gilt bamboo design. The sides have a continuous landscape with women and children in a bamboo grove and buildings. Three block feet support the form. Signed by Ryozan. 6.25" h. *William & Jo-Ann Van Rooy. $8500-10,000.*

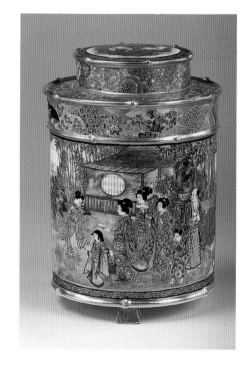

The text of a brown waxed paper advertising broadside for the auction from 1968, 8-1/2" X 11", reads as follows:

The ceramics from this sale include high quality signed Satsuma pieces of various shapes, including many considered rare and unusual. The list of decorators represented reads like a *Who's Who* of the finest men working in the late nineteenth century: Kozan Tsukuru, Kinkozan, Ryozan, and Hadota are each well represented. It is fortunate that Dr. Sutherland and the present owners recognized the rare quality of these unusual examples and have preserved them together.

# Studio Pottery

There developed in Japan in the late nineteenth century a few individual potters who organized their own pottery studios and independently pursued art through study and the production of individualized forms. A few are known today through the international exhibitions where they displayed their work and by their signature marks. Much more study needs to be undertaken in order to recognize more pieces by these makers.

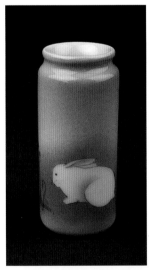

Studio miniature vase with straight round sides and white rabbit decoration on powdered green and purple glaze, marked Nishiura, 2-1/2" h. $600-800.

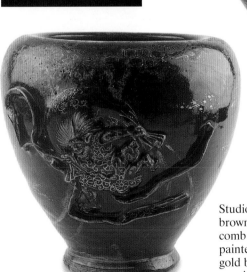

Studio pottery bowl with brown glaze and honeycomb lozenge incised and painted rim decorated with gold birds and relief running man. 9-1/2" h. x 10" d. *Courtesy of the Hilco Collection. $1500-2000.*

## Makuzu Kozan

One studio potter who was both prolific and included in the Western exhibitions was artist Makuzu Kozan, born Myagawa Toranosuke (1842-1916), from Kyoto. Descended from a family of prominent potters, he made Satsuma style ceramics in Kyoto in the 1860s. His examples of old Satsuma style were mentioned with flattering remarks in 1880 by Audsley and Bowes in *Keramic Arts of Japan*. Later, he directed a studio at Ota near Yokohama in 1871 that was specifically set up to produce ware for the export market. Here he and the workshop potters experimented with different glazes and clay types to create both old styles and new forms. Pieces bearing his mark include a wide variety of ceramic types and decorative styles. Between 1876 and 1915, his work was exhibited at the International Exhibitions in the West and Japan. In 1896, he was made a member of the Japanese Imperial Household for Arts and Crafts.

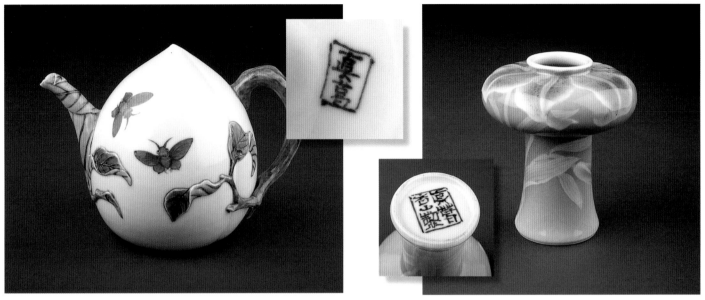

Puzzle pot by studio artist Makuzu Kozan. Signed. 6" h.

Studio made, small porcelain reverse bulbous vase with green glaze and purple lily petal rim decoration, 4" h., marked Makuzu Kozan. $2000-3000.

Round celadon glazed covered box with brown turtles on side and lid, and purple crabs painted inside and with maker's mark under lid, by Makuzu Kozan, 2-1/2" d. $3000-4000.

Studio pottery dish by Makuza Kozan, with water glaze and two ducks, impressed Kogi double gourd mark. 6-1/2" l. $2500-3500.

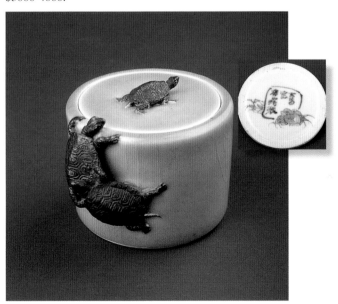

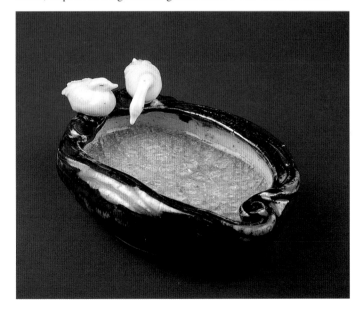

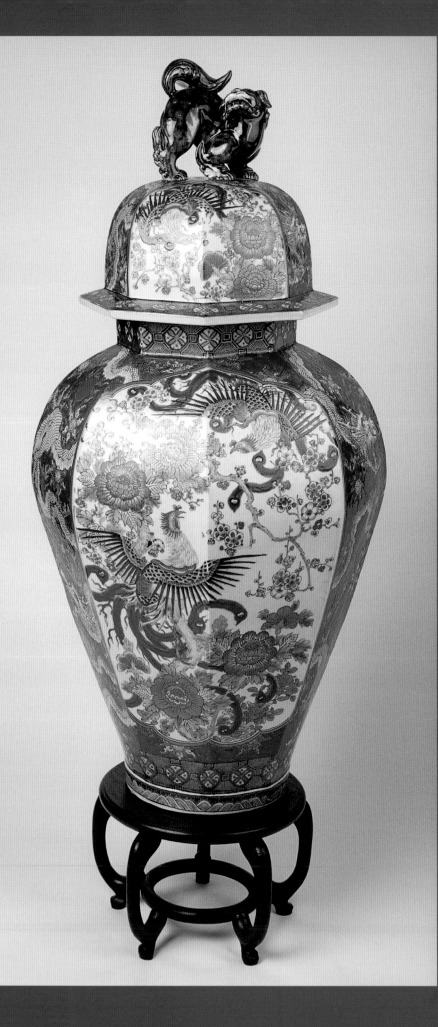

Imari covered jar of circular
and faceted shape with green
background and dragon
decoration, animated birds
and flowers on front and
back panels. 31" h. *Hal Miller
Collection.* $4500-5000.

# Hard-paste Porcelain

The term hard-paste porcelain in this study is reserved for wares made from specific clays that are fired at very high temperatures to create hard, thin, non-porous forms. They contrast with semi-porous soft-paste porcelain, which is made from softer clays and fired at medium temperatures, and earthenware, which is made from very soft clay and fired at low temperatures.

There are several types of Japanese porcelain that were made for export, and only the most prolific and often found in the West are studied here.

## Kaga

The term Kaga today refers to Kutani-style hard-paste porcelain export wares made in the Kaga Province. They include finely painted decorative forms, especially from the early twentieth century.

Kaga vase with flying cranes and pine, 18-1/4" h. $4000-6000.

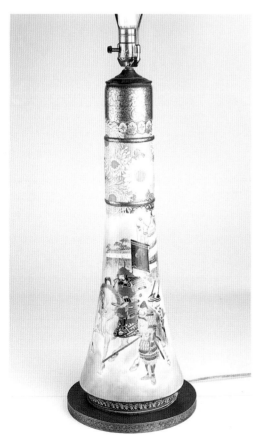

Lamp, a form of Kutani from the Kaga province, decorated with finely painted Samurai decoration and chrysanthemums. Several views, including Imperial Palace. 23" h. *Courtesy of Marvin and Nina Vida.* $1800-2000.

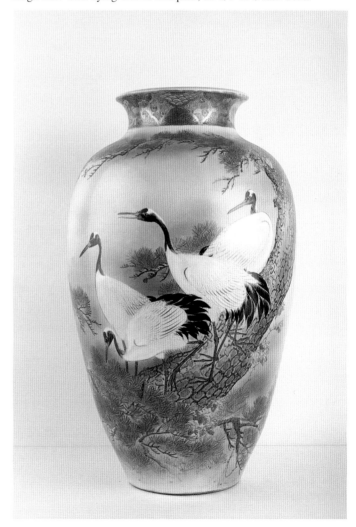

# Seto

The term Seto today refers to hard-paste porcelain export wares made at the village of Seto in Owari Province, near the port of Nagoya. They are hard porcelain in blue and white as well as with colored decorations.

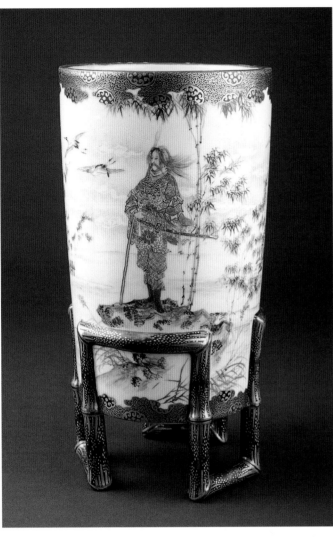

Tall cylinder made in Yokohama in Kutani style with bamboo stick case. Fine landscape. Marked Seto Yamamoto Matsukich. 11-3/4" h. x 6-1/4" d. *Courtesy of Marvin Baer, The Ivory Tower, Inc.* $1500-1800.

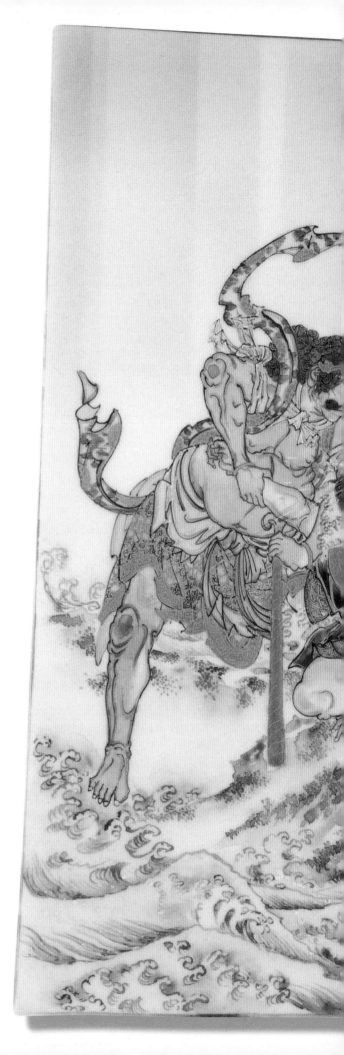

Seto porcelain panel, rectangular with three figures in the surf. 8-3/8" x 12-1/8". $4000-6000.

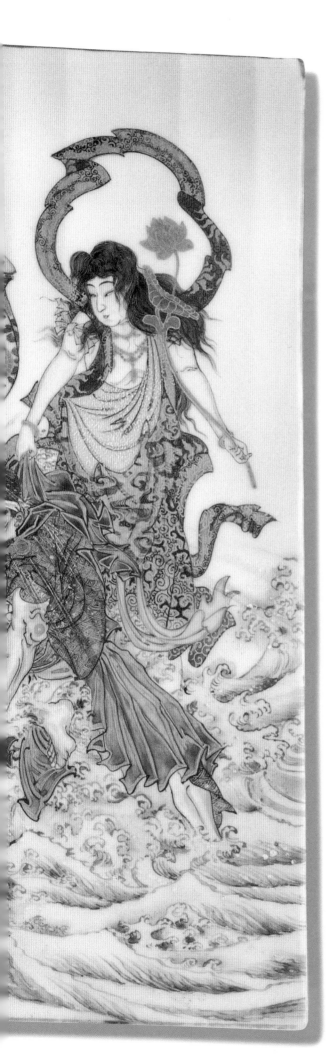

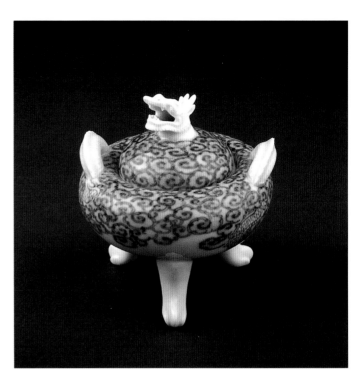

Three legged dish with lid, blue side decoration and lid with dragon head. 4-1/2" h. $600-800

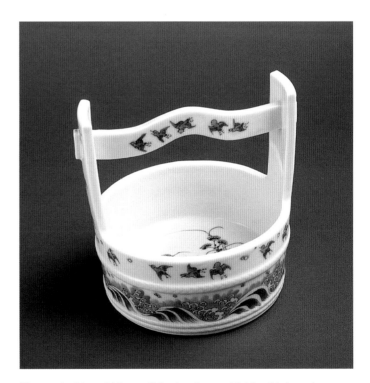

Blue and white wishing well bucket form with blue birds and waves design, 6" h. x 5-3/4" d. *Courtesy of the Drick-Messing Collection.* $1000-1200.

# Hirado

The term Hirado today refers to very finely formed decorative pieces in hard-paste porcelain, often not decorated or with touches of underglaze blue patterns or details. The porcelain clay used was so stiff and fired so hard it could be made into highly pierced forms. The potters here became famous for their fine quality gifts to the Imperial family. The Hirado kiln has a long history under the protection of the Prince of Hirado and originally was located on Hirado Island off the northwestern shore of Kyushu Island.

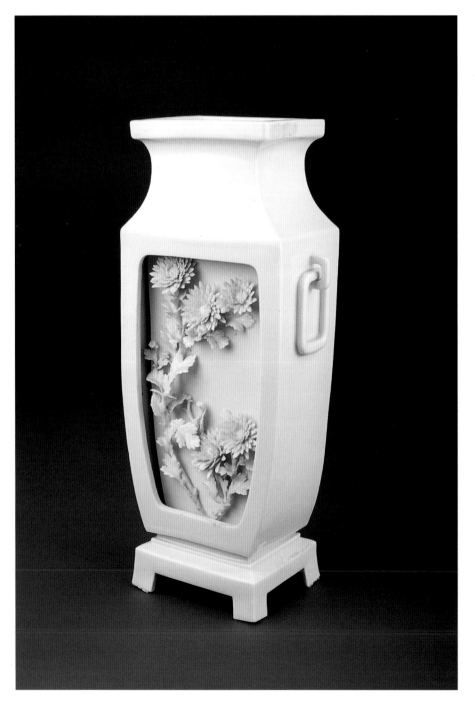

Hirado rectangular vase with open side panels containing relief floral arrangements, 13" h. $2500-3000.

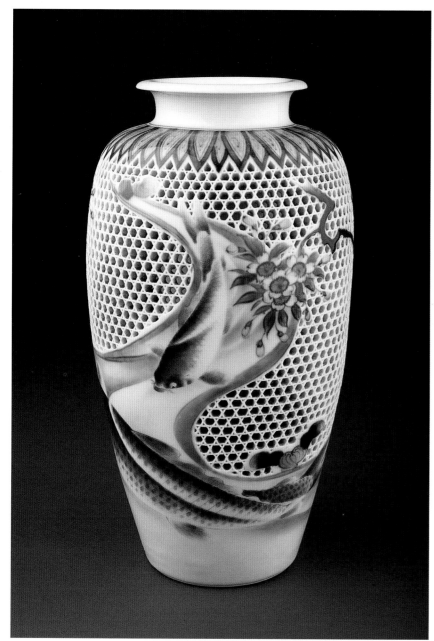

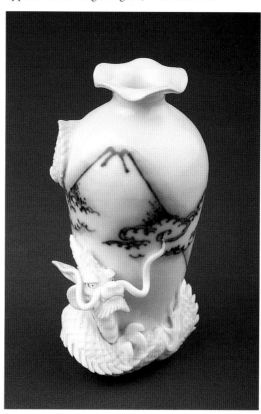

Hirado vase with blue mountain landscape and applied white dragon figure, 4" h. $500-700.

Hirado double walled vase with reticulated side, 12" h. $3000-3500.

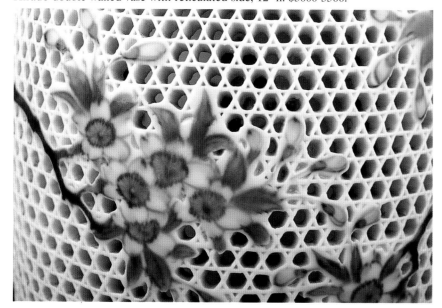

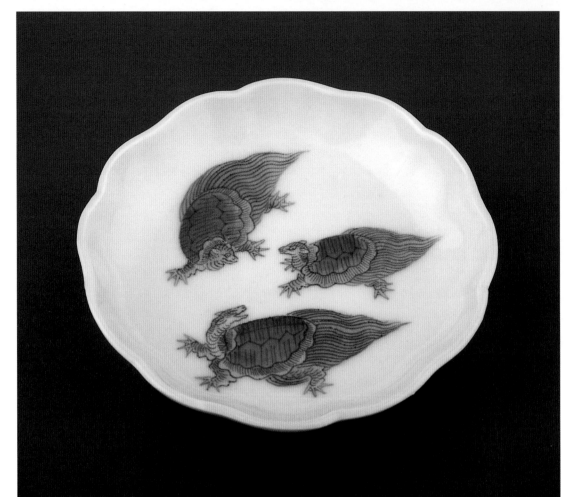

Small Hirado dish with
scalloped rim and three
sea tortoises in decoration,
3" d. $200-300.

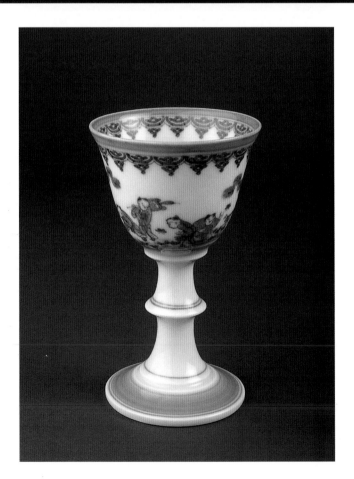

Hirado goblet, copy of silver European form.
5" h. *Courtesy of the Drick-Messing Collection.*
$600-700.

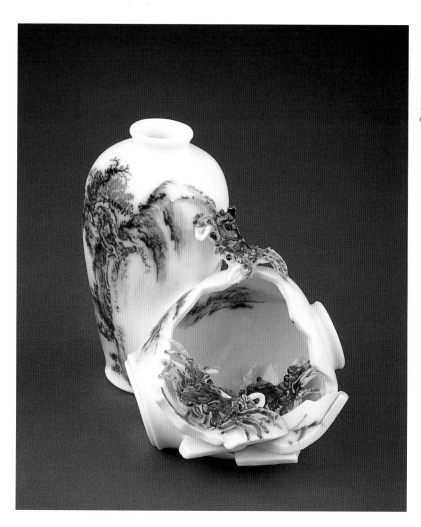

Hirado vase with broken vase form and three crabs, 5" h. $800-1000.

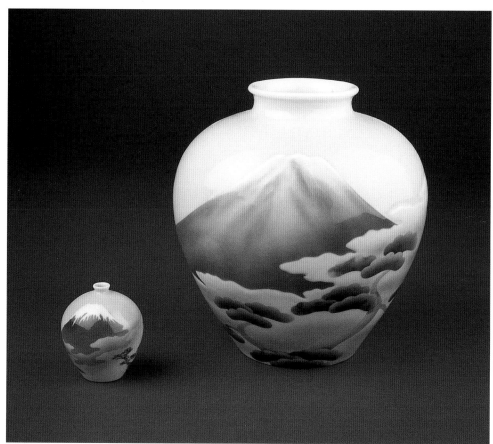

Hirado vase with Mt. Fuji decoration, 8" h. and matching miniature, 2-3/8" h. $500-700.

# Imari

The term Imari today refers to hard-paste porcelain ware made in the vicinity of the town of Arita, in Saga Prefecture in the northwestern part of Kyushu Island. The name Imari derives from the port city of Imari on the northern coast of Kyushu Island where the pieces originally were sold and from which the pieces were shipped to foreign ports. The white clay from the Arita region was usually decorated over the glaze with colored enamels, especially blue, rust red, and gold.

Imari ware dates back centuries and was among the earliest export items to reach the West in the seventeenth century. The decoration is often floral, including birds, landscapes, and people contained in panels framed with geometric or other floral patterns. In keeping with the preferences of the Western consumers, Imari decoration is usually symmetrical and proportional to the shape of the vessel. Fine detail characterizes the best quality Imari and the forms include an especially wide variety of shapes and sized, including very large examples.

## Lidded Forms

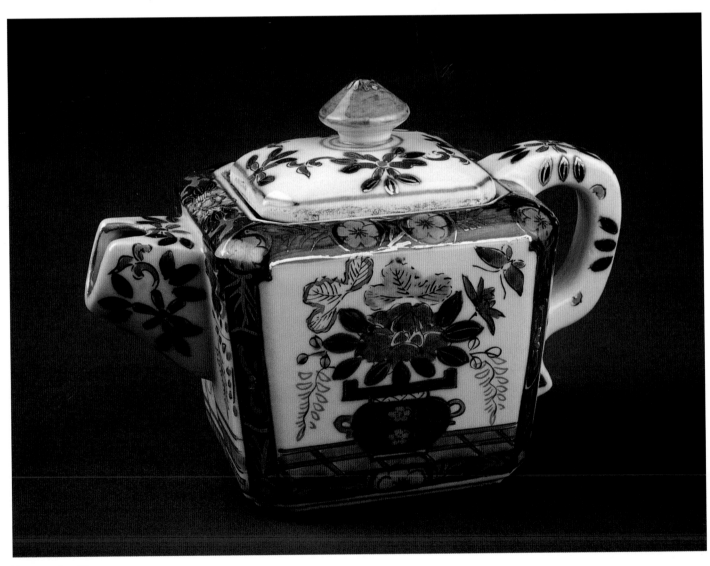

**Rectangular Shapes**
Small square teapot, 4-3/4" h. *Courtesy of The Wasserman Collection.* $600-800.

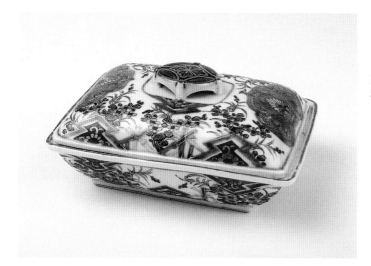

Imari covered box of rectangular shape with raised flat oval finial, 5-5/8" l. *Hal Miller Collection*. $600-800.

Imari covered box with domed lid. 8-1/2" l. *Courtesy of The Wasserman Collection.* $800-1200.

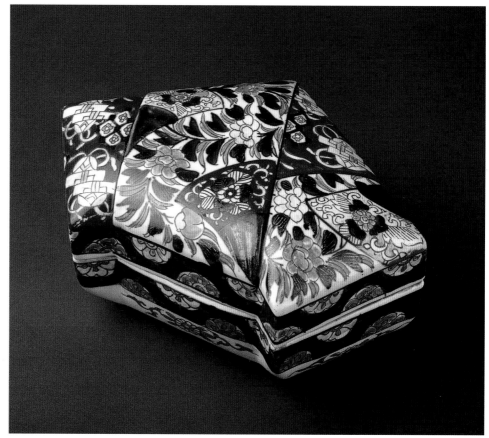

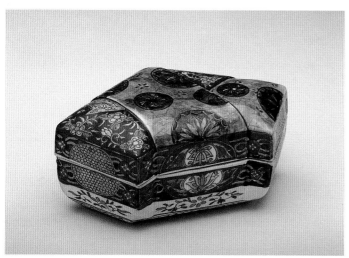

Covered Imari box of wedge shape with five dissimilar sides. The lid and body are decorated with overlapping tapestry design. 8-1/4" long. *Hal Miller Collection*. $800-950.

**Oval Shapes**
Double shaped teapot. 7" h. *Courtesy of The Wasserman Collection.* $1200-1500.

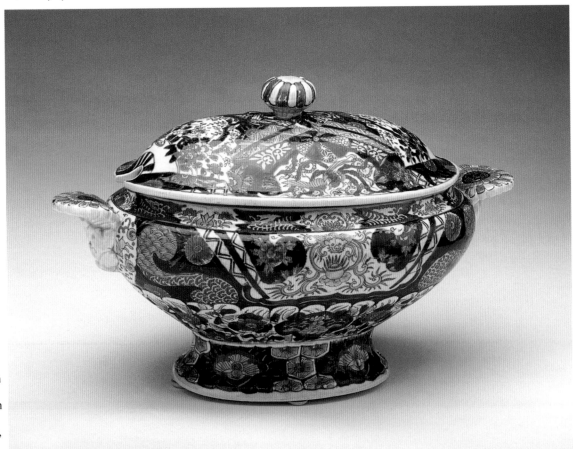

Oval Imari covered tureen of dynamic design with flat and decorated side handles. 10-3/8" high x 16-3/4" long at the handles. Tureen opening, 11-1/2". *Hal Miller Collection.* $2500-3000.

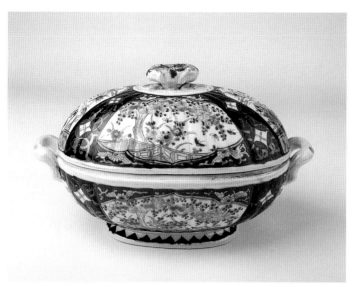

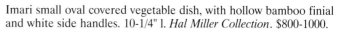
Imari small oval covered vegetable dish, with hollow bamboo finial and white side handles. 10-1/4" l. *Hal Miller Collection.* $800-1000.

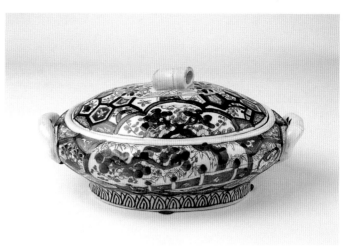

Imari small oval covered vegetable dish with floral finial and loop handles, 10-1/4" l. *Hal Miller Collection.* $1200-1500.

Old Imari, covered round dish. 6-1/4" d. x 3-1/4" h. *Courtesy of the Drick-Messing Collection.* $800-1000.

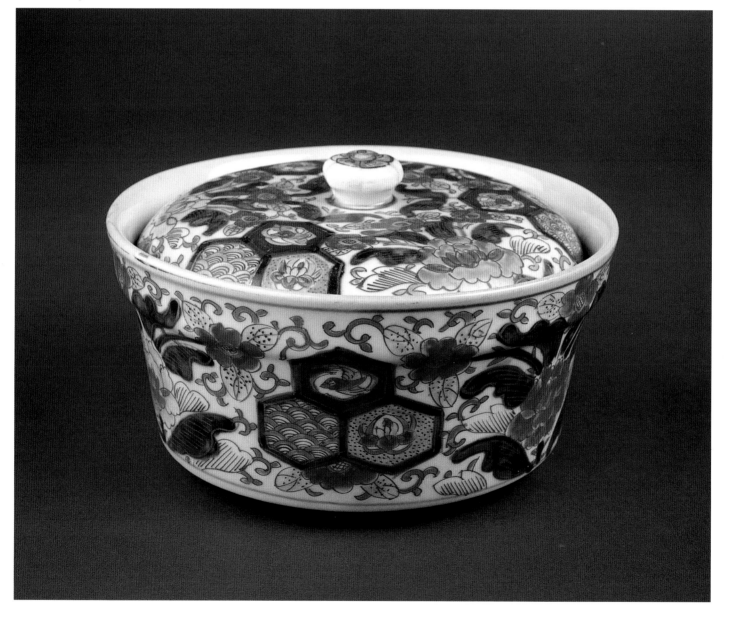

Imari oval covered dish with ribbed sides and a knob finial. 8" long. *Hal Miller Collection*. $800-950.

Imari oval covered vegetable dish with floral bud finial, 9-1/4" l. *Hal Miller Collection*. $800-1200.

Imari oval box of egg shape with blue floral decoration, 6-1/8" l. *Courtesy of The Wasserman Collection*. $800-1000.

**Round Shapes**
Old Imari covered cylinder, 6-1/2"
h. x 5-3/8" d. *Courtesy of the Drick-*
*Messing Collection.* $800-1000.

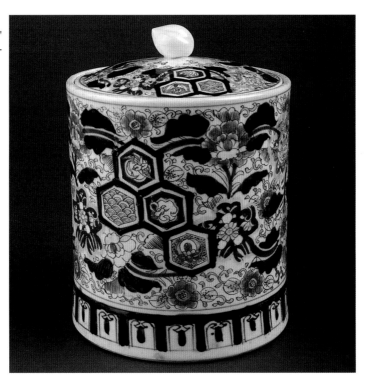

Imari "Mizusashi" water jar with two floral landscape panels and
two butterfly decorated panels, 7-1/4" d. x 9" h. *Hal Miller Collec-*
*tion.* $800-1000.

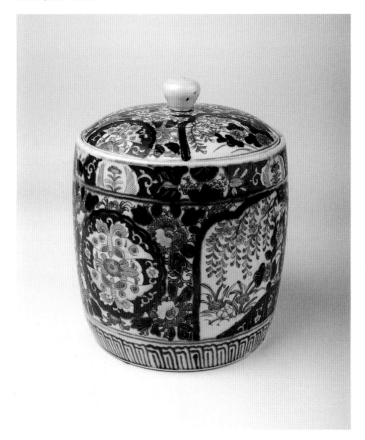

Imari covered jar of circular and faceted shape with green back-
ground and dragon decoration, animated birds and flowers on front
and back panels. 31" h. *Hal Miller Collection.* $4500-5000.

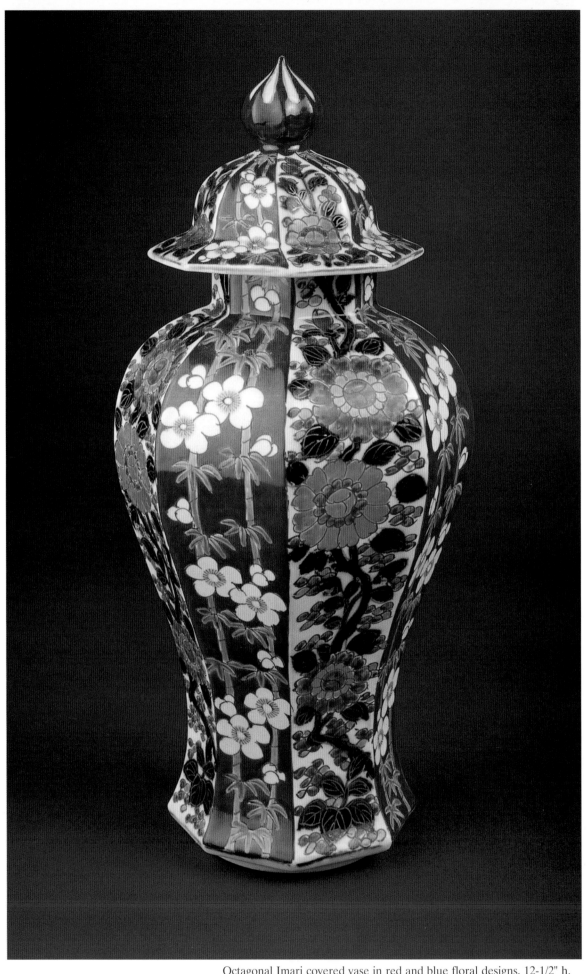

Octagonal Imari covered vase in red and blue floral designs, 12-1/2" h.
*Courtesy of the Drick-Messing Collection.* $1200-1500.

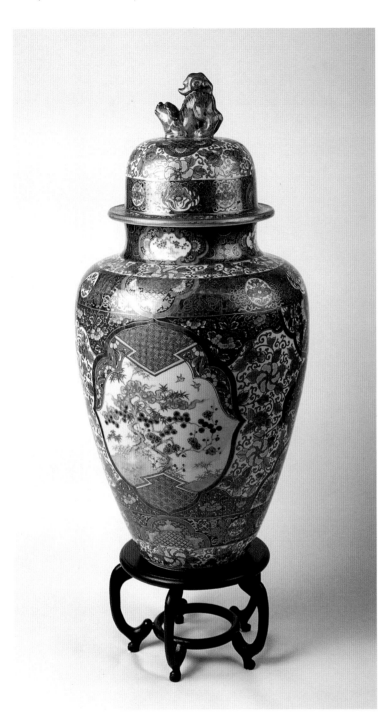

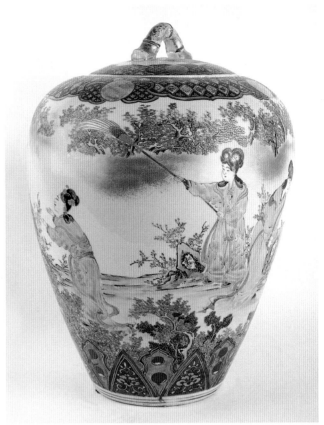

Imari. Covered ginger jar vase, lid with bamboo handle.
1840-50. 13-1/3" h. $4000-5000.

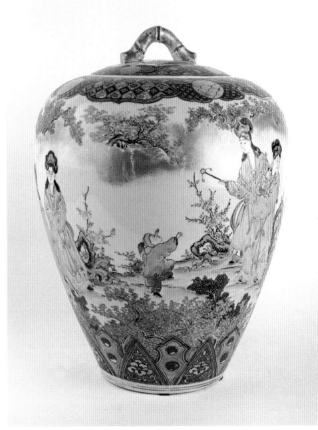

Imari Fukagawa covered jar with 4-char red mark, with floral
decoration and blue foo dog finial. 27-1/2" h. *Hal Miller Collection*.
$3500-4000.

Fukagawa covered bell-shaped jar, brown with floral decoration. c. 1870. Red Koransha mark. 11" h. *Courtesy of The Marvin Baer - Bonnie Boerer Alliance Collection.* $1000-1200.

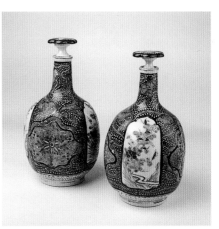

Pair of Imari, Hichozan Shimpo, Fukagawa bottles with red background scrolled vine decoration blue bats in decoration with stoppers and floral panels. 11-1/2" d. *Hal Miller Collection.* $3000-3500.

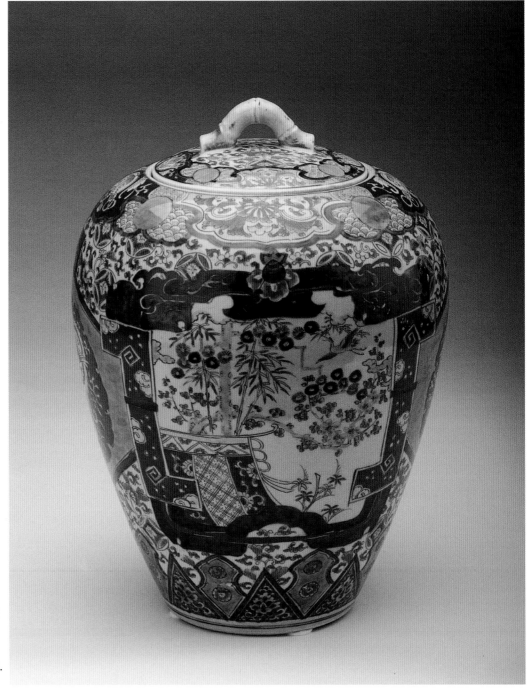

Covered Imari ovoid jar with floral decorated panels including the "three friends" (pine, plum, andbamboo).The lid handle is shaped as bamboo. 14" high x 10" d. *Hal Miller Collection.* $2500-3000.

Imari covered tall necked bottle with bulbous form. 11-1/4" h. *Hal Miller Collection*. $700-1000.

Imari chocolate pot with tall bulbous body and small lid. 9-1/4" h. *Courtesy of the Drick-Messing Collection*. $1800-2000.

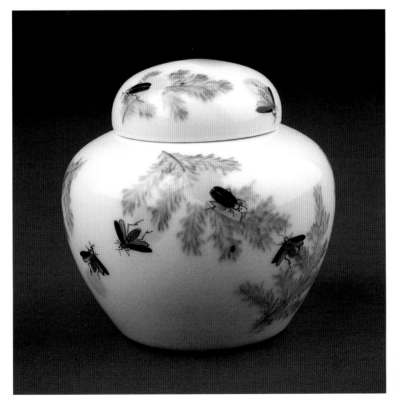

Fukagawa covered bowl with blue lightning bug decoration and the blue orchid mark. 3-1/2" h. $600-800.

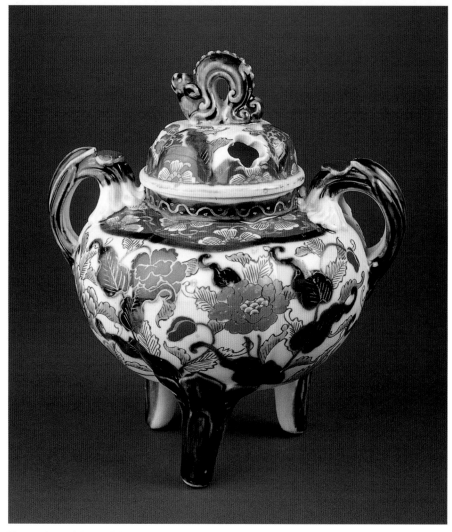

Koro of Imari in traditional Chinese bronze form, 7-1/2" h. *Courtesy of the Drick-Messing Collection.* $700-900.

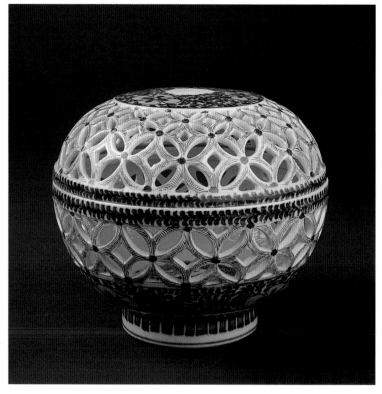

Imari covered and pierced bowl with pierced lid. 6-1/2" d. *Courtesy of The Wasserman Collection.* $800-1200.

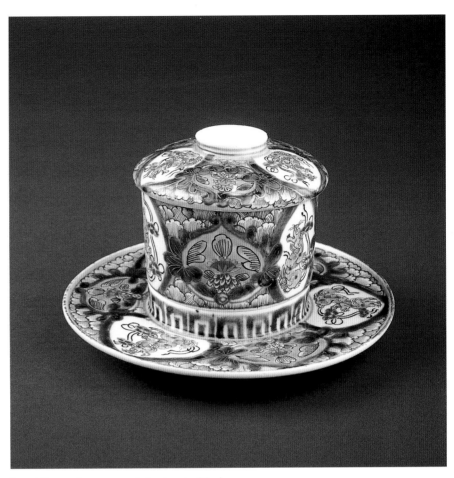

Imari three-piece covered rice bowl with ring.
*Courtesy of The Wasserman Collection.* $500-600.

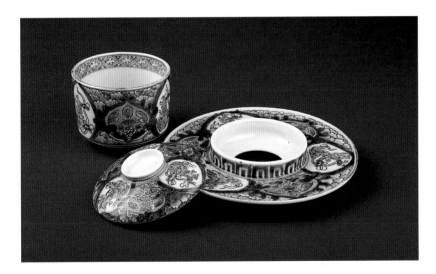

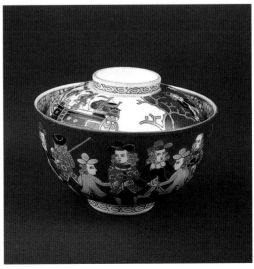

Old Black Ship decorated covered rice bowl, c. 1804.
*Courtesy of the Drick-Messing Collection.* $700-900.

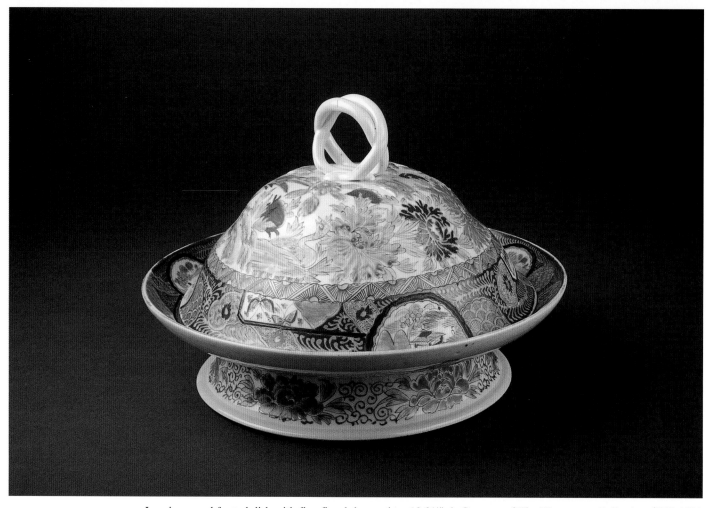

Imari covered footed dish with fine floral decoration. 10-3/4" d. *Courtesy of The Wasserman Collection.* $800-1000.

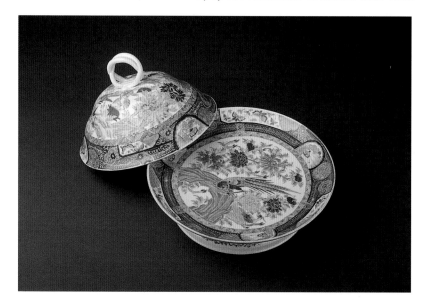

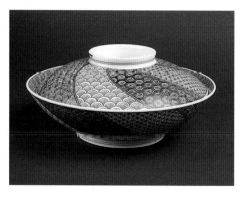

Imari covered dish with the lid and base decorated in swirled exterior design. 10-1/2" d. *Courtesy of the Drick-Messing Collection.* $1500-1800.

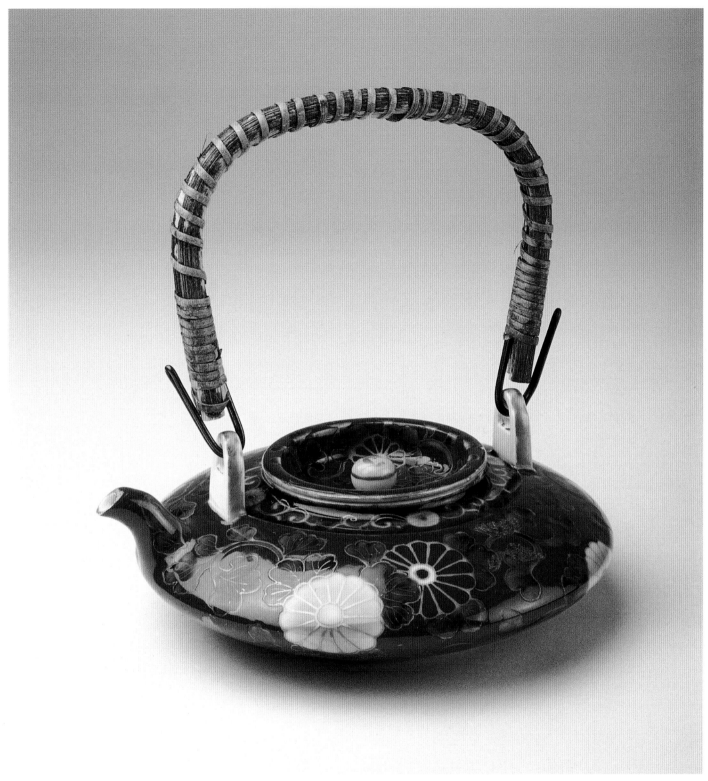

Saki pot with dark red and blue floral decoration and bamboo handle. 7" d.
*Courtesy of The Wasserman Collection.* $500-600.

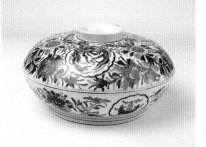

Imari covered rice serving bowl with all-over floral decoration, 9" d. *Hal Miller Collection*. $400-600.

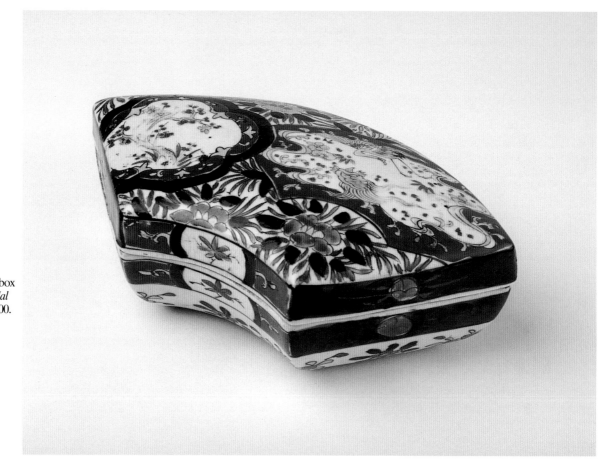

**Geometric Shapes**
Imari sectional covered box of crescent shape, 8" l. *Hal Miller Collection*. $600-900.

Crescent-shaped Imari covered box with floral decoration and the red Koransha mark. 6-3/4" long. *Hal Miller Collection*. $450-550.

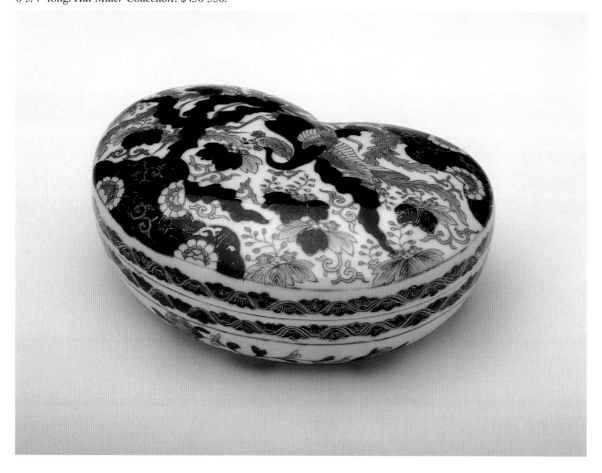

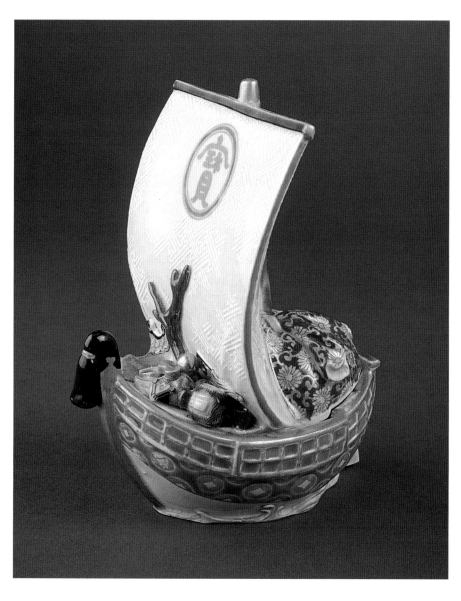

Two-piece koro of boat shape, "Ship of Good Fortune." 4-3/4" h. x 4" l. *Courtesy of the Drick-Messing Collection.* $2500-3000.

Boat-shaped Imari sauceboat with lid partially covering the body and with a cutout hole in the lid and body to accommodate a spoon. 8" l. *Hal Miller Collection.* $800-950.

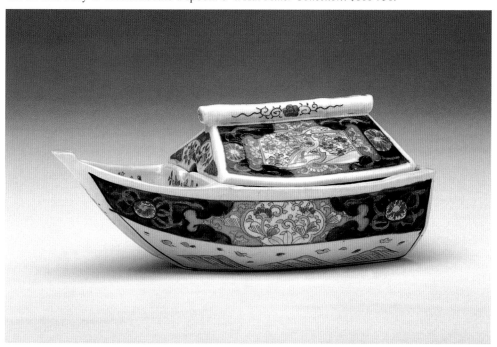

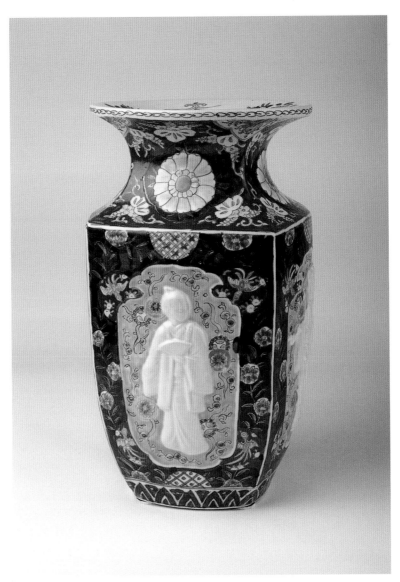

**Rectangular and Geometric Shapes**
Imari square vase with four pastel blue background panels and white relief of women. Round neck reserve with chrysanthemum decoration. 12" h. x 6-3/4" d. *Hal Miller Collection.* $1000-1250.

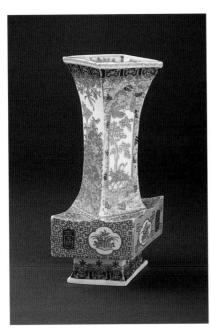

Imari vase with angled rectangular sides and flaring rim. 11" h. *Courtesy of The Wasserman Collection.* $600-800.

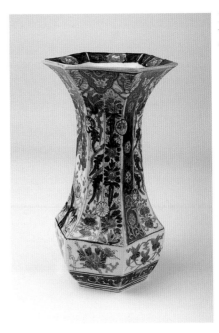

Imari six-sided bulbous vase. 9-3/4" h. *Hal Miller Collection.* $1800-2400.

**Round Shapes**
Imari umbrella stand, 24" h. *Hal Miller Collection*. $2800-3200.

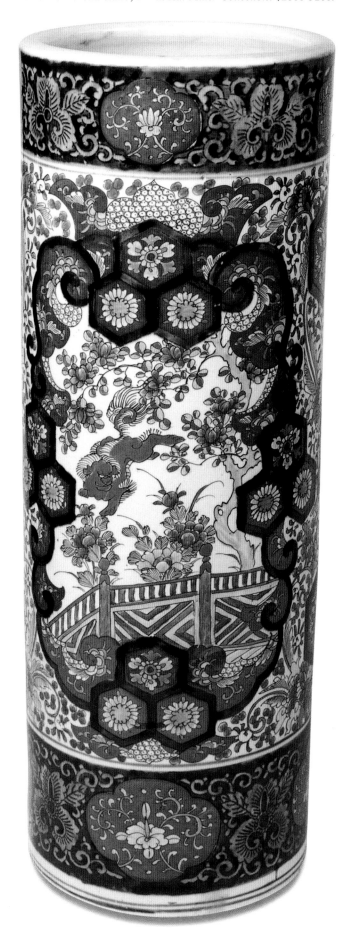

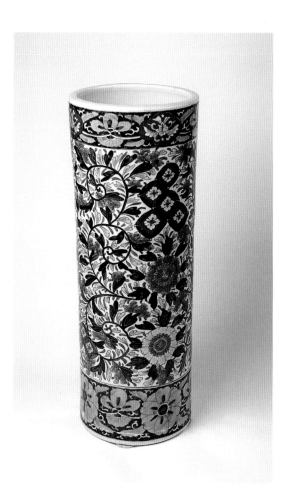

Imari umbrella stand, 24" h. *Hal Miller Collection*. $2500-3000.

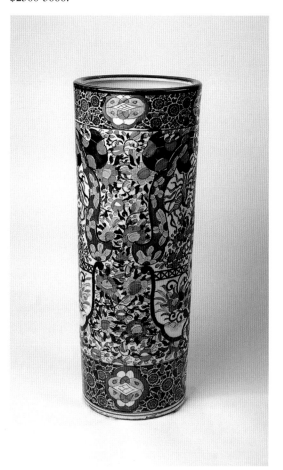

Imari umbrella stand, 24" h. *Hal Miller Collection*. $2500-3000.

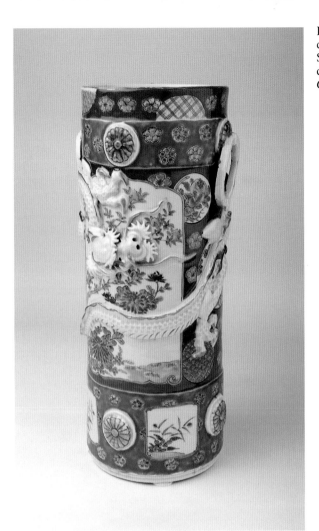

Imari scroll jar with two ring handles, raised dragon decoration, light blue and red background. Signed Hichozan Shimpo, Fukagawa, and 6-character red mark. 13-1/4" x 5" d. *Hal Miller Collection*. $1200-1500.

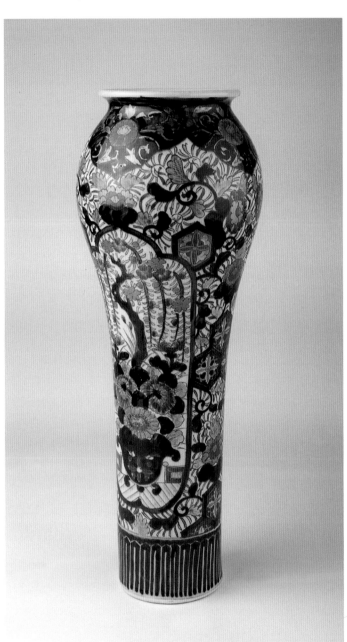

Arita porcelain vase with two gray coi carp painted in Fukagawa style. 12-1/8" h. $4000-5000.

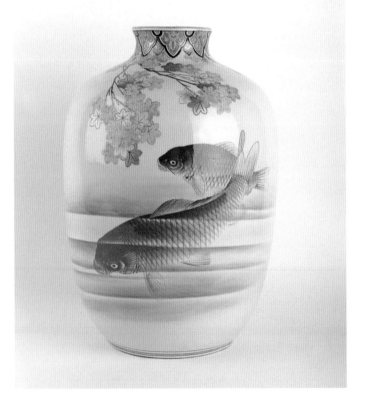

Imari tall vase of swelling form, 16-1/2" h. *Hal Miller Collection*. $1500-1800.

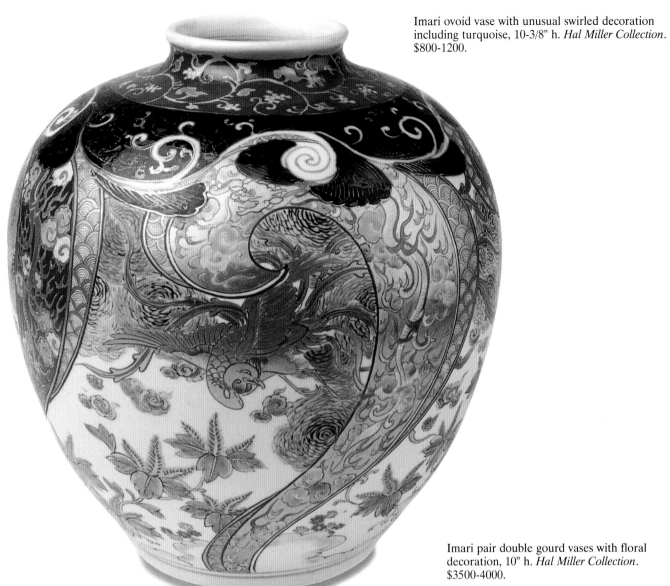

Imari ovoid vase with unusual swirled decoration including turquoise, 10-3/8" h. *Hal Miller Collection.* $800-1200.

Imari pair double gourd vases with floral decoration, 10" h. *Hal Miller Collection.* $3500-4000.

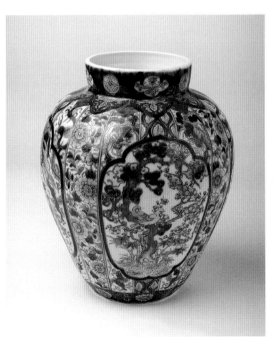

Imari pair of ribbed vases with floral decoration in vertical panels and four oval reserves, red Koransha mark. 9-1/8" h. *Hal Miller Collection.* $3000-3500 the pair.

Map vase with 1840 date mark, made at Arita. 13-3/4" h. *Courtesy of the Drick-Messing Collection.* $2000-2500.

Large Imari jar with two decorated panels of green background and white flowers. 21-3/4" h. *Courtesy of Marvin and Nina Vida.* $2500-3000.

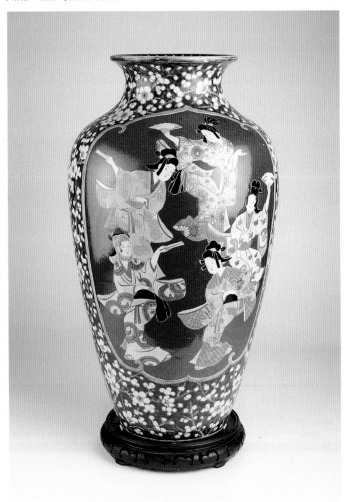

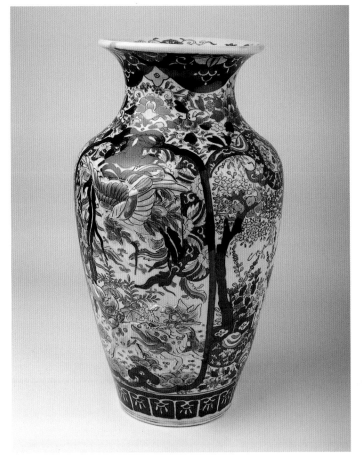

Imari vase with raised bird and lion/dragon decoration in floral ground, 14-3/4" h. *Hal Miller Collection.* $1200-1500.

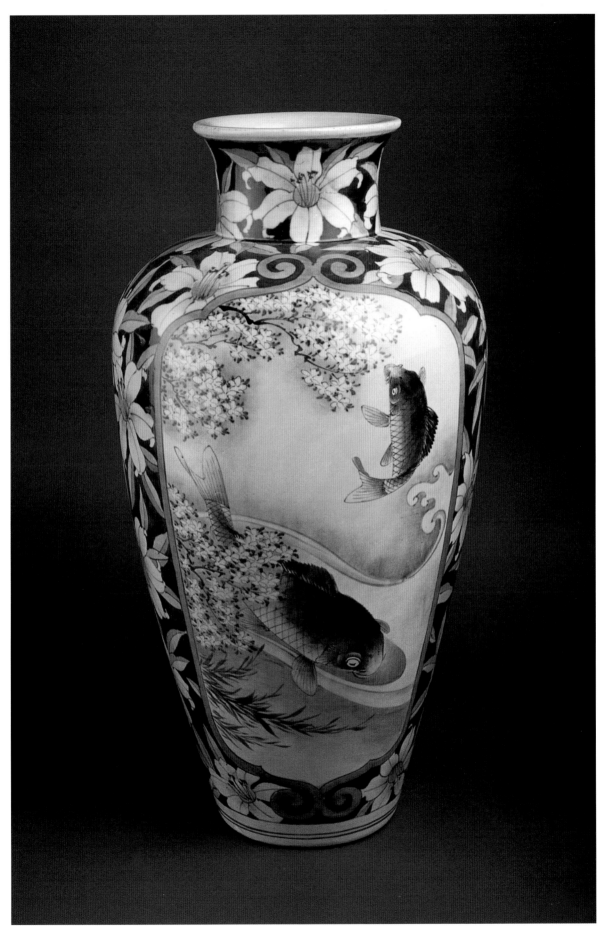

Mid-19th century (circa 1840-50) baluster vase with blue flowers and black fish decoration. 19" h. *Courtesy of the Drick-Messing Collection.* $2500-3000.

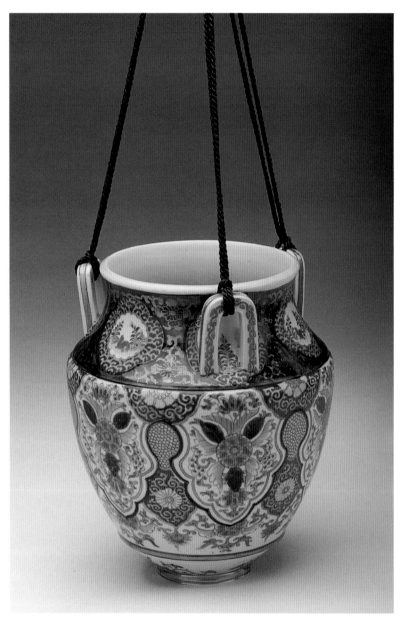

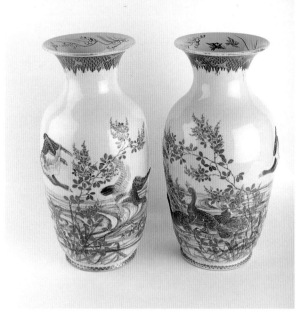

Pair of vases with raised geese decoration. 16-1/2" h. $5000-6000.

Imari hanging planter with a dark blue decorated neck and three handles pierced for a hanging cord. 9" h. x 6" d. *Hal Miller Collection*. $850-1000.

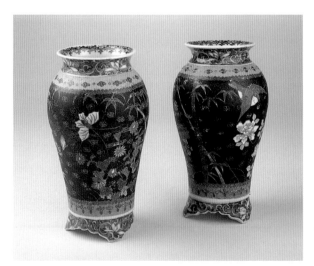

Pair of Imari porcelain and cloisonné vases. 8" h. *Courtesy of Marvin Baer, The Ivory Tower, Inc.* $2000-2200.

Imari vase with scrolled background decoration and figures representing "See, Hear and Speak No Evil." 9-3/4" h. *Courtesy of The Wasserman Collection.* $600-800.

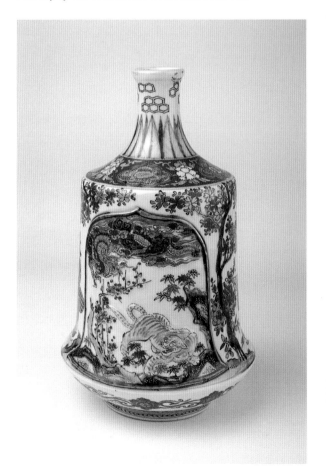

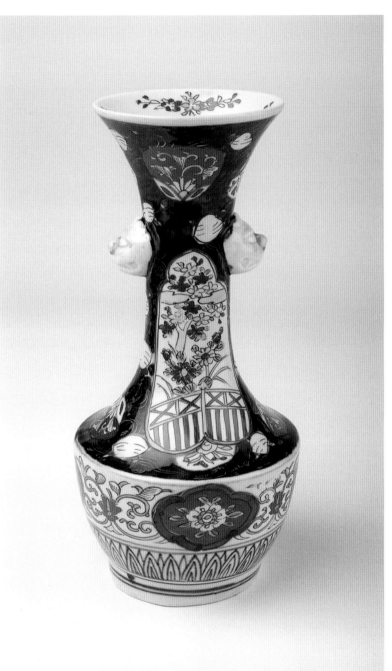

Imari bulbous round bottle-shaped vase with tall neck and two mask handles, 9-1/2" h. *Hal Miller Collection.* $800-1000.

Imari bottle of bell shape with two raised bell-shaped panels of raised lion decoration and two panels with dancing geishas, 11-3/8" h. *Hal Miller Collection.* $2000-2500.

Tall-necked Imari saki bottle with alternating panels of floral decoration, 11-3/4" h. $2500-3000 the pair.

Imari bottle of round bulbous base and long neck with polychrome tapestry design, 7" h. *Courtesy of the Drick-Messing Collection.* $500-600.

Pair of Imari saki bottles. Blue orchid Koransha mark of Fukagawa. 9-1/2" h. $1200-1500.

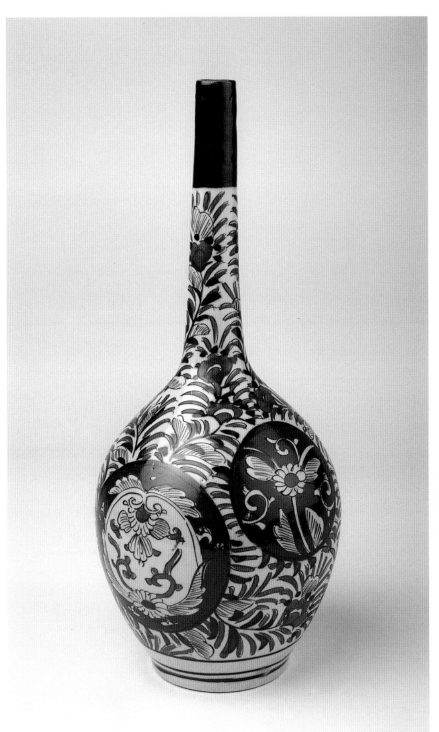

Imari tall necked saki bottle with floral trail pattern and four red reserves with stylized floral decoration, 11-3/4" h. *Hal Miller Collection*. $1800-2400.

43

# Bowls

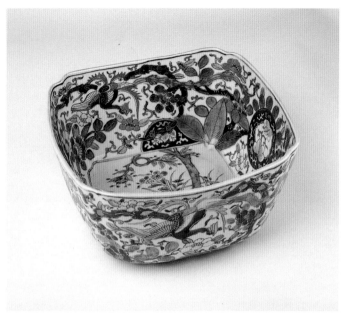

**Rectangular Shapes**
Imari square cut-corner bowl with interior and exterior floral decoration, 10-1/2" w. x 5-1/4" h. *Hal Miller Collection*. $600-900.

Imari square dish on round base, bird and fanciful lion decoration, against floral background. 1" h. x 10" sq. *Hal Miller Collection*. $750-1000.

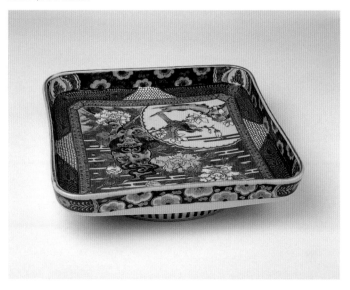

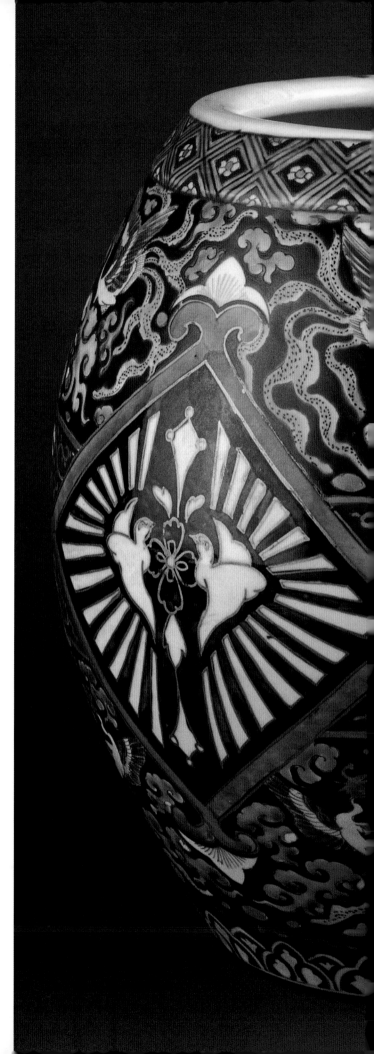

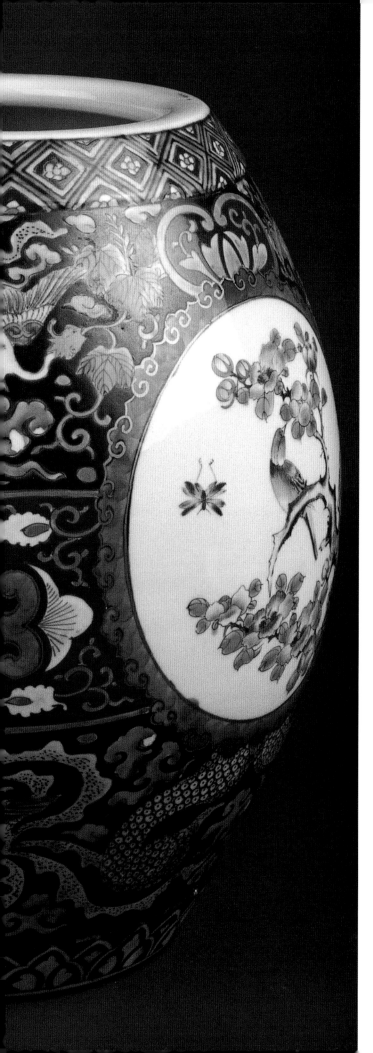

**Oval Shapes**
Imari oval bulbous bowl with glaze decorated rim, 8" l. *Hal Miller Collection*. $800-1200.

Imari bowl with shaped sides. 6-3/8" w. *Hal Miller Collection.* $400-600.

Barrel shaped vase with brown background with deco-looking design. Signed Hichosan Simposai. 10-1/2" h. *Courtesy of the Drick-Messing Collection.* $1800-2400.

**Round Shapes**
Imari basket form with light blue landscape and over-glaze pink and yellow floral decoration. 9-1/4" h. *Courtesy of The Wasserman Collection.* $800-1200.

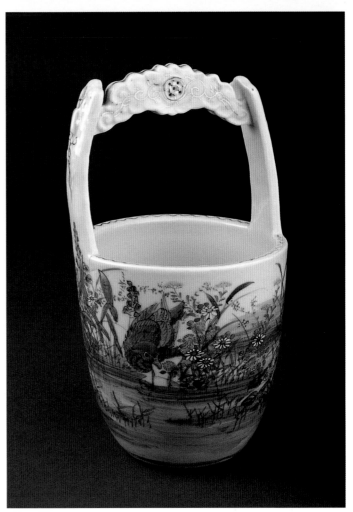

Large ribbed Imari jardinière with floral decoration and flaring and sculpted rim. 14-3/8" h. x 15" d. *Hal Miller Collection.* $3600-4000.

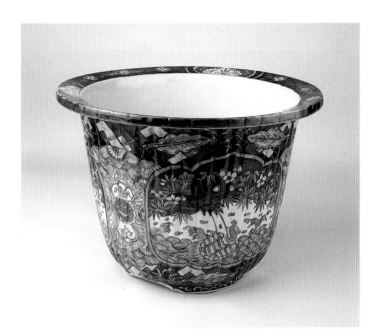

Imari jardinière with flaring ribbed sides. Under plate missing. 9" h. x 12-1/2" d. *Hal Miller Collection*. $1000-1200.

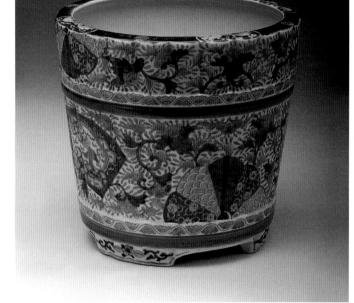

Imari jardinière with ribbed sides, 10" d x 8-1/4" h. *Hal Miller Collection*. $800-1200.

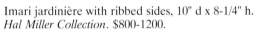

Imari jardinière of ribbed barrel shape resting on three raised feet and the sides decorated with fan and floral designs. 10" d. x 9-1/2" h. *Hal Miller Collection*. $1100-1400.

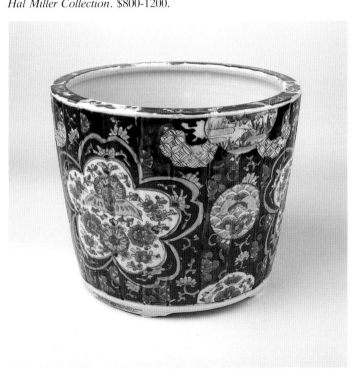

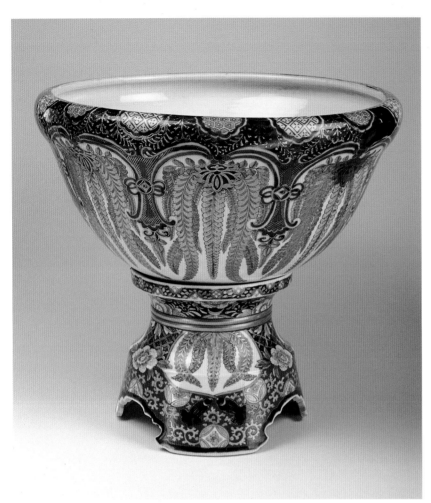

Two-piece Imari presentation bowl with pedestal base. The interior has dragons and two phoenix birds of five-color Imari coloring (cobalt, iron red, green, gold, and white). The upper rim is folded inward and has scalloped decoration. The center is completely decorated with green and orange wisteria that extends from the border to the base. The base has peony and wisteria decoration with a scalloped cutout bottom forming three legs. Early 19th century. 16" d. x 14.25" h. *Harry & Carol Willems.* $8000-10,000.

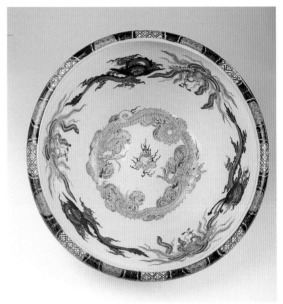

Imari large round fish bowl with butterflies painted inside, 17-1/2" x 10-1/2" h. *Hal Miller Collection.* $3000-3500.

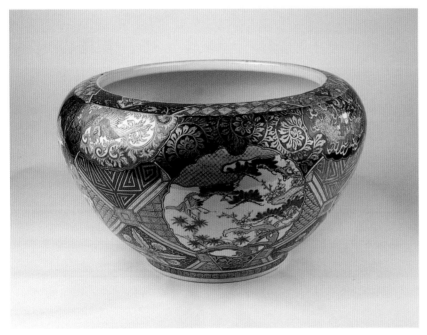

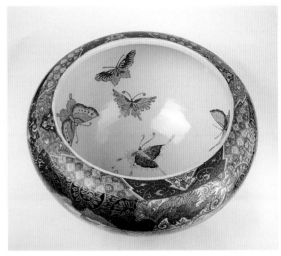

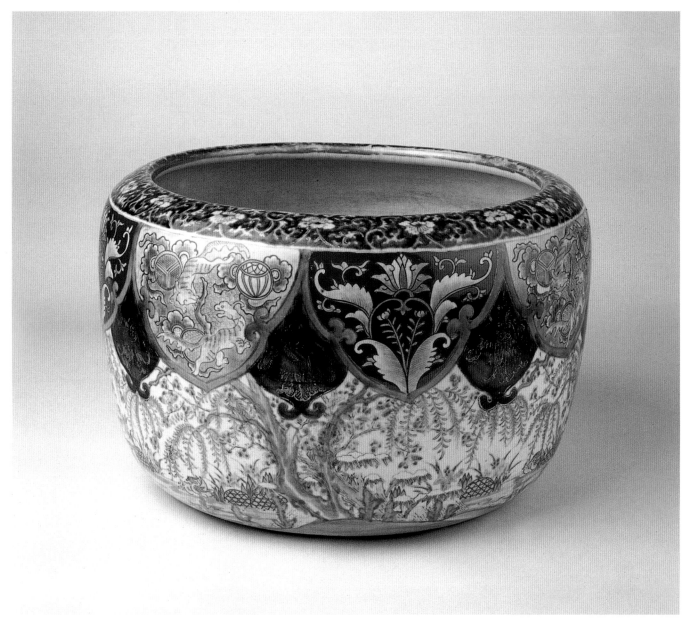

Imari hibachi with shaped panels at the top and willow landscape below. 12" x 7-3/4". *Hal Miller Collection*. $1000-1250.

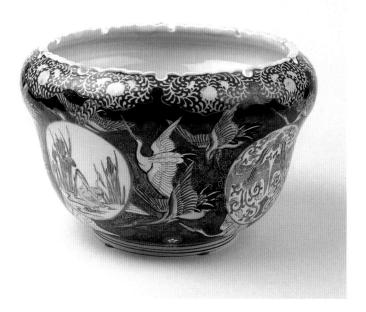

Imari bowl of unusual shape with a cutout rim in the style of a monteith (a punch bowl with rim cut out to support wine glasses that would be hung from the rim with their bowls submerged in ice to cool them). 10" d. x 6-3/4" h. *Hal Miller Collection*. $400-600.

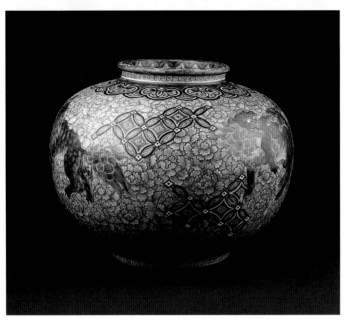

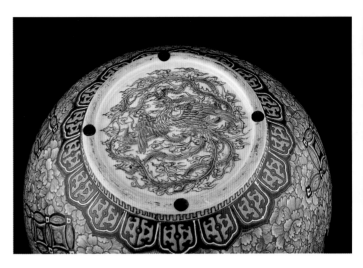

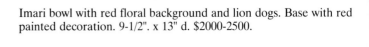
Imari bowl with red floral background and lion dogs. Base with red painted decoration. 9-1/2". x 13" d. $2000-2500.

Imari ribbed bowl with finely painted dragon with pastel shades and bird and floral decoration, early 20th century, 10-1/2" h. x 14" d. *Hal Miller Collection*. $1200-1500.

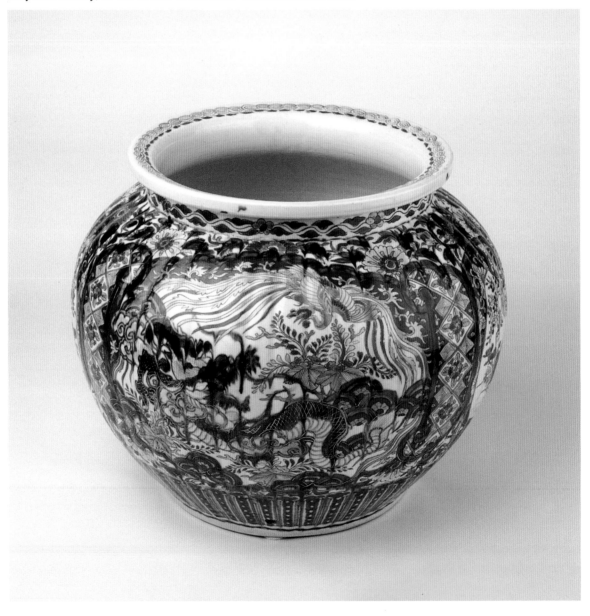

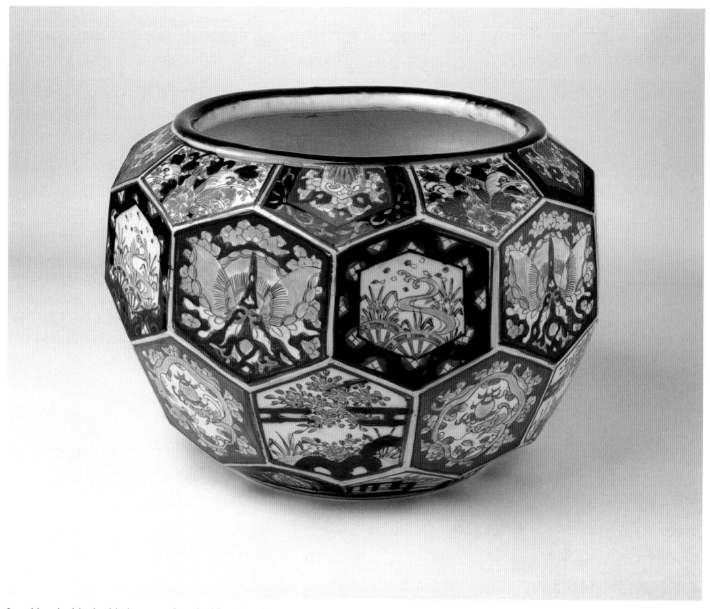

Imari bowl with six side lozenges interlocking. 7-5/8" h. x 11" d. *Hal Miller Collection*. $1200-1500.

Bowl with red ground (*kinrande*) and silver bird and floral decoration. Signed by Eiraku. c.1865.
5" h. x 19" d. *Courtesy of the Drick-Messing Collection*. $4500-5000.

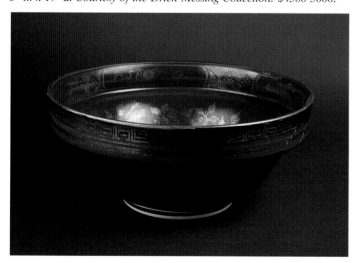

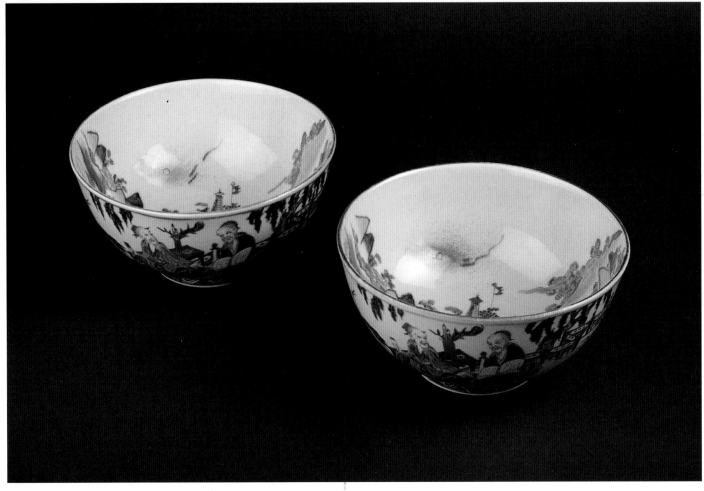

Pair of deep bowls with Fuku (good luck) mark, decorated with interior landscape and exterior figures of scholars and birds design. 7-1/4" d. x 3-1/2" h. *Courtesy of the Drick-Messing Collection.* $2000-2500.

Deep bowl with tapestry designs on interior and exterior and interior dragons in base. 9-5/8" d. x 6-1/4" h. *Courtesy of the Drick-Messing Collection.* $1200-1500.

Typical Arita teacup with red and gold over blue decoration of two women flanking a vase of flowers. 3" d. *Courtesy of MPL and BL collection.* $100-120.

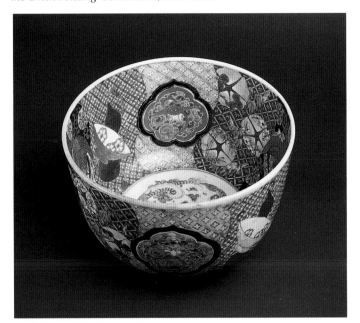

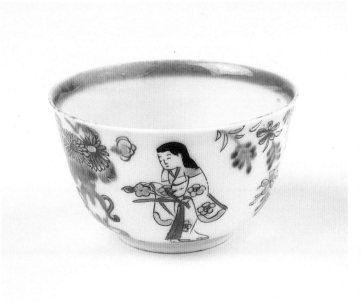

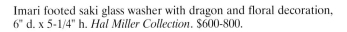

Imari footed saki glass washer with dragon and floral decoration, 6" d. x 5-1/4" h. *Hal Miller Collection.* $600-800.

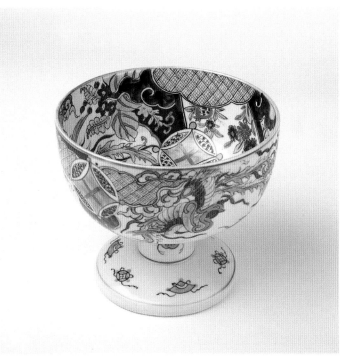

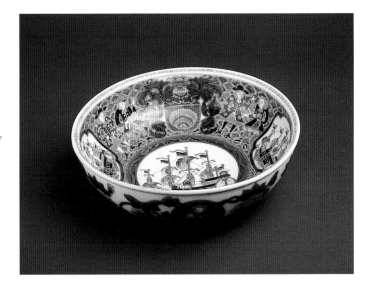

Fine Imari Black Ship bowl. Signed Kotobuki. 10" d. *Courtesy of the Drick-Messing Collection.* $1200-1500.

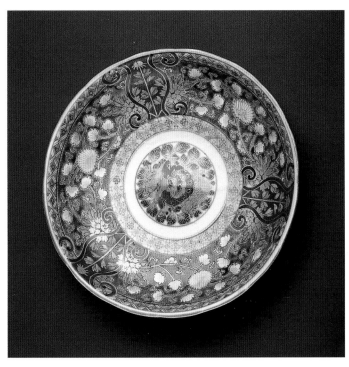

Old Edo Imari bowl with green background. 9" d. *Courtesy of the Drick-Messing Collection.* $800-1000.

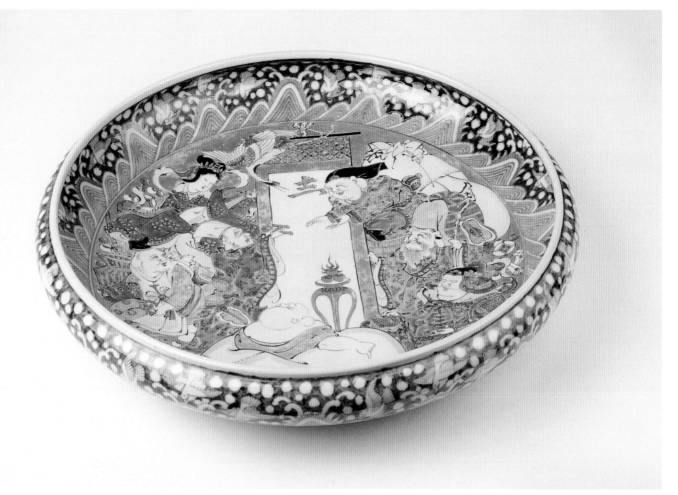

Large Imari round dish with rolled sides, center painted with figures and table with three flaming balls. 18" d. *Courtesy of MPL and BL collection.* $2000-2500.

Imari large and deep bowl with inward curved edge and tapestry decoration. 17-1/2" d. *Hal Miller Collection.* $2500-3000.

Round dish with lacquered handle, red floral and blue bundle of sticks decoration. Signed on base with blue orchid mark of Koransha and in gold on the handle. $600-800.

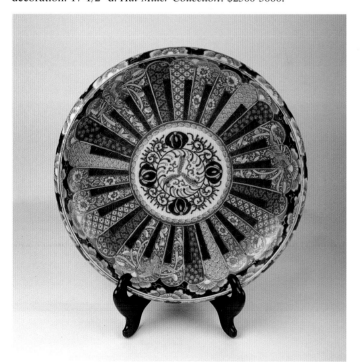

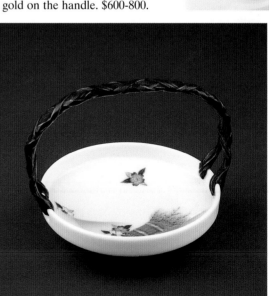

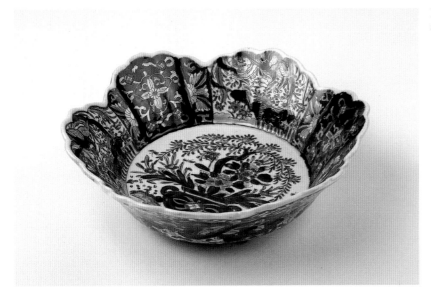

Imari bowl with six-lobed rim and central floral arrangement, 10" d. *Hal Miller Collection.* $750-1000.

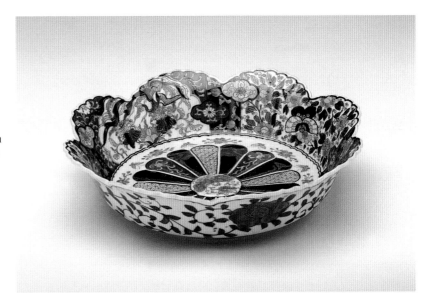

Octagonal Imari bowl with a flat bottom and the rim divided into eight lobes. Blue and white floral decoration on the exterior and red and blue floral decoration on the interior. 12" d. *Hal Miller Collection.* $850-1000.

Imari oval bowl with scalloped edge and ribbed sides, 11" l. *Hal Miller Collection.* $600-900.

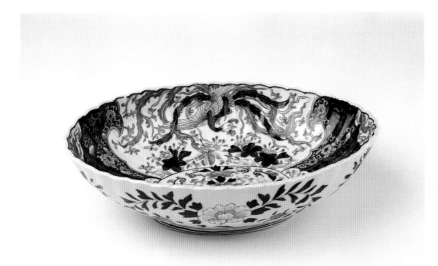

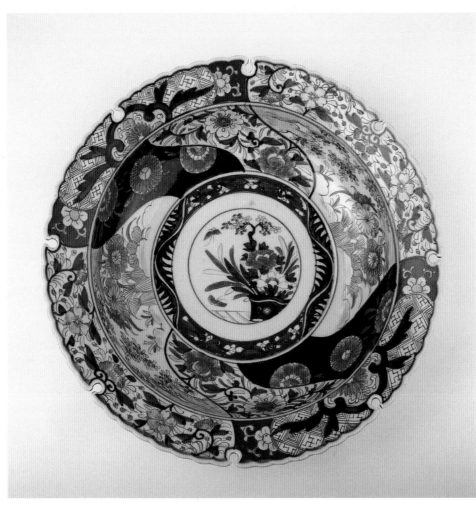

Imari deep bowl with monteith-style notched edge and floral decoration. 13-3/4" d. *Hal Miller Collection*. $800-1200.

Imari bowl with honeycomb tapestry and three women in the decoration. 7-3/8" d. *Courtesy of the Drick-Messing Collection.* $800-1000

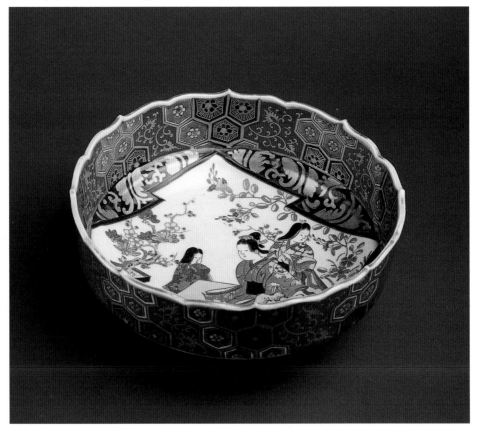

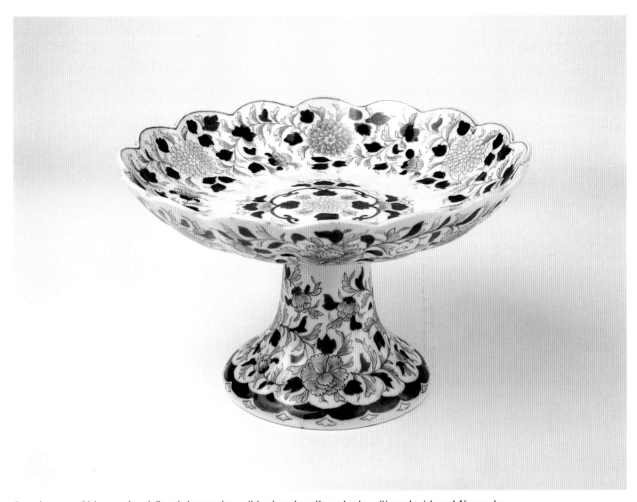

Imari tazza of blue and red floral decoration, ribbed and scalloped edge. Signed with red Koransha mark. 9-3/4" x 5-3/4" h. *Hal Miller Collection*. $1100-1400.

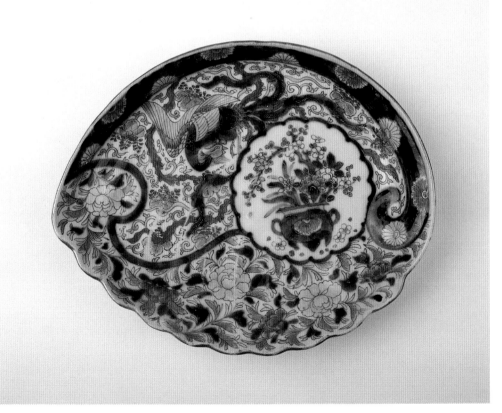

**Geometric Shapes**
Imari oval shell-shaped dish with floral and bird decoration and round reserve with floral arrangement. Front and back views. 8-1/2" d. *Hal Miller Collection*. $600-900.

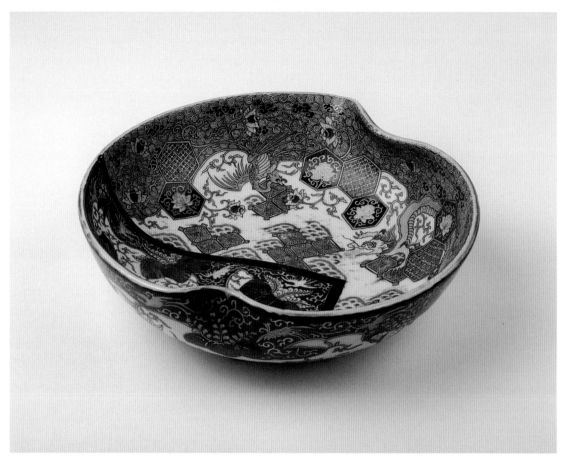

Imari bowl with collapsed sides. Red Koransha mark. *Hal Miller Collection*. $1500-1800.

Imari six-sided bowl with straight edges. 9" d. *Hal Miller Collection*. $800-1000.

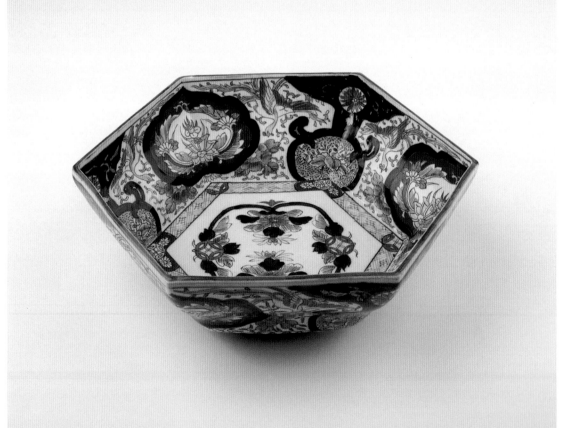

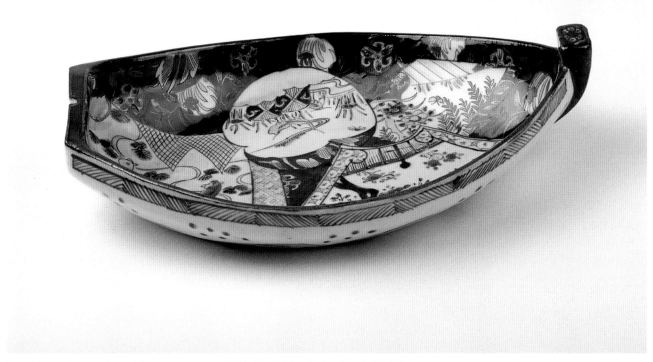

Imari boat-shaped dish with three reserves. 11" l. *Hal Miller Collection*. $700-1000.

Imari boat-shaped dish with two deer in landscape. 13-7/8" l. *Hal Miller Collection*. $800-1200.

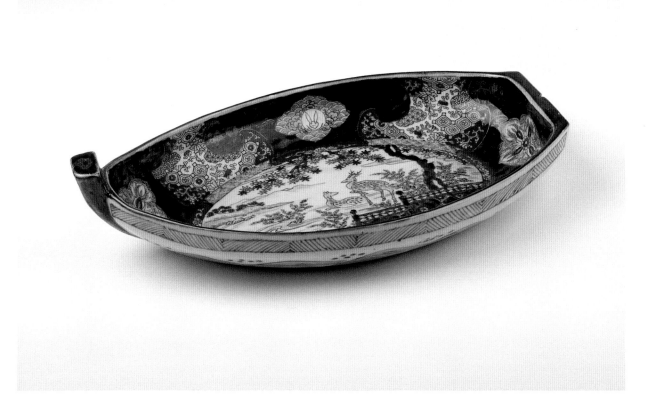

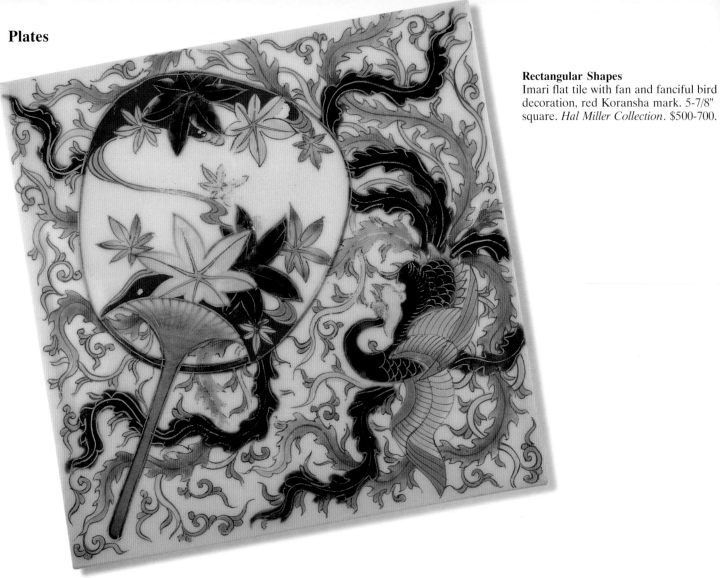

Square plate with blue floral center and four red reserves. *Courtesy of the Drick-Messing Collection.* $600-800.

Square Imari plate with reticulated rim and floral decoration overlaid by two partial round reserves decorated with tapestry patterns. 11" square. *Hal Miller Collection.* $800-1000.

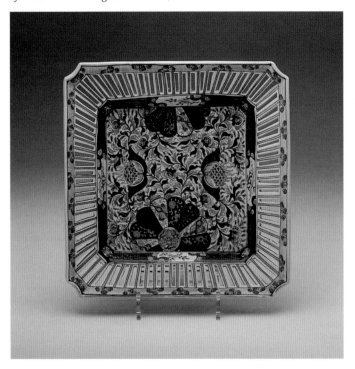

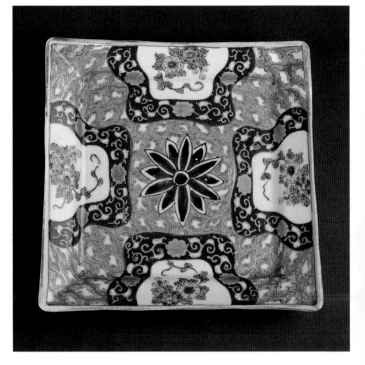

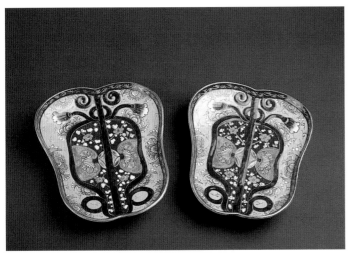

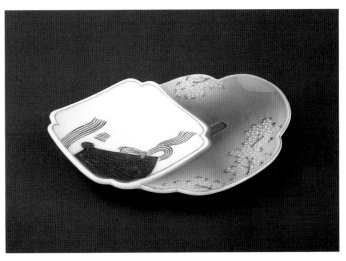

Pair of Fukagawa fan-shape plates in polychrome enamels. Red Koransha mark. 8-3/4" l. *Courtesy of the Drick-Messing Collection.* $1000-1200.

Double plate, one part of rectangular shape white fan design and the other part of oval shape blue tsuba design. Blue orchid mark. 5-1/2" l. $500-700.

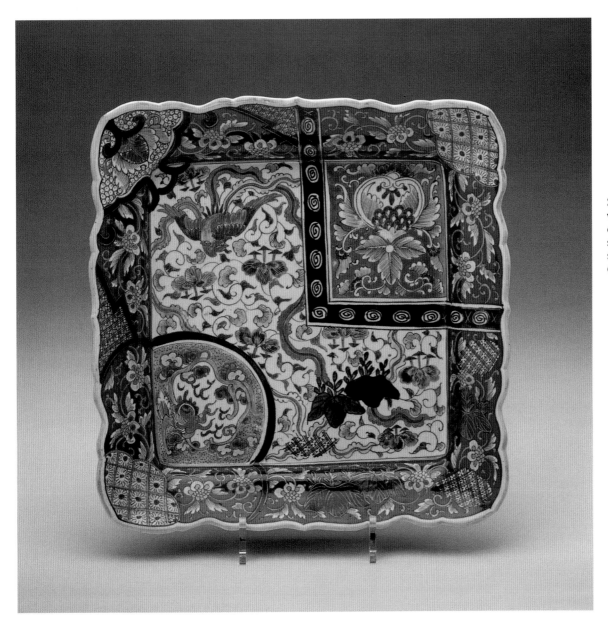

Square Imari plate with asymmetrical decoration and a shaped rim. 12-3/8" square. *Hal Miller Collection.* $800-1000.

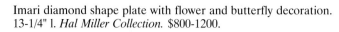

Imari diamond shape plate with flower and butterfly decoration. 13-1/4" l. *Hal Miller Collection.* $800-1200.

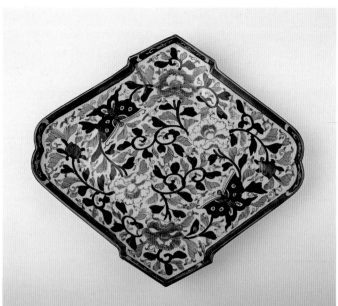

One of an Imari five-piece nesting set of rectangular plates with raised rims. 6-1/2" to 11-3/4" w. *Hal Miller Collection.* $800-1000.

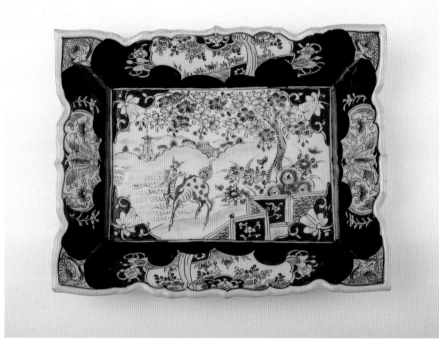

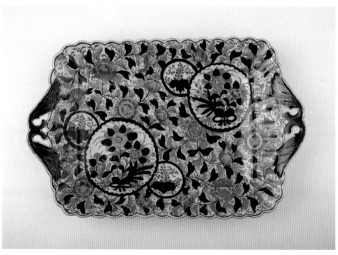

Imari rectangular platter with cutouts at the handles and floral decoration. 13-3/4" l. *Hal Miller Collection.* $800-1200.

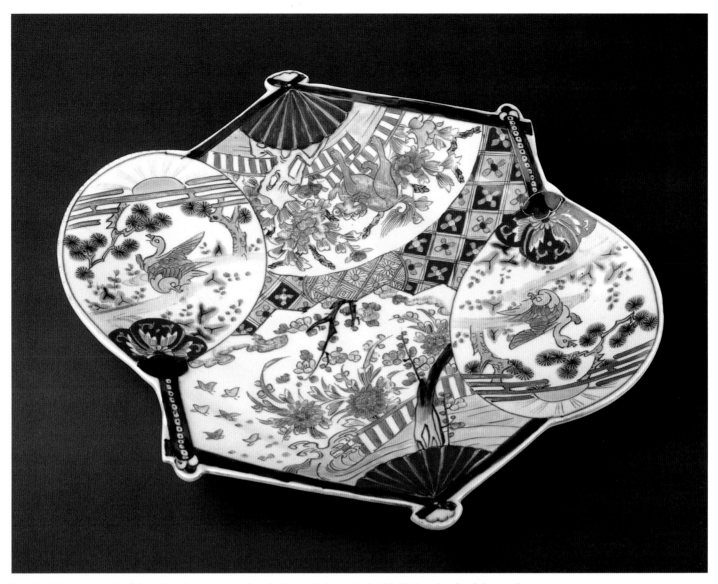

Imari plate composed of four fans in a rectangular design and decorated with bird and animal decoration. 14" l. *Courtesy of The Wasserman Collection.* $900-1100.

Imari rectangular platter with an orange carp and floral decoration. 12-1/2" l. *Hal Miller Collection.* $1200-1500.

Imari plate composed of four fans in a rectangular design. 14" l. *Hal Miller Collection.* $900-1100.

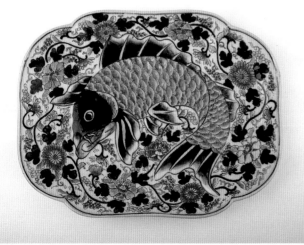

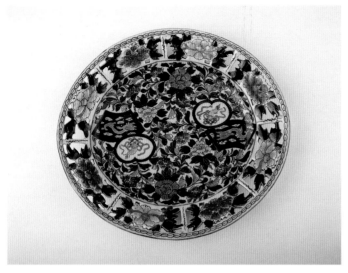

**Oval Shapes**
Imari oval plate with pierced rim. Front and back views.
11-5/8" l. *Hal Miller Collection.* $700-900.

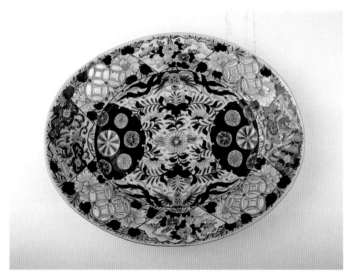

Large Imari oval plate with pierced rim. Front and back views.
15-3/8" l. *Hal Miller Collection.* $1800-2000.

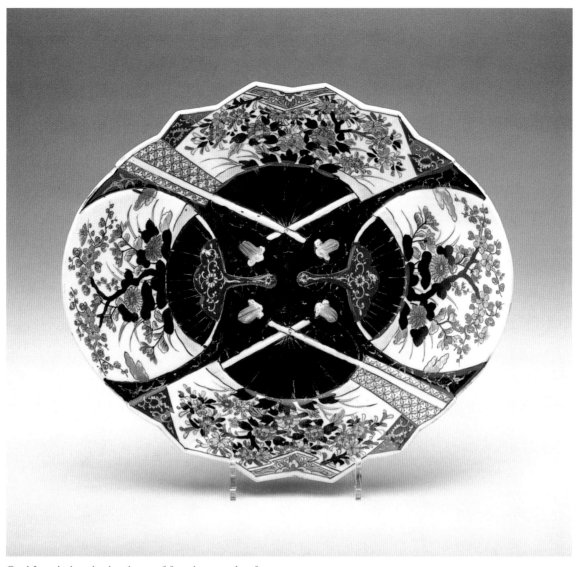

Oval Imari plate in the shape of four intersecting fans and a dark blue central background. 15" long x 13" wide. *Hal Miller Collection*. $800-1000.

Imari oval platter with lions, birds, and floral decoration. 21-1/2" h. x 24" w. *Hal Miller Collection*. $1500-1800.

Imari platter with floral decoration, scalloped top rim, and shaped lower rim. 13-1/4" w. *Hal Miller Collection*. $800-1000.

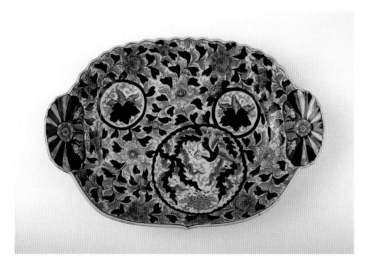

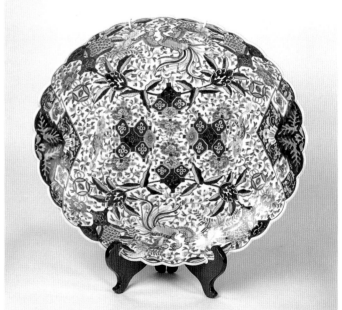

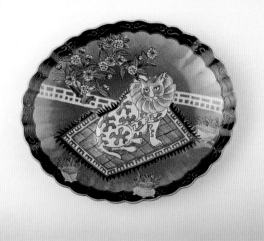

Imari oval plate with relief decoration of an esteemed cat on a carpet. 11-1/8" l. *Hal Miller Collection.* $2000-2500.

Imari oval plate with scalloped edge, blue background and white esteemed cat in center with a neck ruff. 11-1/8" w. *Hal Miller Collection.* $1800-2200.

Imari oval plate with scalloped edge and relief design below panels of tapestry and floral decoration, 12" l. *Hal Miller Collection.* $800-1000.

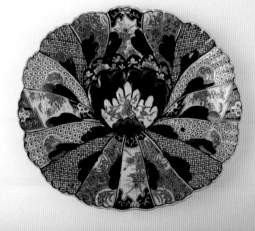

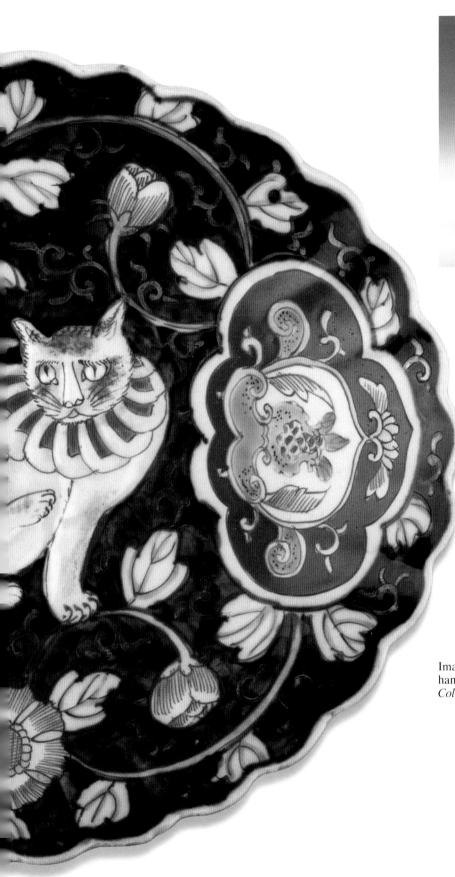

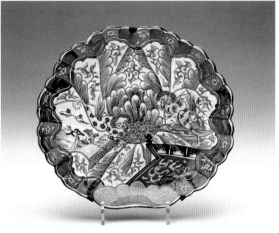

Imari oval plate with a raised scalloped and decorative pattern that is painted with a floral design and two shi-shi at play. 11-3/4" d. *Hal Miller Collection.* $750-900.

Imari deep plate with ribbed scalloped edge and pierced handles and a fine floral decoration. 12-7/8" w. *Hal Miller Collection.* $1000-1250.

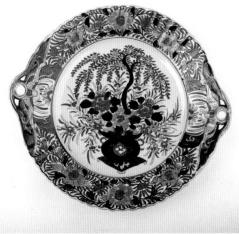

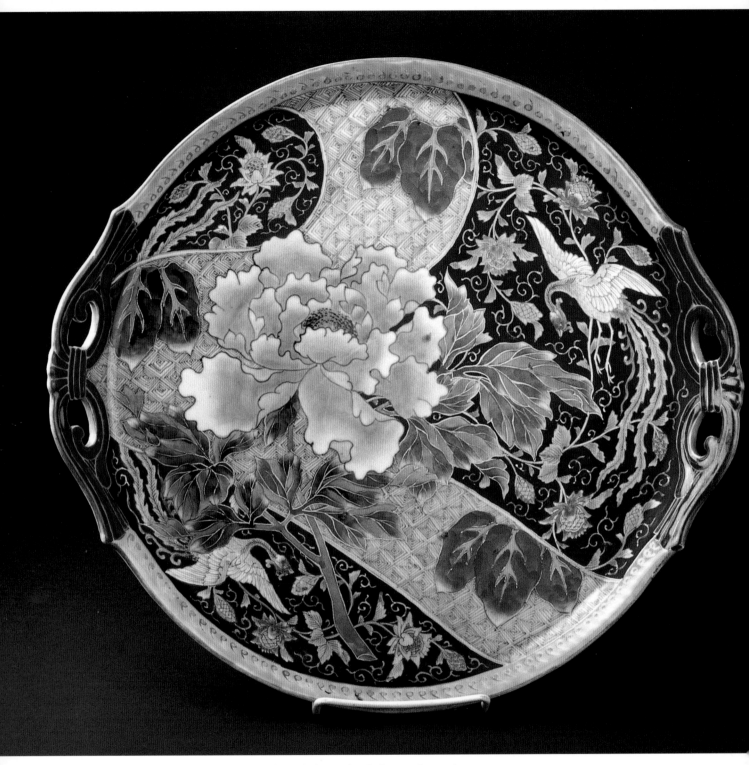

Fukagawa tray with pierced handles and blue floral design and polychrome decoration. Red Koransha mark. 14-3/4" d. *Courtesy of The Marvin Baer - Bonnie Boerer Alliance Collection.* $1200-1500.

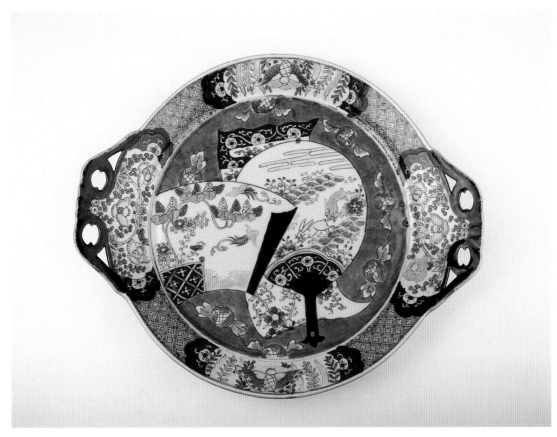

Imari oval platter with pierced handles and elaborate decoration including fans. Blue painted "ship" mark. 15" l. *Hal Miller Collection*. $1500-1800.

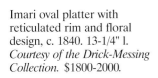

Imari oval platter with reticulated rim and floral design, c. 1840. 13-1/4" l. *Courtesy of the Drick-Messing Collection.* $1800-2000.

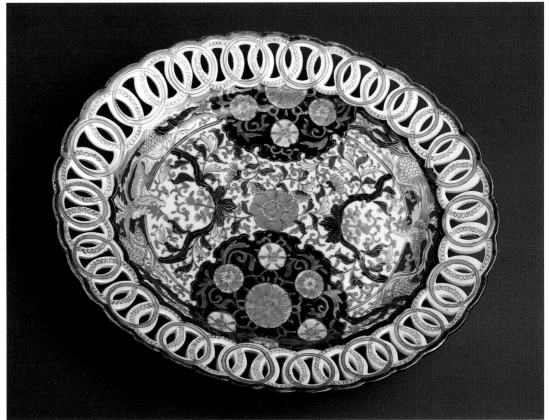

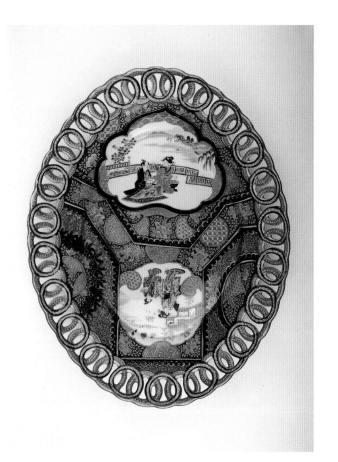 

Imari oval platter with ring-pierced rim and two reserves with people in the decoration over tapestry bands. Front and back views. 15-1/2" d. *Hal Miller Collection*. $2500-3000.

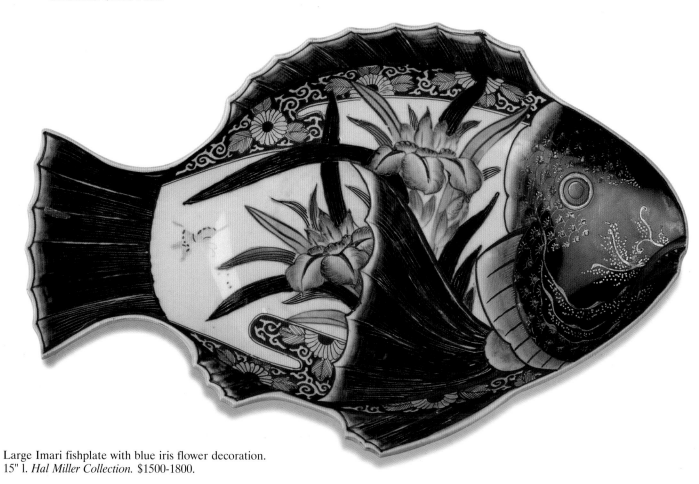

Large Imari fishplate with blue iris flower decoration. 15" l. *Hal Miller Collection*. $1500-1800.

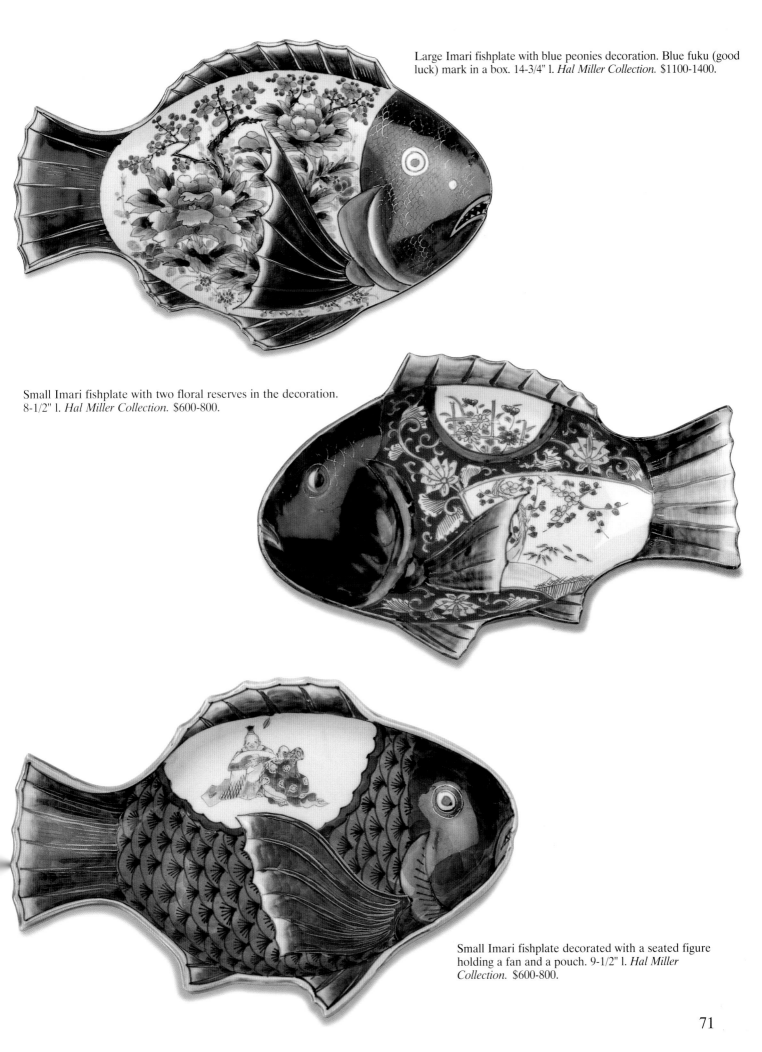

Large Imari fishplate with blue peonies decoration. Blue fuku (good luck) mark in a box. 14-3/4" l. *Hal Miller Collection.* $1100-1400.

Small Imari fishplate with two floral reserves in the decoration. 8-1/2" l. *Hal Miller Collection.* $600-800.

Small Imari fishplate decorated with a seated figure holding a fan and a pouch. 9-1/2" l. *Hal Miller Collection.* $600-800.

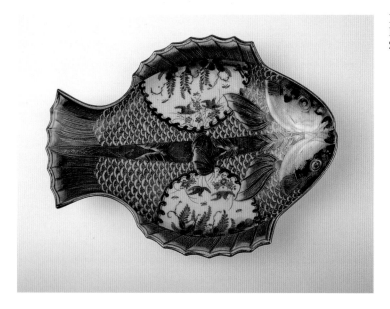

Imari double fishplate with floral decoration and gold details. Blue fuku (good luck) mark. 12-5/8" l. *Hal Miller Collection*. $900-1250.

Imari double fishplate with a scholar and floral decoration. 12" l. *Hal Miller Collection*. $1000-1250.

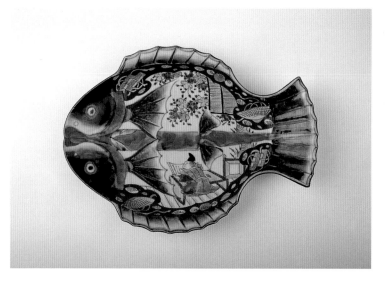

Imari double fishplate with relief scales and waves and flying birds in the decoration. 11" l. *Hal Miller Collection*. $800-1200.

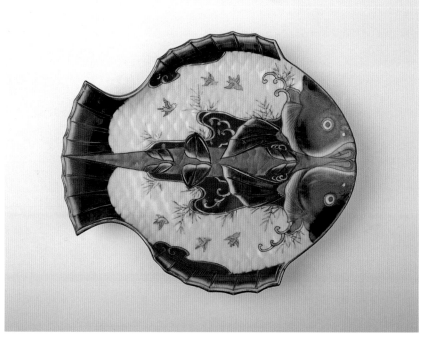

72

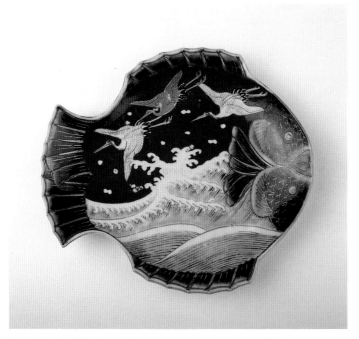

Imari double fishplate with three cranes and waves in the decoration. 9" l. *Hal Miller Collection.* $900-1200.

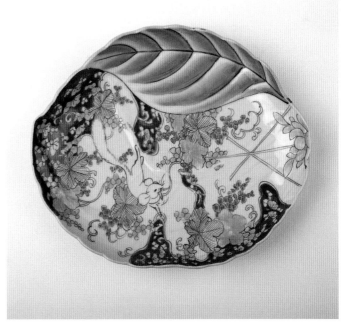

Imari oval leaf-shaped plate with red squirrel, grape vine decoration, and blue leaf. Blue Koransha mark. 9" l. *Hal Miller Collection.* $600-900.

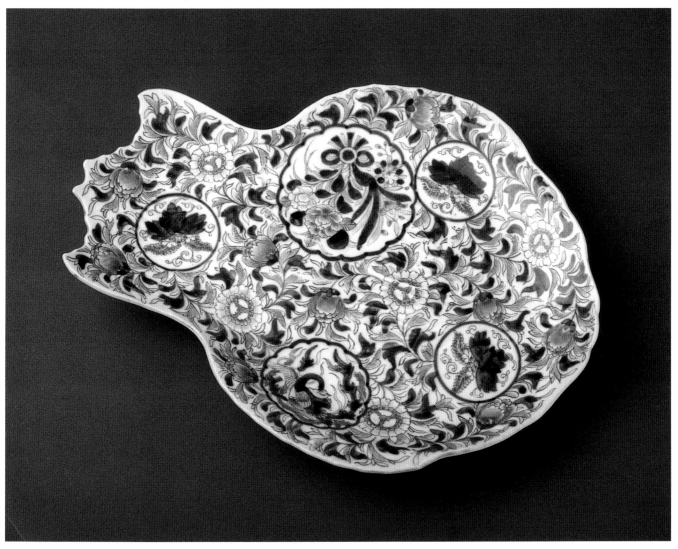

Imari double fishplate with an all-over floral decoration. Koransha blue mark. 12" l. *Courtesy of The Wasserman Collection.* $600-800.

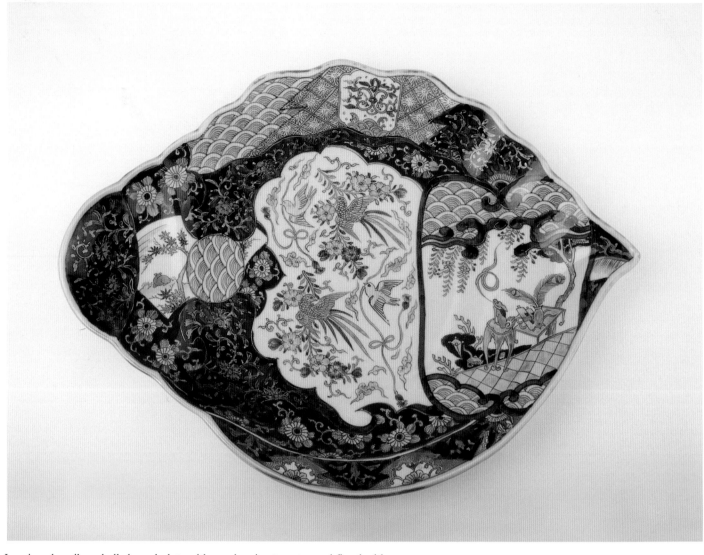

Imari oval snail or shell-shaped plate with overlapping tapestry and floral with
birds decorated panels. 16" w. *Hal Miller Collection*. $1800-2400.

Imari oval plate of shell design with scalloped top. Blue Koransha
mark, 10-3/4" w. *Hal Miller Collection*. $600-900.

Imari eggplant-shaped plate with floral decoration.
12-1/2" l. *Hal Miller Collection*. $1200-1500.

Imari leaf-shaped plate with cigar and purse pouches in the decoration. 10-3/4" l. *Hal Miller Collection.* $800-1000.

Imari leaf-shaped plate with floral decoration. Red Koransha mark of Fukagawa. 10" l. *Hal Miller Collection*. $700-900.

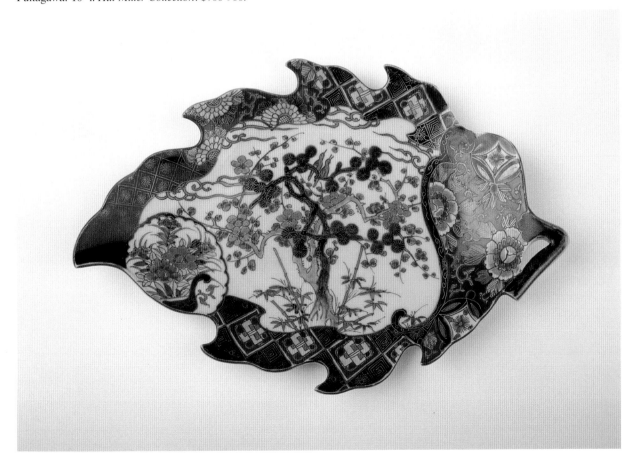

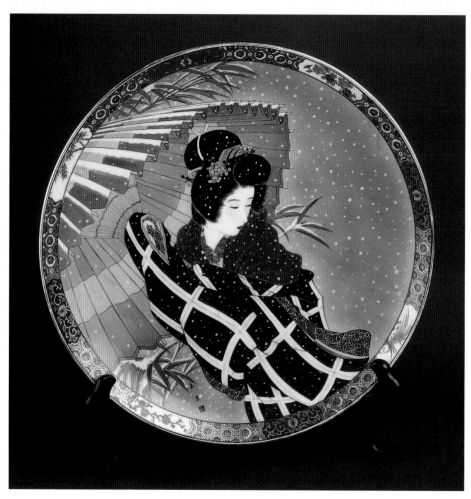

**Round Shapes**
Arita platter showing a woman with a parasol in a snowstorm. c. 1900-1920. 18" d. *Courtesy of the Drick-Messing Collection.* $3000-3500.

**Round Shapes**
Arita platter showing a woman with a parasol in a snowstorm. c. 1900-1920. 18" d. *Courtesy of the Drick-Messing Collection.* $3000-3500.

Round Arita plate with painted blue cat, target, and dish decoration. 8-1/4" d. Signed Seigi. $300-400.

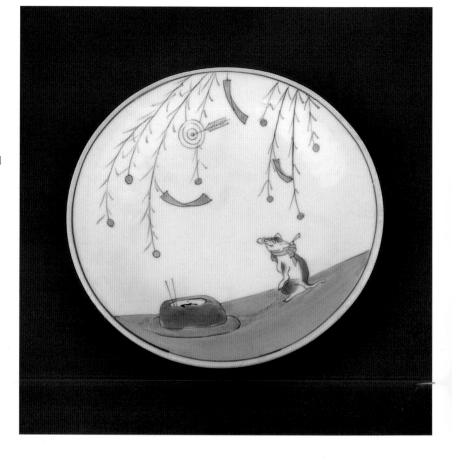

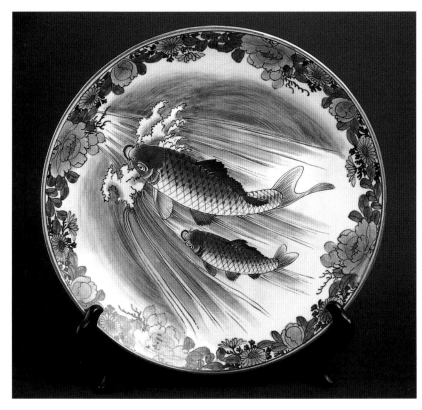

Round platter decorated with two gray fish and a floral rim. Attributed to Fukagawa. 13-1/2" d. *Courtesy of the Drick-Messing Collection.* $1500-1800.

One of a pair of Imari round platters with flying cranes and two floral round reserves on a tapestry background. 14-3/4" d. *Hal Miller Collection*. $2500-3000 the pair.

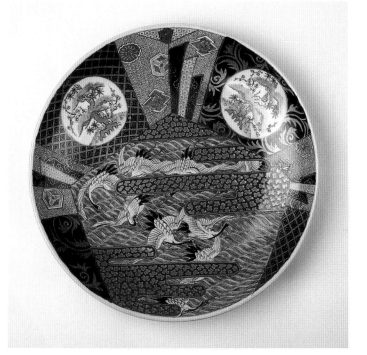

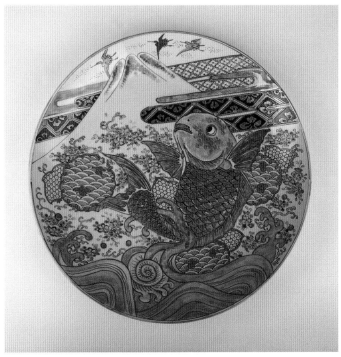

Imari large round platter with relief fish and Mt. Fuji decoration in pastel red and gold shades, 13-5/8" d. *Hal Miller Collection*. $1200-1500.

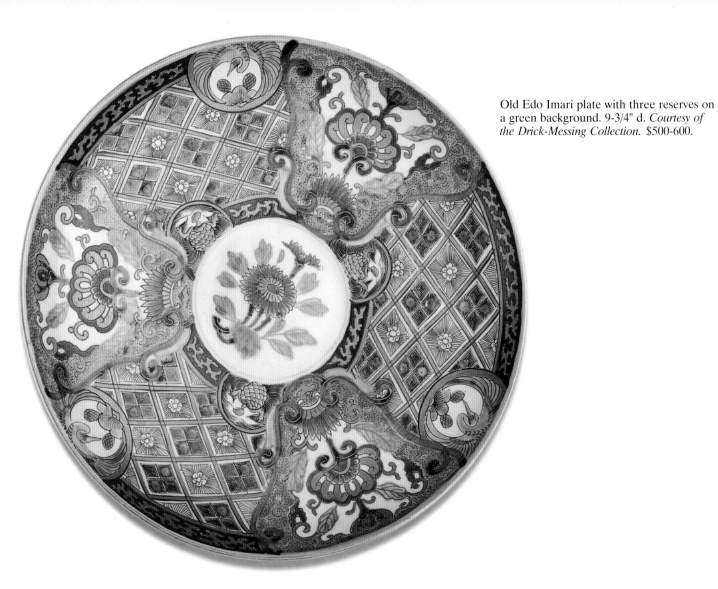

Old Edo Imari plate with three reserves on a green background. 9-3/4" d. *Courtesy of the Drick-Messing Collection.* $500-600.

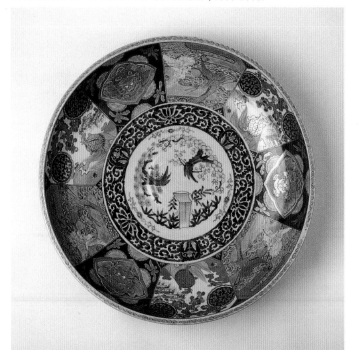

Imari round platter with blue three-friends decoration in the center, and red paneled floral and turtle, foo dog, and flying cranes decoration. 18" d. *Hal Miller Collection.* $1600-2000.

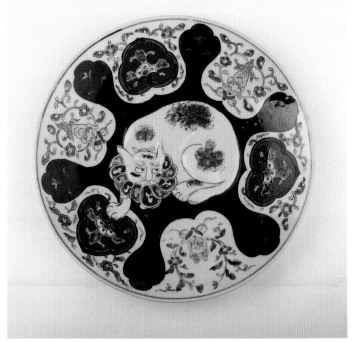

Imari round plate with raised design of an esteemed white cat with a ruffled neck collar. 12-1/4" d. *Hal Miller Collection.* $1800-2400.

Imari plate with scalloped edge and ribbed upper surface. Triangular design with a four-lobed center decoration. 8-1/2" d. *Hal Miller Collection.* $600-800.

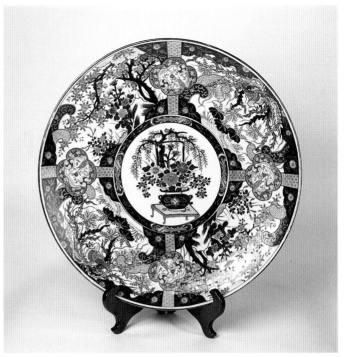

Imari round platter with a central floral arrangement on a table and symmetrical floral decoration with birds. 24" d *Hal Miller Collection.* $2000-2500.

Two unusual Imari plates, each with blue transfer decoration in triangular moth design on a white body and clear glaze. 7-1/4" d. and 9-7/8" d. *Hal Miller Collection.* $400-600 and $600-800.

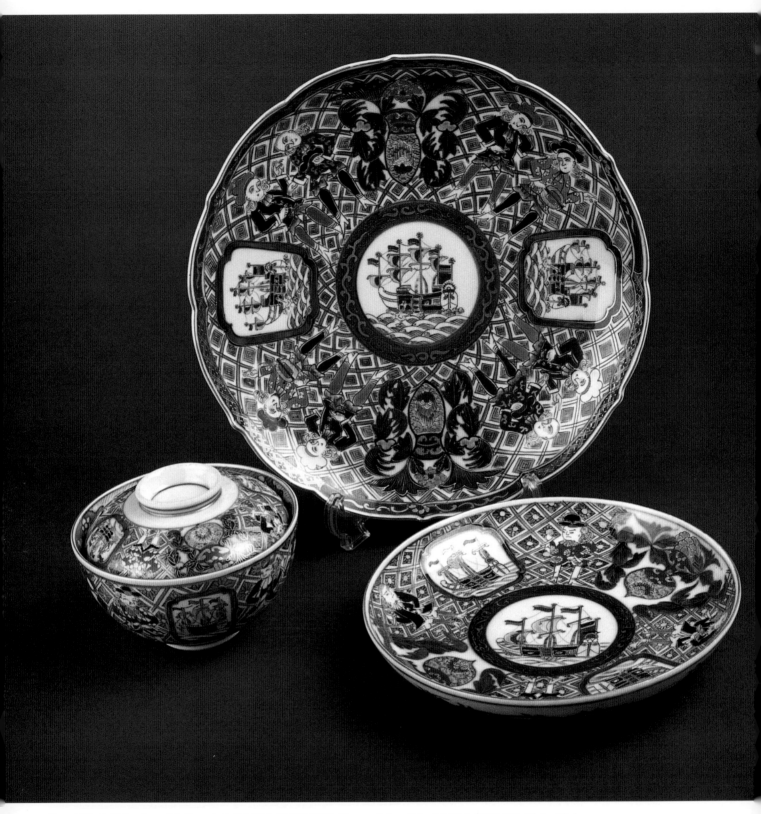

Imari Black Ship plate, Meiji period. 9-1/4" d. $1000-1200. Covered rice dish. 4-3/8" d. $500-700. Plate. 7" d. *Courtesy of the Drick-Messing Collection.* $700-900.

Imari round plate with cranes decoration and a generic European style coat of arms in the center. 9-5/8" d. *Hal Miller Collection*. $500-700.

Imari barber's bowl in Genroku style. c. 1710, 10-5/8" d. *Hal Miller Collection*. $2500-3000.

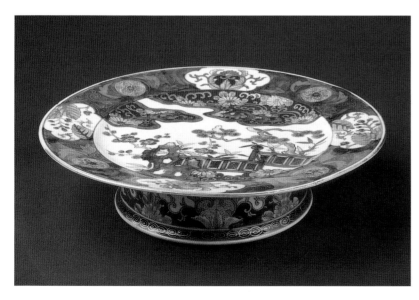

Imari footed dish with landscape polychrome decoration. 9-1/2" d. *Courtesy of The Wasserman Collection.* $800-1000.

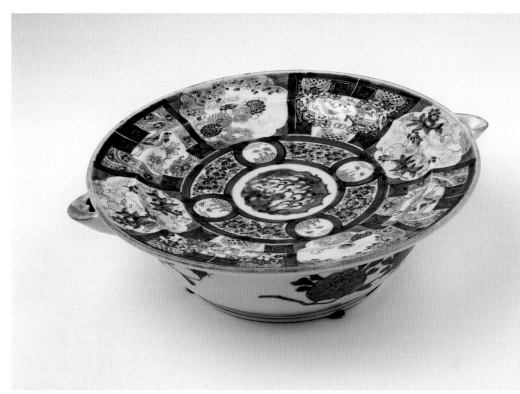

Imari hot water dish with fine underglaze blue and overglaze polychrome floral decoration. Signed Hichozan Shinpo. 18th century. 10-3/4" w. *Hal Miller Collection*. $1200-1400.

Pair of Imari hot water dishes with red rims, peacock and floral decorations. 19th century. 9-3/4" d. *Courtesy of the Drick-Messing Collection*. $1500-1800 the pair.

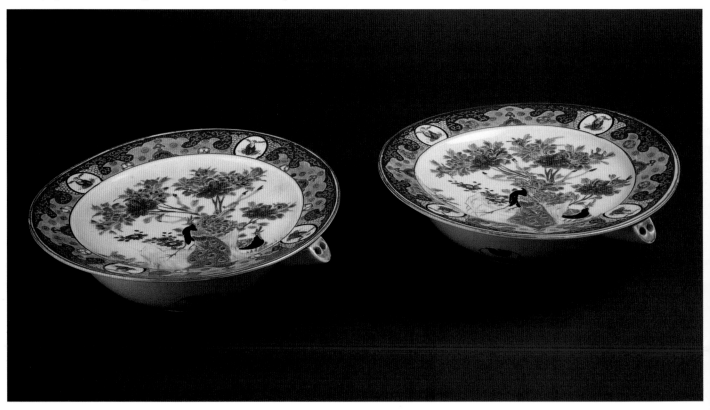

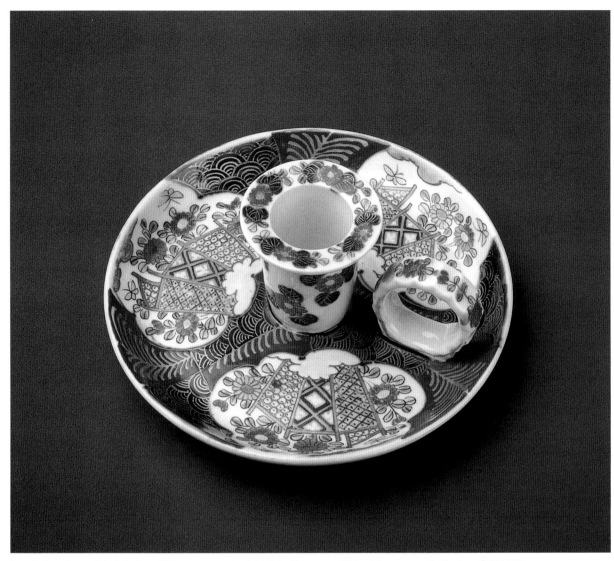

Imari chamber stick. Modern Fukagawa mark. 5-1/4" d. *Courtesy of The Wasserman Collection.* $400-600.

Imari round plate with cutout rim, tapestry decoration, and scenic panels. Signed Fuki Choshun. 16" d. *Hal Miller Collection*. $2000-2500.

Imari deep plate with scalloped edge and six small cutout indents. Two floral arrangements in the decoration. 8" d. *Hal Miller Collection*. $400-600.

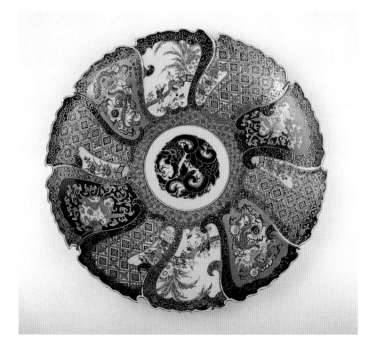

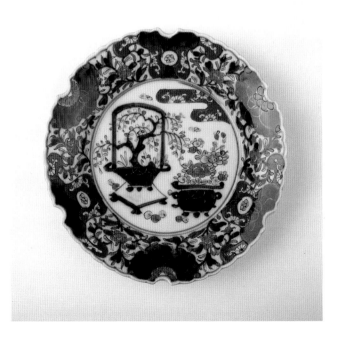

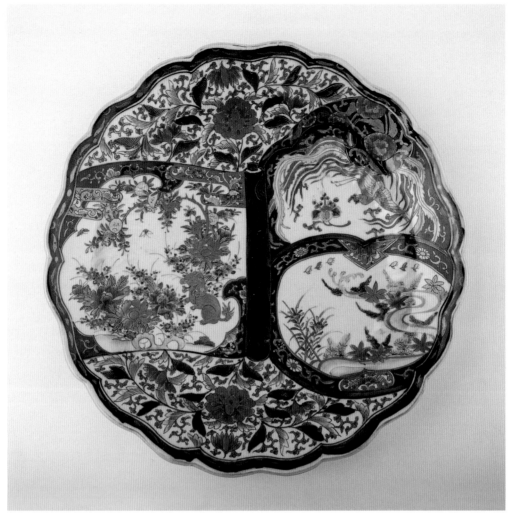

Imari round plate with scalloped edge and three overlapping reserves. 13-3/8" d.
*Hal Miller Collection*. $1200-1500.

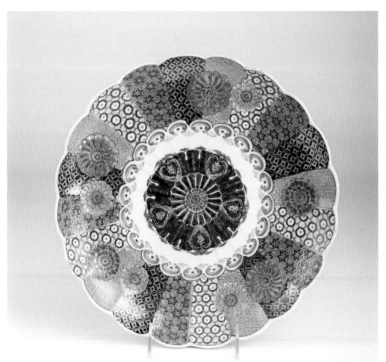

Imari plate with tapestry decoration and scalloped
edge. Two paper labels are on the back, one for the U.S.
Customs Department and one with Japanese writing
(partially damaged). 12" d. *Courtesy of Marvin and Nina
Vida.* $800-1000.

Imari round fluted plate with raised
chrysanthemum decoration. 12-1/2" d.
*Hal Miller Collection.* $1000-1250.

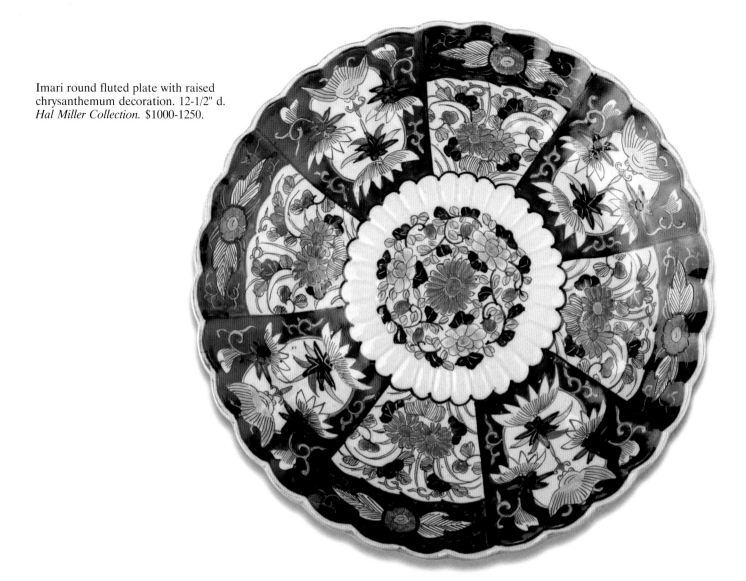

Imari shallow dish with blue tree decoration and overglaze floral
and bird design, the center with a blue dragon. 11-1/2" d. *Hal Miller
Collection.* $500-700.

Imari round deep dish with fluted edge and tied tapestry obi decoration
on a floral field. 12-3/8" d. *Hal Miller Collection*. $1000-1250.

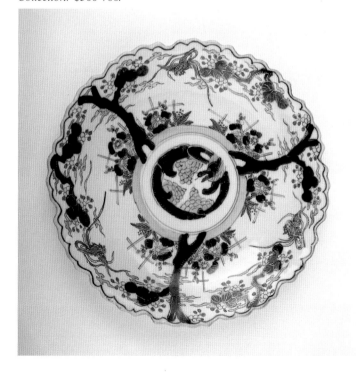

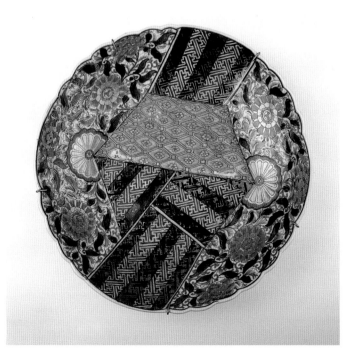

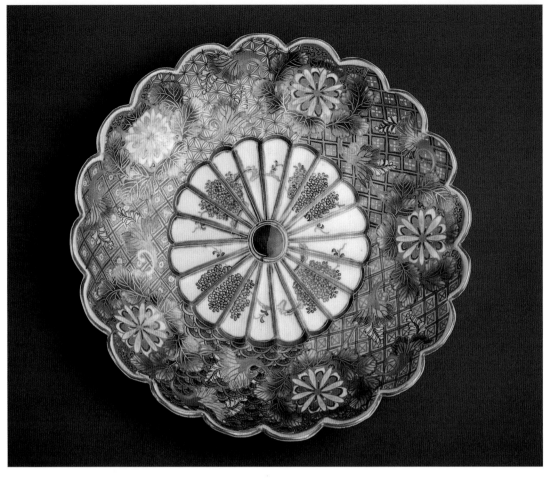

Old Imari scalloped dish with complete fan center decoration. 9-3/4" d. *Courtesy of the Drick-Messing Collection*. $500-700.

Imari round plate with shaped rim and Black Ship decoration. 9-3/4" d. *Hal Miller Collection*. $800-1000.

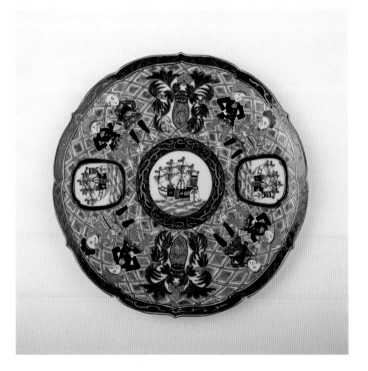

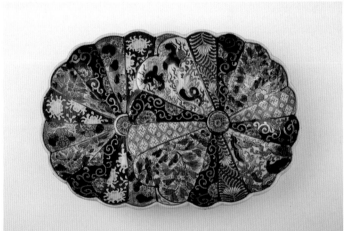

Imari oval dish with lobed edge and raised overlapping tapestry design. 11-1/4" l. *Hal Miller Collection*. $800-1000.

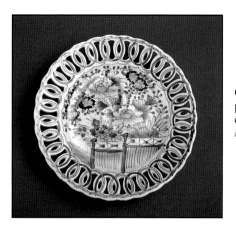

Old Imari plate with a hand-pierced rim painted red and garden and fence decoration. c. 1670-1690. 8-1/2" d. *Courtesy of the Drick-Messing Collection.* $1800-2000.

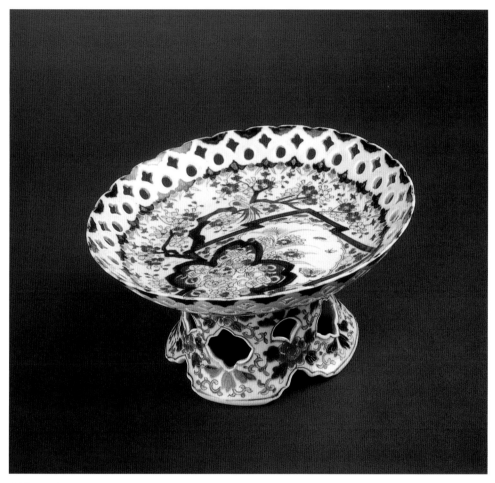

Old Imari footed cake dish with pierced edge and high pierced foot. 8-3/4" d. x 4-1/4" h. *Courtesy of the Drick-Messing Collection.* $2000-2400.

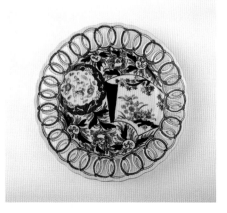

Imari plate with hand pierced rim in overlapping rings, and floral and reserves decoration. 8-3/8" d. *Hal Miller Collection.* $500-800.

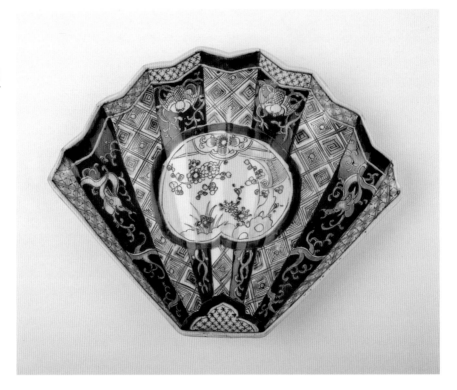

**Geometric Shapes**
Imari fan-shaped dish with tapestry decoration and central floral reserve. 9-3/4". *Hal Miller Collection.* $600-800.

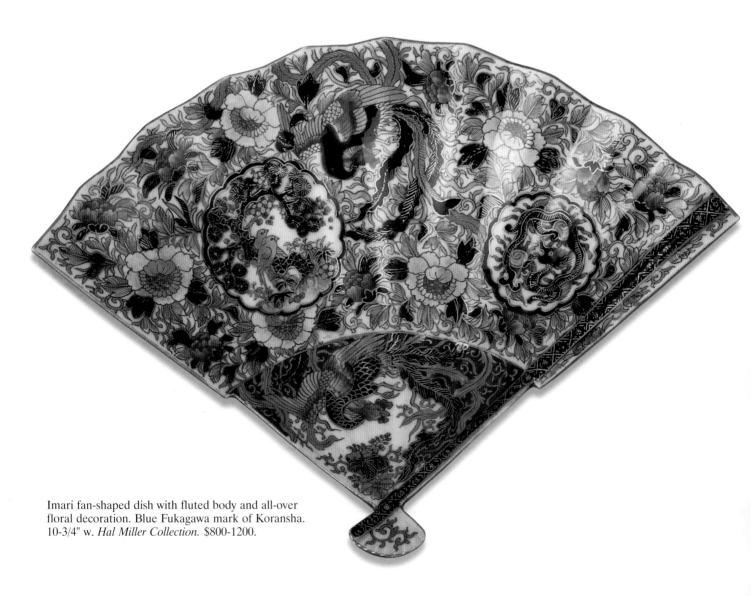

Imari fan-shaped dish with fluted body and all-over floral decoration. Blue Fukagawa mark of Koransha. 10-3/4" w. *Hal Miller Collection.* $800-1200.

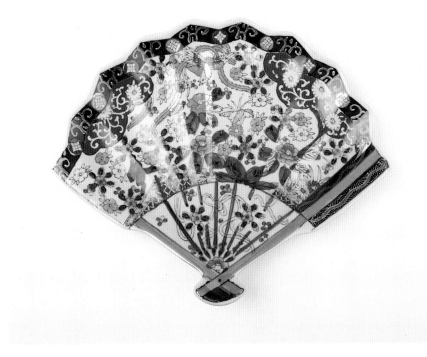

Imari fan-shaped dish with hand-painted blue, red, and gold decoration. Back Signed "Victoria Ware" with blue transfer design, c. 1800. 11-1/2" w. *Hal Miller Collection.* $1500-1800.

Imari triangular plate with bird and floral three-friends decoration. 9-1/4" w. *Hal Miller Collection.* $1200-1500.

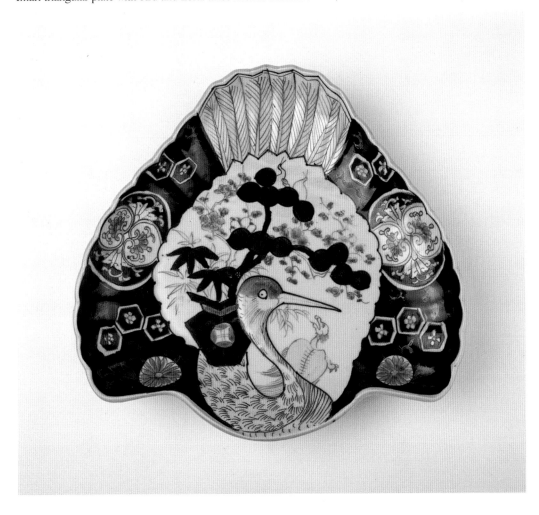

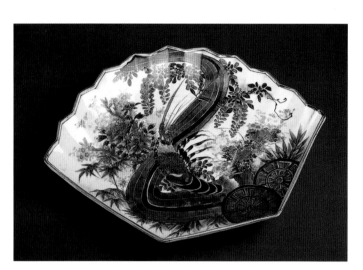

Fan-shaped Imari dish with blue underglaze shrimp decoration and overglaze enamels. Red Koransha mark. 17" w. x 12-1/2" h. *Courtesy of the Drick-Messing Collection.* $2000-2500.

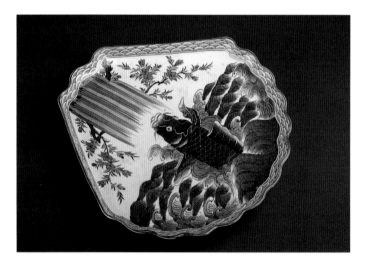

Fan-shaped Imari dish with blue fish decoration. Signed Ken. 13" long and high. *Courtesy of the Drick-Messing Collection.* $800-1000.

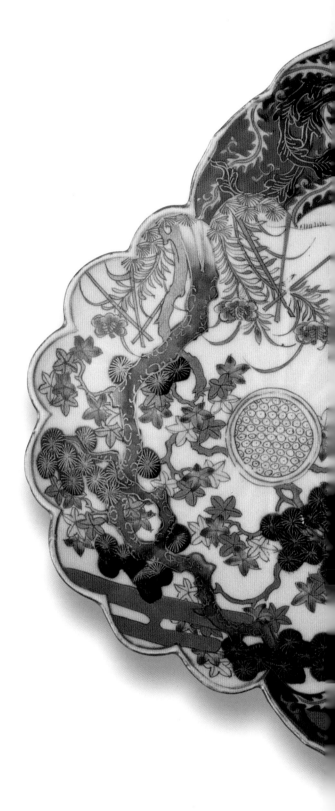

Imari dish of unusual scalloped shape with seven top lobes. Tapestry decoration. 11-1/4" l. *Hal Miller Collection.* $1000-1400.

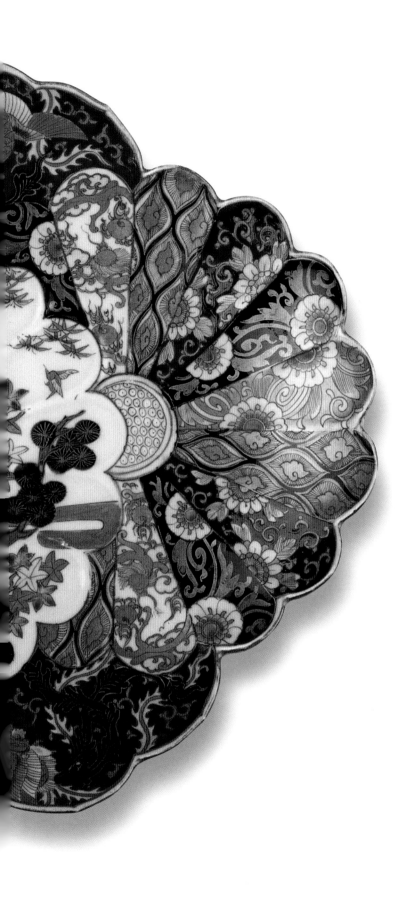

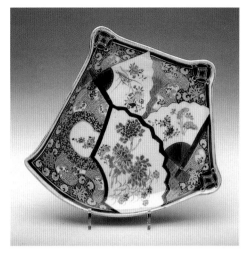

Kite-shaped Imari dish with fan decoration. Red character mark on base. 13-7/8" l. x 13-1/8" w. *Hal Miller Collection*. $850-1000.

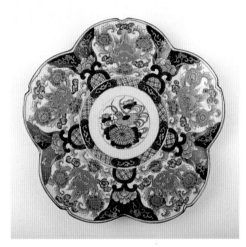

Imari five-lobed and scalloped rim dish with bird decoration in the center. 18th century. 10" d. *Hal Miller Collection*. $800-1200.

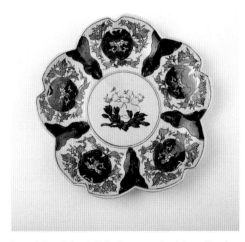

Imari five-lobed dish decorated with stylized flowers in the lobes and in the center. 7-7/8" square. *Hal Miller Collection*. $400-600.

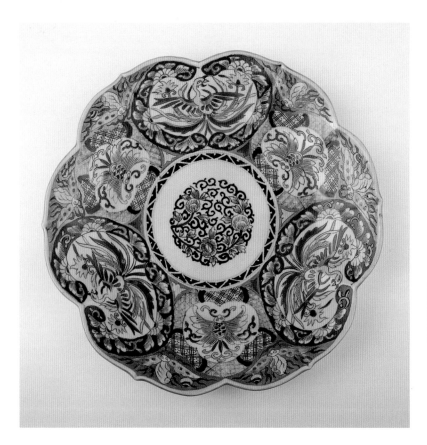

Imari six-lobed plate with red and gold floral and bird decoration and a blue center. The back rim has repeating reclining rabbits. Front and back views. 11-3/4" d. *Hal Miller Collection.* $750-1000.

Imari five-lobed plate with floral decoration and each lobe cutout at the center, 12-1/4" d. *Hal Miller Collection.* $800-1200.

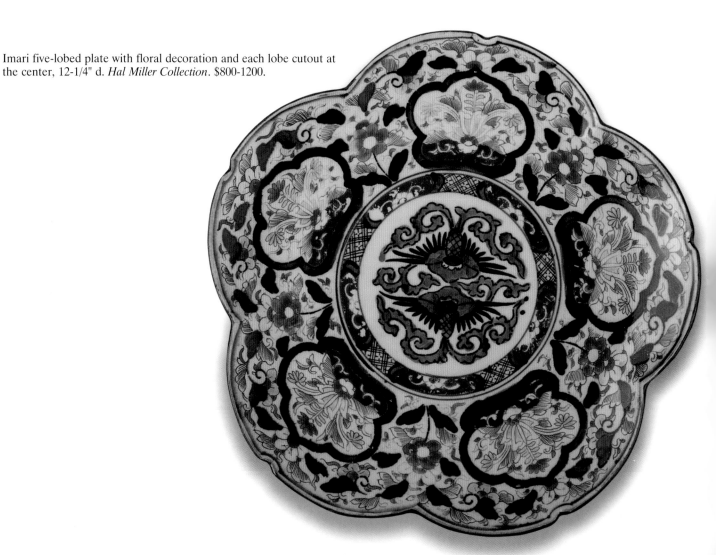

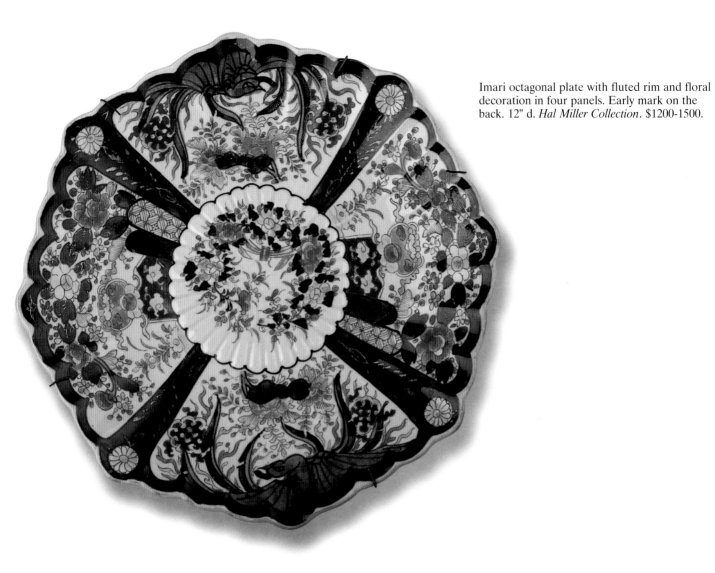

Imari octagonal plate with fluted rim and floral decoration in four panels. Early mark on the back. 12" d. *Hal Miller Collection*. $1200-1500.

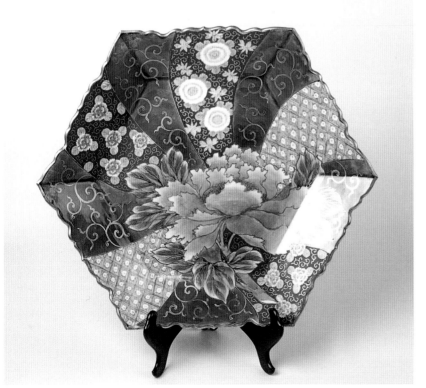

Imari six-sided plate with tapestry decoration and floral blue decoration typical of the work of Chugi Fukagawa of Arita, c. 1870-1875. Paper on back is inscribed in German and is dated 1922. 22" d. *Courtesy of MPL and BL collection*. $2500-3000.

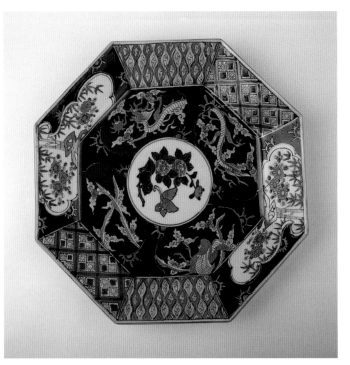

Imari octagonal dish with a paneled rim and four reserves in red with dragon and bird decoration. 11-1/2" w. *Hal Miller Collection*. $600-900.

Imari plate with ten points, floral and tapestry decoration. 9" d. *Hal Miller Collection*. $500-700.

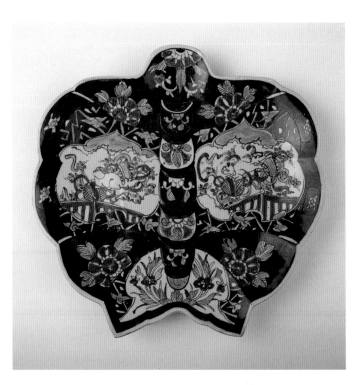

Imari butterfly-shaped dish decorated in cobalt and red with two shi-shi among tapestry balls in a garden setting. 12-3/8" w. *Hal Miller Collection*. $1200-1500.

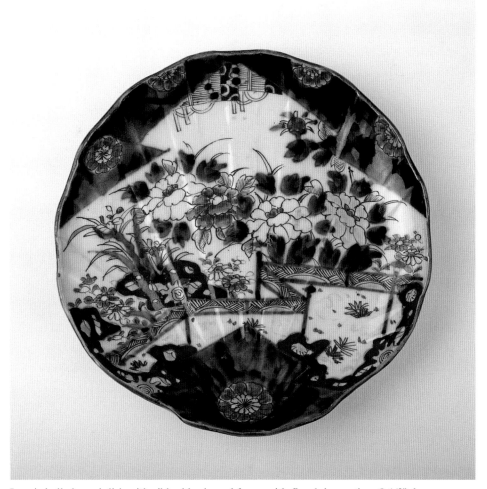

Imari shell-shaped dish with ribbed body and fence with floral decoration. 8-1/2" d. *Hal Miller Collection*. $600-800.

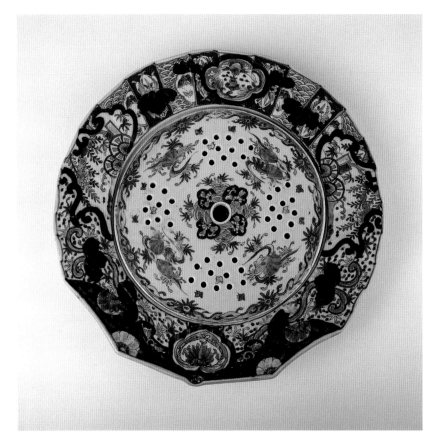

Shell-shaped Imari plate with pierced round insert for draining food. Fine imaginary floral and ho-ho bird decoration. Shown with and without the pierced insert. 12.85" d. *Hal Miller Collection*. $1200-1500.

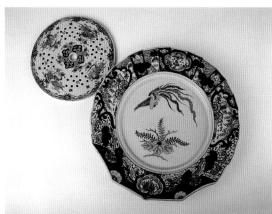

# Kutani

The term Kutani (which means "nine valleys") refers to ceramics of various types, both hard-paste porcelain and soft-paste porcelain, with a variety of overglaze decorations often including an abundance of red. The clay blanks of hard porcelain probably originated at Arita in Saga Prefecture in the seventeenth century and were carried in trade to Kutani, in the rice growing region of Kaga province, where they were decorated. In the following centuries, the origins of the clay blanks varied, and decorations applied in the Kutani region evolved through time.

## Lidded Forms

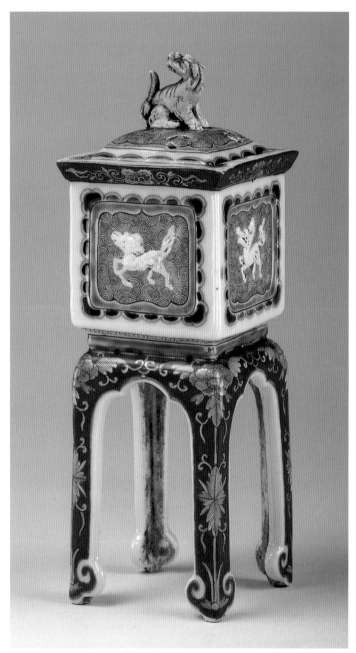

**Rectangular Shapes**
Kutani square incense box on four raised legs. The lid has a lion dog finial in bisque and colored enamels as bands. The square box is decorated with two pairs of kirin and mythological horse relief figures in recessed and color enameled panels on the sides. 8-1/2" h. $3000-5000.

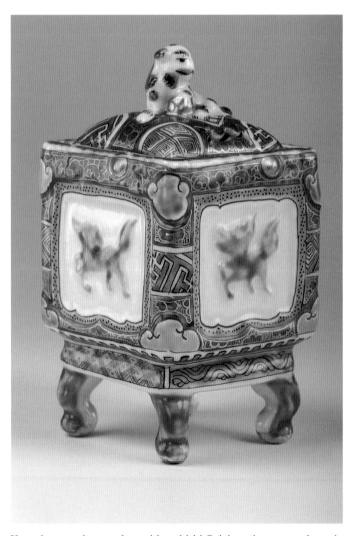

Kutani square incense box with a shishi finial on the square domed cover and four short leg. Four side panels are decorated with two kirin and two mythological horses relief figures. A patterned border design has iron red, purple, green, gold, and cobalt areas. Meiji period (1868-1912). 4.25" h. *Harry & Carol Willems.* $500-600.

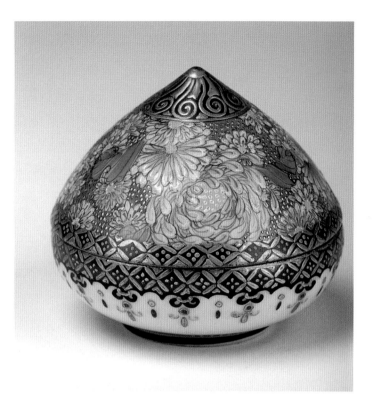

## Round Shapes

Kutani round, teardrop shaped covered kogo box. The exquisitely painted lid is decorated with a large spiral gold and wine colored medallion, which has a peaked top. The painting below the cover is meticulous with an all-over pastel floral pattern. Both the lid and lower portion of the box have a geometric border of gold and turquoise with wonderfully decorated arabesque tassels hanging down. The inside of the lid has a painting of Daikoku opening his money sack with coins of the realm and three krako boys helping themselves to their gift from Daikoku. The lower portion has a very heavily painted gold and wine colored floral design and the inside contains a fan with a long tassel cord attached. Signed Taniguchi on the bottom. 2.25" high, 2-1/2" wide. *William & Jo-Ann Van Rooy.* $800-1000.

Kutani bell-shaped incense burner with a gold and iron-red looped handle. The upper portion is decorated with four hobnail panels in gold and iron red of symmetrical brocade design. The base has three legs with cutout scalloped finish and a three-dimensional dragon circling the perimeter. Six-character Kutani mark. Meiji period. 10" h. *Harry & Carol Willems.* $1000-1200.

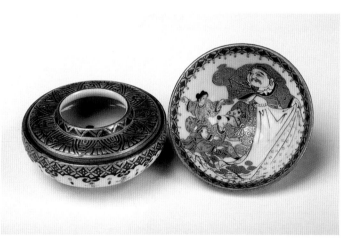

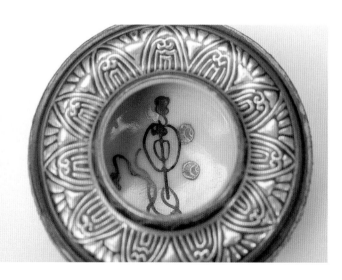

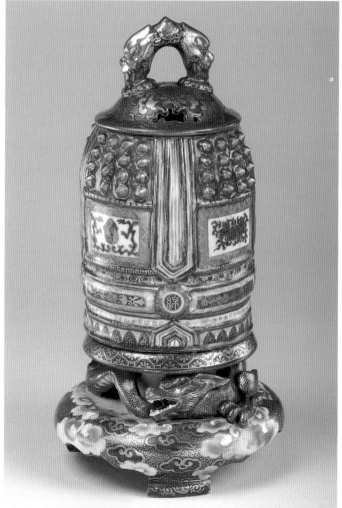

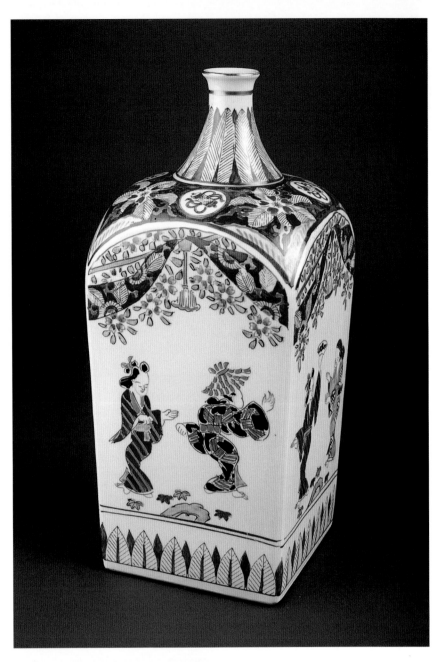

**Rectangular Shapes**
Square Kutani bottle with each side decorated with pairs of women. 11-1/4" h. *Courtesy of the Drick-Messing Collection.* $1000-1200.

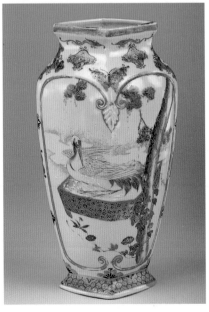

Diamond shaped vase with two decorative scenes, one of a hawk pursuing a goose and the other of a nesting Manchurian crane. The decoration includes butterflies and floral design. Signed with the eight-character Kutani mark. 11" h. *Harry & Carol Willems.* $800-1000.

**Round Shapes**
Pair of cylindrical Kutani vases with scrolled handles at the shoulders and three crouching boy figures as feet. The vases are decorated with facing images of ladies in a garden and cranes in a landscape. 9-3/4" h. *Courtesy of the Hilco Collection*. $1500-1800.

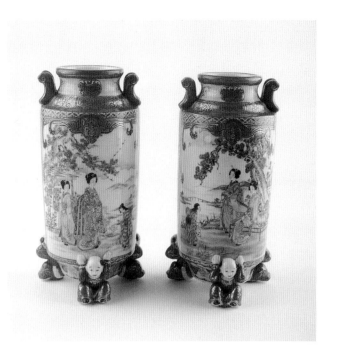

Kutani cylindrical vase with two boys flanking the mouth and three boys holding up the base. A large bird of paradise decorates one panel and a mother with two girls decorate another panel. Iron red and gold brocade design separates the panels. Greek key design above the base. Three-character Kutani mark. Late Meiji period. 10.25" h. *Harry & Carol Willems.* $600-800.

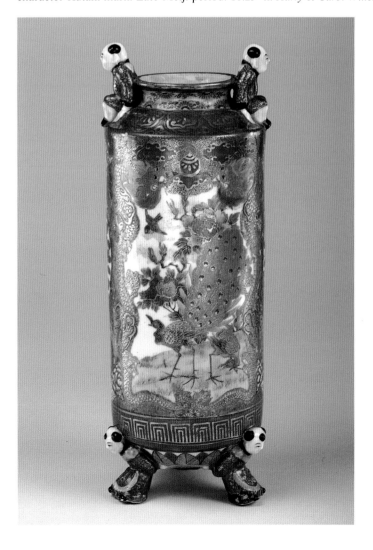

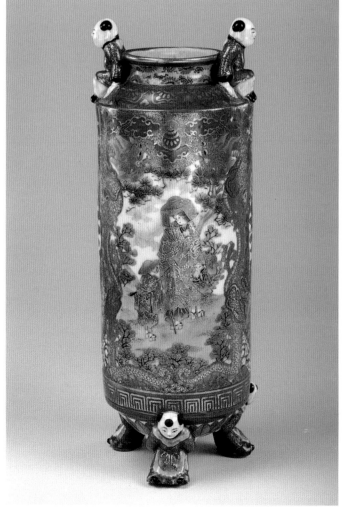

Kutani vase of barrel form with a 1-1/4" wide gold lattice band in the center. The entire vase has a mesh overlay of white on white enamel. An iron red and gold border circles the base. 10" h. x 6-1/2" w. *Harry & Carol Willems.* $1200-1500.

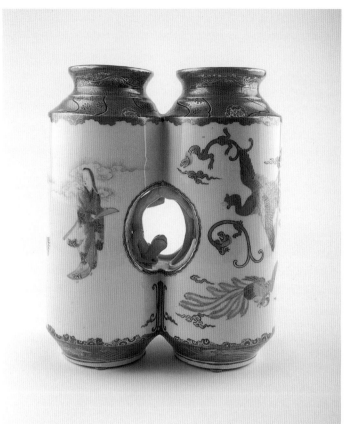

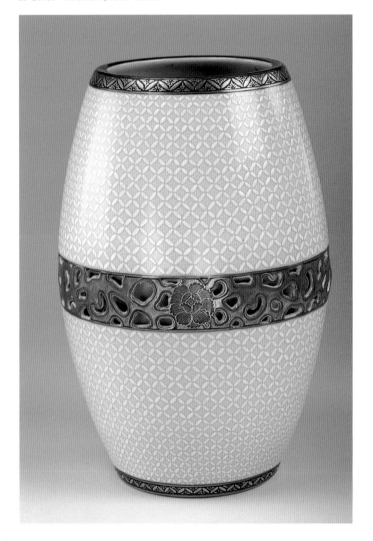

Kutani double vase with a moon cutout enclosing relief salamanders decoration. The sides are painted with red ornamental birds and woman highlighted with gold. 13-1/4" h. *Courtesy of the Hilco Collection.* $2000-2200.

Kutani double vase of urn shapes decorated with painted dressed bird musicians entertaining a seated important man. 12-1/4" h. *Courtesy of the Hilco Collection.* $2000-2500.

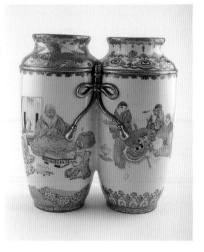

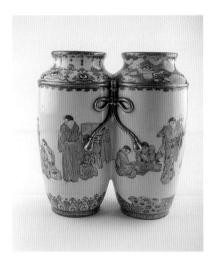

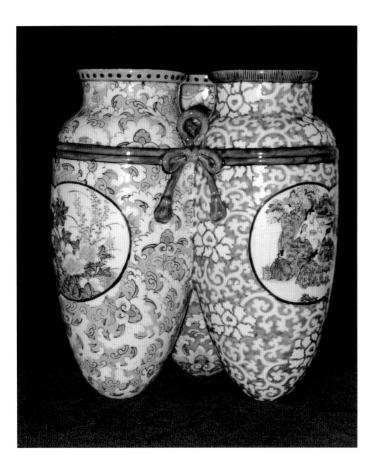

Rare Kutani triple vase formed from three similar amphora, each decorated individually and joined in the middle and with a blue cord design tied in a bow. Each has a floral background and circular reserve enclosing floral or figural decoration. The rims are brown and green with black dots or lines. Unsigned. c. 1880. 10" h. *Courtesy of the L. Robbins Collection.* $1800-2200.

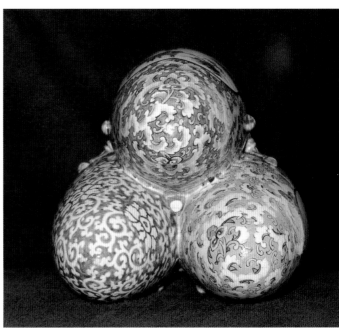

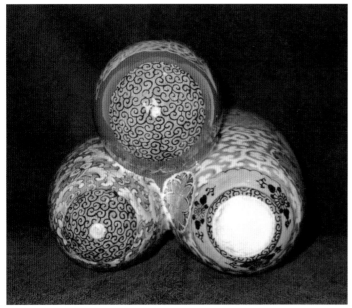

Rare Kutani triple vase formed from three different narrow-necked vases. The tallest and the medium vases have floral tapestry background decoration. The shortest has red background and a group of colorfully painted human figures. 10-7/8" h. *Courtesy of the L. Robbins Collection.* $1800-2200.

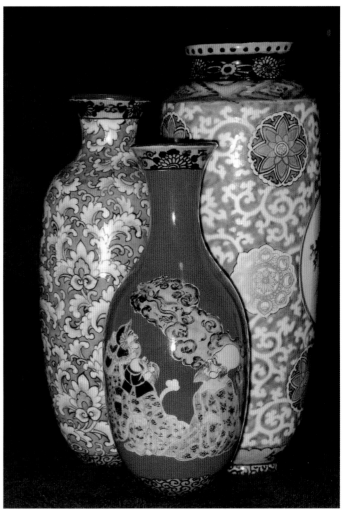

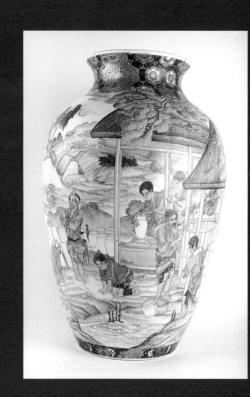
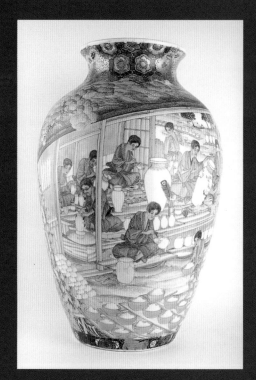
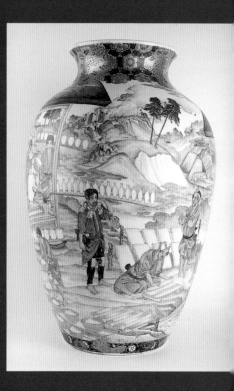

Very large and rare Kutani vase of ovoid shape beautifully painted with an allover landscape scene displaying the handmade pottery industry in Japan. c. 1860-1870. 22" h. $12,000-14,000.

Kutani ovoid vase with gilt and enamel geometric bands on the rim and shoulder. The body has a circular scene of a kingfisher in a marsh surrounded by a floral and leaf decoration. A four-character mark is on the base. 12" h. *Harry & Carol Willems.* $800-1000.

Kutani vase with black and gold figures, man on fish, and children. 8-1/2" h. *Courtesy of the Hilco Collection.* $1200-1500.

Kutani porcelain vase painted with scenes of Rakons, flying dragon, and a mythical landscape in polychrome with phoenix bird and shishi. Attributed to Imura. 18-3/8" d. *Courtesy of the L. Robbins Collection.* $8000-8500.

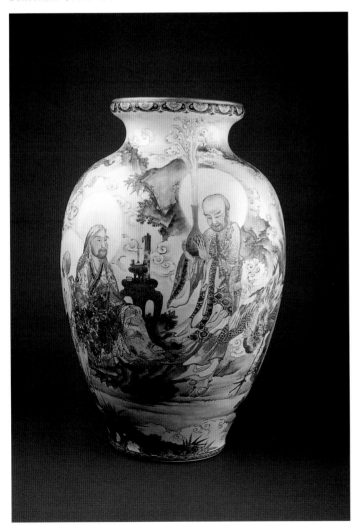

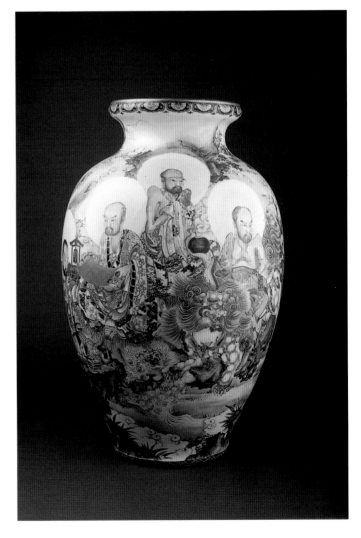

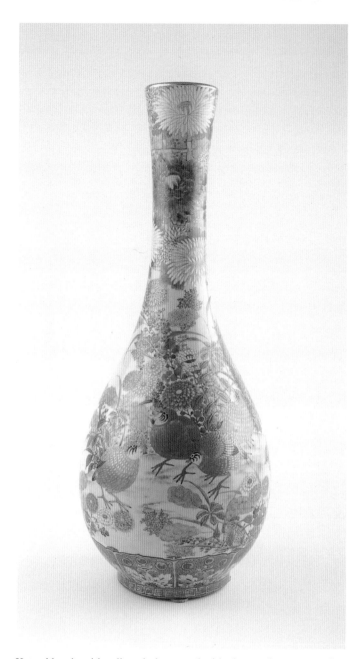

Kutani bottle with tall neck decorated with chrysanthemums and quail. Red 6-character mark on the base. 15-1/2" h. *Courtesy of the Hilco Collection.* $800-1200.

Kutani urn shaped jar decorated with fine floral painting by Seiboku in a wide band. Below, a chevron-patterned golden band extends to the base. 9-1/4" h. *Courtesy of MPL and BL collection.* $1800-2000.

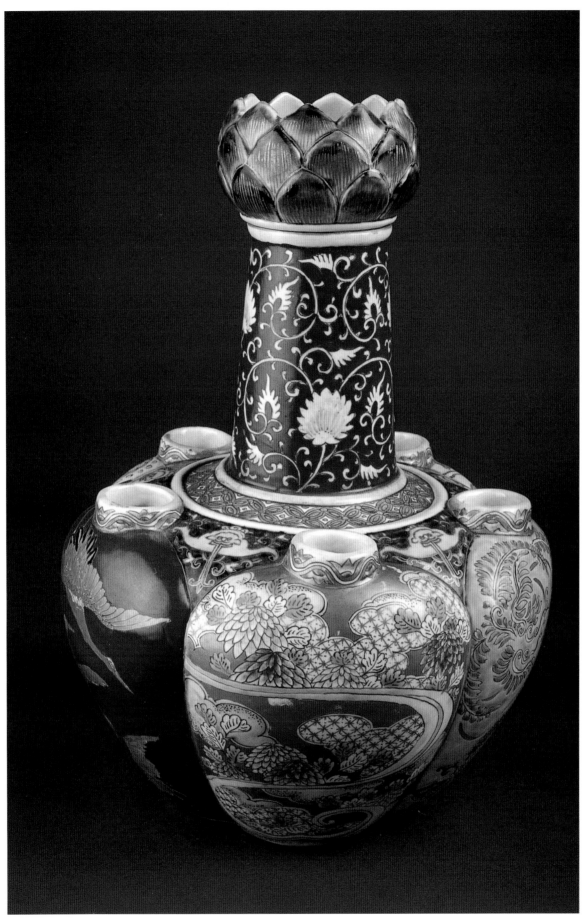

Kutani crocus vase with polychrome decoration and five side openings, each shaped as a bulbous vase. The tall red, central stem has a bud-shaped, saw tooth rim. 12-1/2" h. *Courtesy of the Drick-Messing Collection.* $3000-4000.

Kutani beaker form vase with flared mouth and decoration in Satsuma style. The flaring rim has several segments of enamel and raised gold brocade decoration. The center scene depicts women and children playing on the grass. The inside of the flared rim has scalloped brocade decoration with floating gold leaves. Signed Kutani Imura. 7" tall. *Harry & Carol Willems.* $500-600.

## Bowls

Large and important Kutani bell-shaped bowl decorated with fine painted decoration of bearded men flanking a haloed central man. 14-1/2" d. x 14" h. $6000-8000.

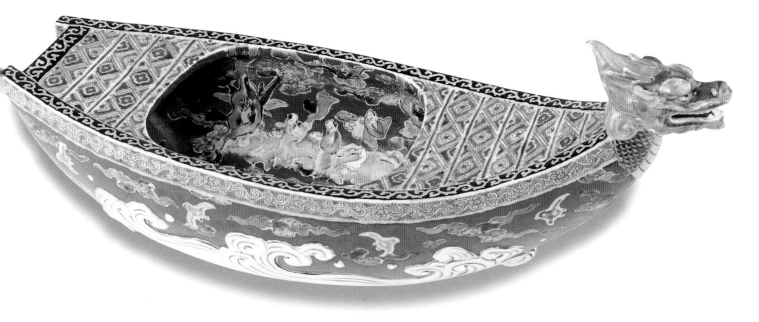

Kutani boat-shaped bowl with a dragon bow and interior painted decoration of fish and people in a garden landscape. 14-1/2" l. *Courtesy of MPL and BL collection*. $1200-1500.

## Plates

Kutani shallow bowl of crackleware bearing rare painted decoration of a single Black Ship in full sail. Green Kutani mark on the back. 10-1/2" d. *Harry & Carol Willems.* $500-600.

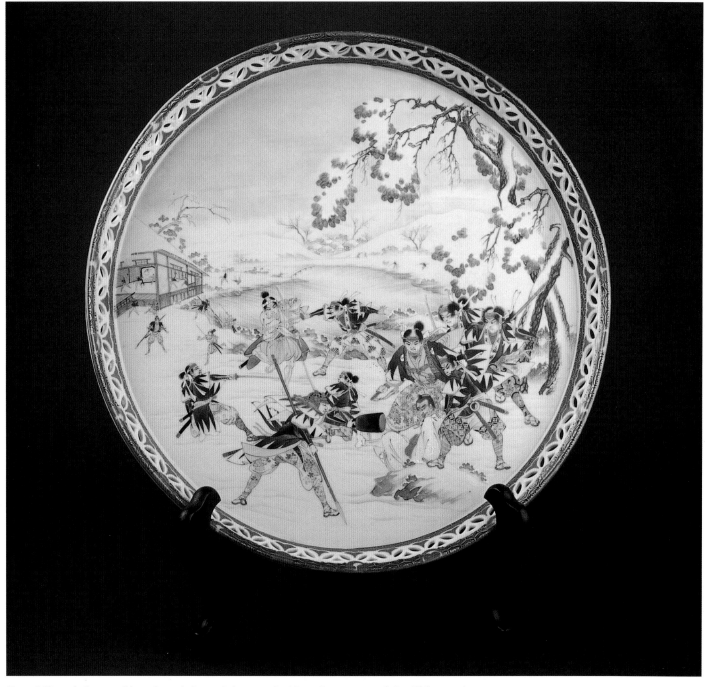

Round Kutani platter with a pierced rim and decorated with a winter scene of the 47 Samurai in battle. 14" d. *Courtesy of the L. Robbins Collection.* $3000-3500.

Large round Kutani platter decorated with a central rectangular panel painted to show figures in a landscape carrying Buddha. The rim border has raised gold enamel interrupted with four half-round medallions. 15-1/2" d. $2500-3000.

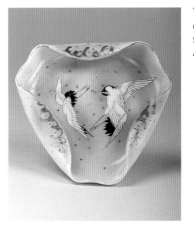

Triangular Kutani plate with folded corners and decorated with two flying cranes and raised gilt scrollwork on the folded flaps. Unsigned. 4" d. *Harry & Carol Willems.* $150-250.

Early Kutani pedestal plate with a 1/2" recessed well. Scene shows two boys printing calligraphy on a scroll beneath a tree. The outer portion of the bowl is covered with green scrollwork and three raised chrysanthemums. Signed Kutani. Late Edo period. 8" d. x 2" h. *Harry & Carol Willems.* $250-300.

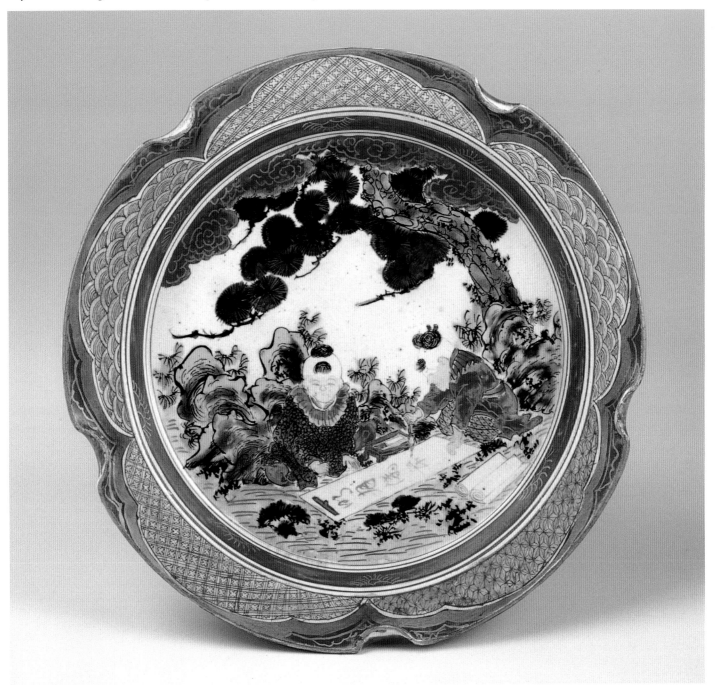

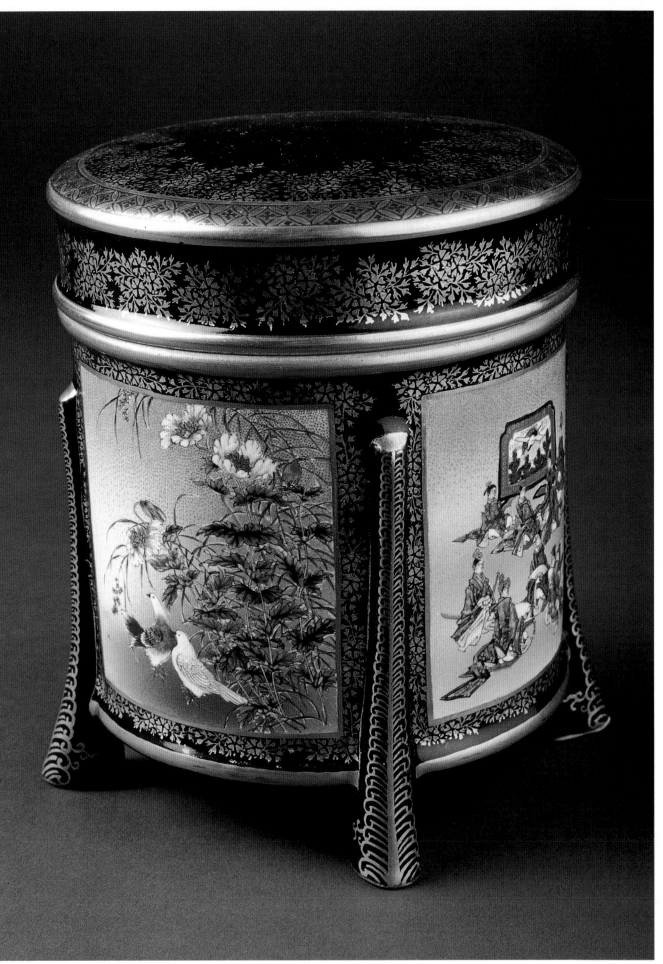

# Soft-paste Porcelain

## Satsuma

The term Satsuma refers to soft-paste porcelain ware of two types. The older type, dating from the seventeenth century to the early nineteenth century, originated in Kagoshima Prefecture in Satsuma Province in the southwestern area of Kyushu Island and was made primarily for domestic Japanese use. The later type of Satsuma, dating from the middle of the nineteenth century onward, has soft-paste porcelain blanks that were brought to decorators, primarily in Kyoto but also in Yokohama and Tokyo, for decoration and were usually exported to foreign places. These are among the most skillfully decorated Japanese ceramics and are much sought after today.

Satsuma glaze is characteristically crackled all over the cream-colored clay and enamel and gold decoration is applied on top of the glaze. Old Satsuma ware should be compared with later Satsuma wares to distinguish them. The later export forms are lighter and the glossy glaze is shinier; decorations are usually more tightly designed and well painted.

The sophistication of much Kyoto Satsuma soft-paste porcelain export ware results from both finely potted blanks and carefully designed decoration. The decoration usually follows the shape and surfaces of the form, fitting into spaces that can be seen completely by the viewer at one glance. For example, very often a round shape is decorated in four panels, each one viewed completely from one view point. Decorations that surround a form and need to be viewed by circling the piece or turning it are less often found.

**Lidded Forms**

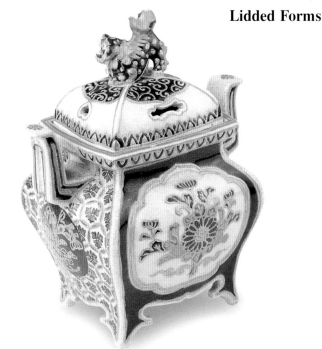

**Kyoto Satsuma decorated by Kinkozan**
Kinkozan IV was the artist name for Kobayashi Sobei (1824-1884) and another Kobayashi Sobei (1868-1927) used the artist name Kinkozan V.

**Kyoto Satsuma decorated by Yabu Meizan**
Born Yabu Seishichi (1853-1934) at Osaka, he was a prolific decorator c. 1880-1916. In the period c. 1880-1890, he painted primarily Buddhas and Rakons with golden halos and festivals such as the 100 boys scenes. Circa 1890 he used Japanese themes of Samurai and Hiroshige's block prints series of the Tokaida Road between Kyoto and Edo (Tokyo). Also butterflies, flowers, and processions. He exhibited at the International Exhibitions in Paris (1900) and London (1910).

**Opposite page:** Satsuma canister with cobalt blue background and gold floral details rests on four raised feet that extend up the sides. A flat cobalt blue lid has gold floral details. Four finely painted polychrome scenes, two with people and two with birds in a garden, decorate the sides. Signed by Kinkozan. 6-1/2" h. $2000-2500.

**Rectangular Shapes**
Small Satsuma covered box with foo dog finial, rectangular pierced lid on rectangular box with two side arms and raised feet. 3-3/4" h. *Courtesy of MPL and BL collection.* $1500-2000.

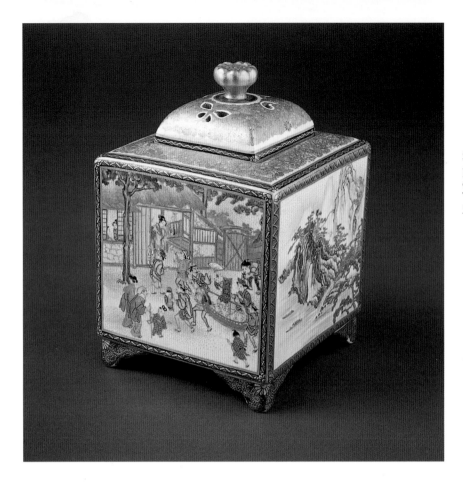

Satsuma square koro with four painted sides. Lid pierced and decorated with all-over floral decoration against gold background by Shozan. Two panels with people and two with landscapes. 5-1/2" h. $5500-7500.

Small Satsuma covered square box. Lid decorated on four sides with floral design and the scene on the cover has implements of the tea ceremony. The four scenes on the box include two of krako boys playing and two of valuable objects. The borders around the scenes have intricate design work with raised gold work dots to highlight it. Each of the four feet has a gold and black Greek key design. Signed Ryozan. Box 2" high, 1-3/4" square. Lid 1.25" x .25" h. *William & Jo-Ann Van Rooy.* $1500-2000.

Satsuma tea caddy with silver lid (probably a European replacement) and sides decorated with images of Buddha, Kannon, and a small attendant with a flower. Signed probably by Kinkozan. 5.25" h. *William & Jo-Ann Van Rooy.* $2500-3500.

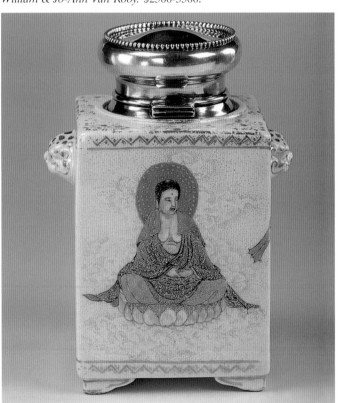

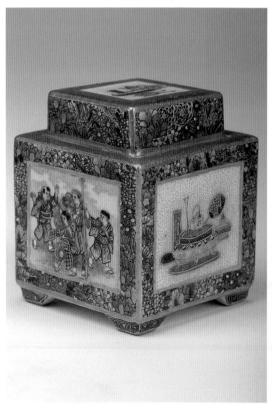

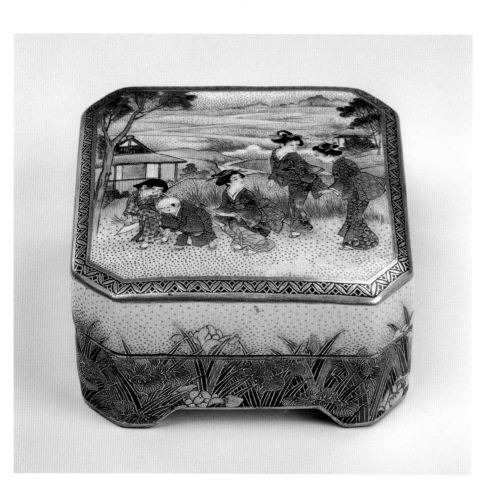

Satsuma square covered box with mitered corners painted in enamels and gold. The top is decorated with a landscape scene with women and children. The sides have a band of iris and peony floral decoration extending to the four blocked feet, which are mitered at the corners. Signed by Ryozan with the pseudo-factory mark. 2-3/4" wide. *William & Jo-Ann Van Rooy.* $1200-1500.

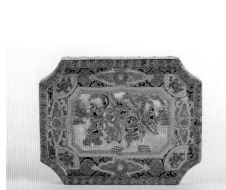

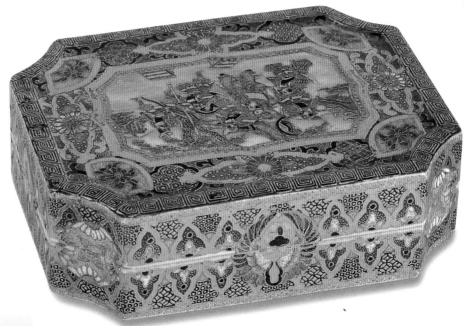

Octagonal Satsuma rectangular box with borders detailed in gold. The top depicts a scene with Samurai warriors. Inside are floral and butterfly decorated panels. Signed by Kinkozan. 3-1/4" l. x 2-1/2" d. $7000-8000.

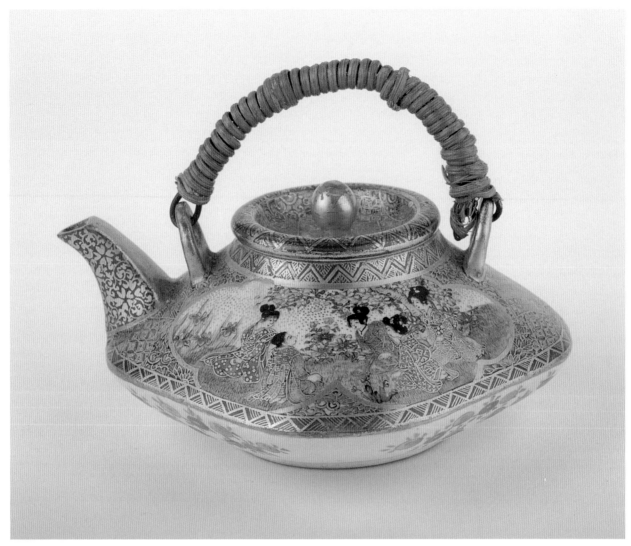

Satsuma square teapot decorated with figures in a garden.
3" square. *Courtesy of H. Walker Nowell.* $1200-1500.

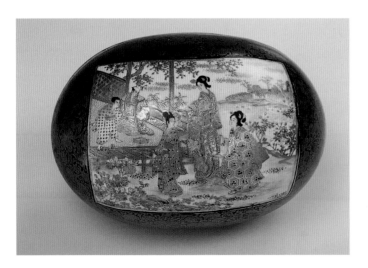

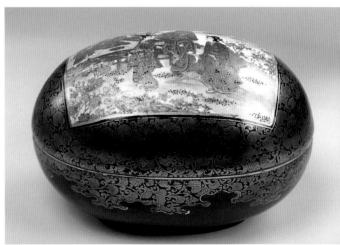

**Oval Shapes**
Satsuma egg kogo, oval box in two parts. The top has a scene of three
women, a man, and boy in a garden setting with a background of
Lake Biwa and cherry blossoms. The top and bottom have a black
background decorated with a silver brocade floral design that extend
to the middle of the lower portion with gold outline defining the
border. The great rarity is the solid black background, rarely found i
Satsuma ware. Signed with the impress mark of Kinkozan on the foo
4-3/4" long. *William & Jo-Ann Van Rooy.* $6000-7500.

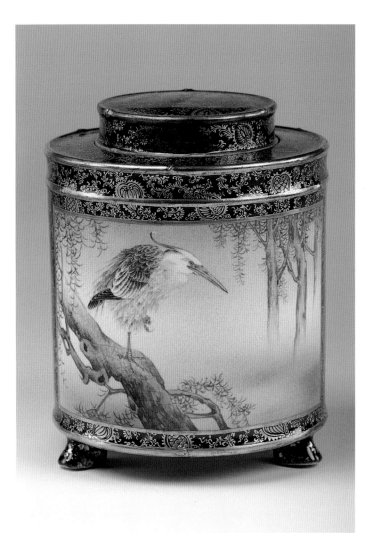

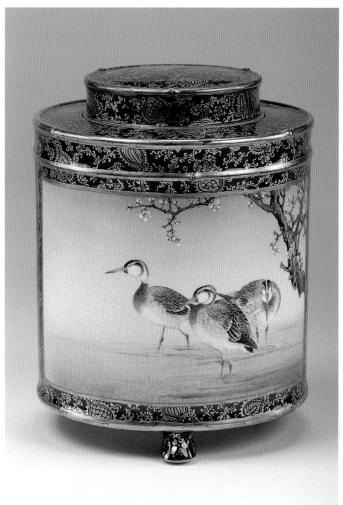

Covered Satsuma canister with gold bamboo rim, cobalt blue background, and applied gold floral and scroll design. The raised round lid fits inside the flat top. Two rectangular panels are painted in enamels with landscapes including a kingfisher on one and three ducks on the other. The base rests on three cobalt blue and gold decorated feet. Signed by Kinkozan. 6" h. *William & Jo-Ann Van Rooy.* $6000-7500.

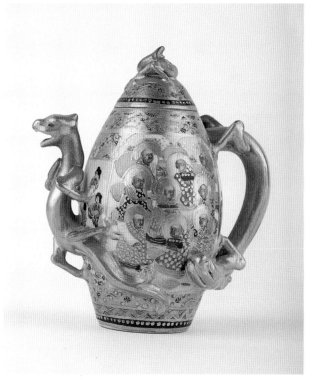

Tall oval teapot with dragon handle and a dragon spout and finial. Decorated with groups of painted sages and elaborate gold background incised with floral details. *Courtesy of H. Walker Nowell.* $1200-1500.

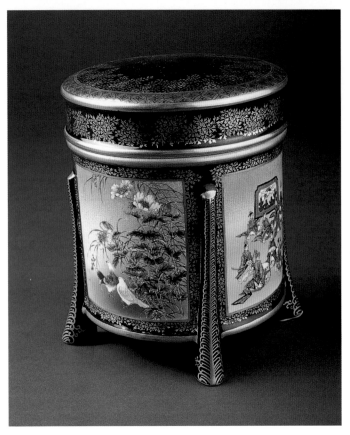

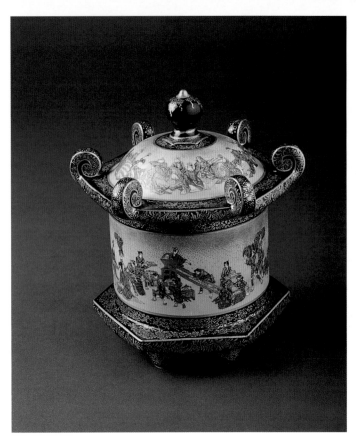

**Round Shapes**
Satsuma canister with cobalt blue background and gold floral details rests on four raised feet that extend up the sides. A flat cobalt blue lid has gold floral details. Four finely painted polychrome scenes, two with people and two with birds in a garden, decorate the sides. Signed by Kinkozan. 6-1/2" h. $2000-2500.

Satsuma covered canister with dark blue and gold decorated rims. The lid rests in a rim with six pagoda-style scrolls and a hexagonal base rests on four feet. Many figures are finely painted around the body and the lid. 6-1/2" h. $5000-7000.

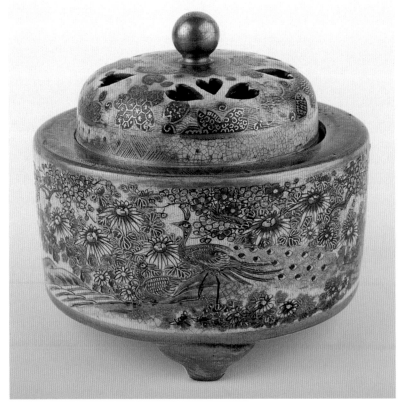

Satsuma canister-shaped small incense burner decorated with a peacock in a garden around the body that rests on red painted bracket feet. The lid has heart-shaped piercing and floral painted decoration with gold. Signed by Hodota. 5" d. *Courtesy of H. Walker Nowell.* $1200-1500.

116

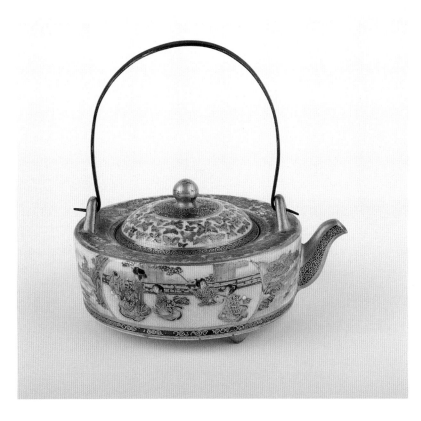

Satsuma teapot with straight sides decorated with groups of women and children in reserves and butterflies on the lid. 3-3/4" d. *Courtesy of H. Walker Nowell.* $1200-1500.

Tall Satsuma teapot with dragon handle and a dragon spout and finial. The canister sides are painted with sages and elaborate gold details. The Satsuma mark, red circle with gold cross and chop, is on the base. 4-3/4" h. *Courtesy of H. Walker Nowell.* $1200-1500.

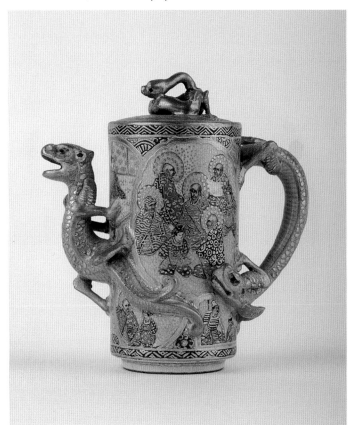

Satsuma chocolate pot with delicately painted polychrome floral decoration. Signed by Kinkozan. 7" h. *Courtesy of The Marvin Baer - Bonnie Boerer Alliance Collection.* $4000-5000.

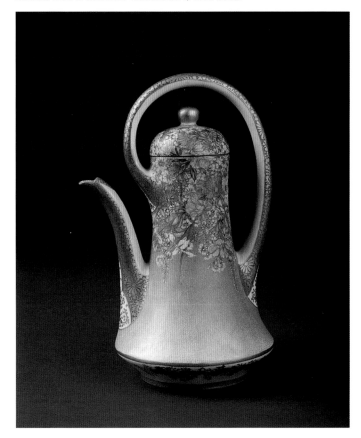

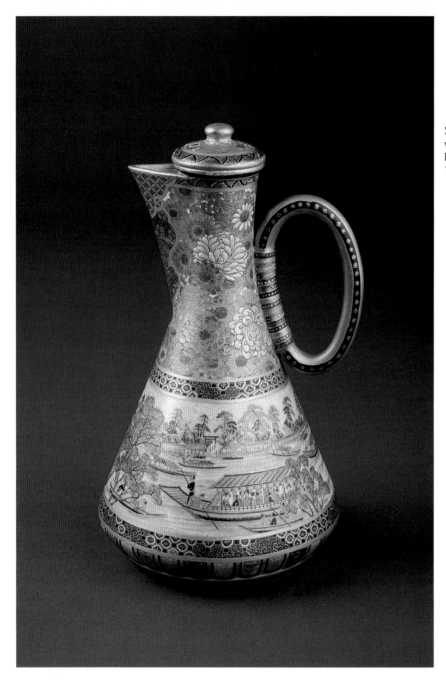

Satsuma saki pitcher with an oval handle, decorated with a river scene of boats full of passengers. Signed by Kozan. 6-1/2" h. *Courtesy of Marvin Baer, The Ivory Tower, Inc.* $3500-4000.

Satsuma barrel flask with gilded cover, finely painted groups and floral panels on the sides that rest on four scrolled legs. Signed by Kinkozan. 3-1/8" h. *Courtesy of MPL and BL collection.* $3500-4000.

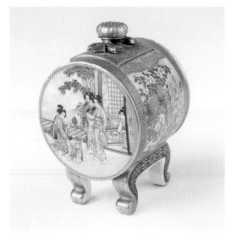
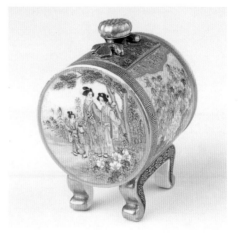

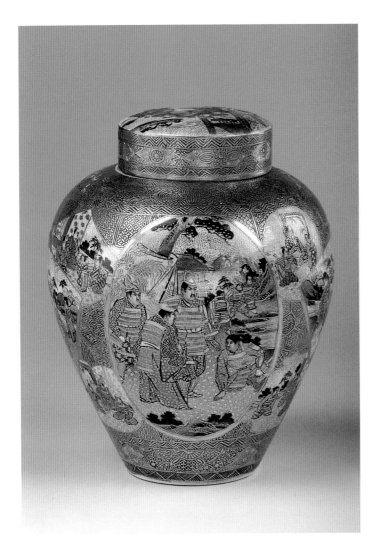

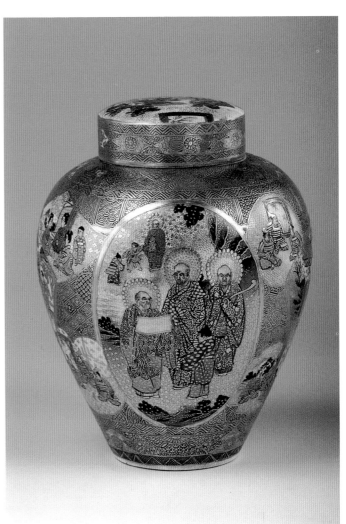

Satsuma tea caddy in the form of a ginger jar with both interior and exterior lids decorated with raised enamel and gold designs. The outside top surface is decorated with men in military Samurai uniforms. The sides have a relief gold and enamel background decoration interrupted with twelve overlapping reserves painted in enamels and gold with various scenes of Samurai and sages in landscape settings. Signed Kitayama. 6" h. *William & Jo-Ann Van Rooy.* $1500-2000.

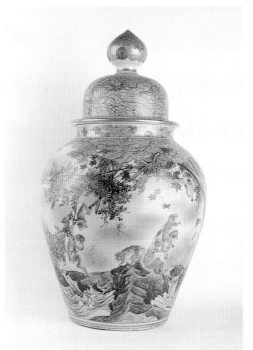

Covered Satsuma jar with tall gold domed lid with finial. The sides are painted with branches and Makoc monkeys in a landscape above a river. Signed by Kanzan. 23" h. $2500-3000.

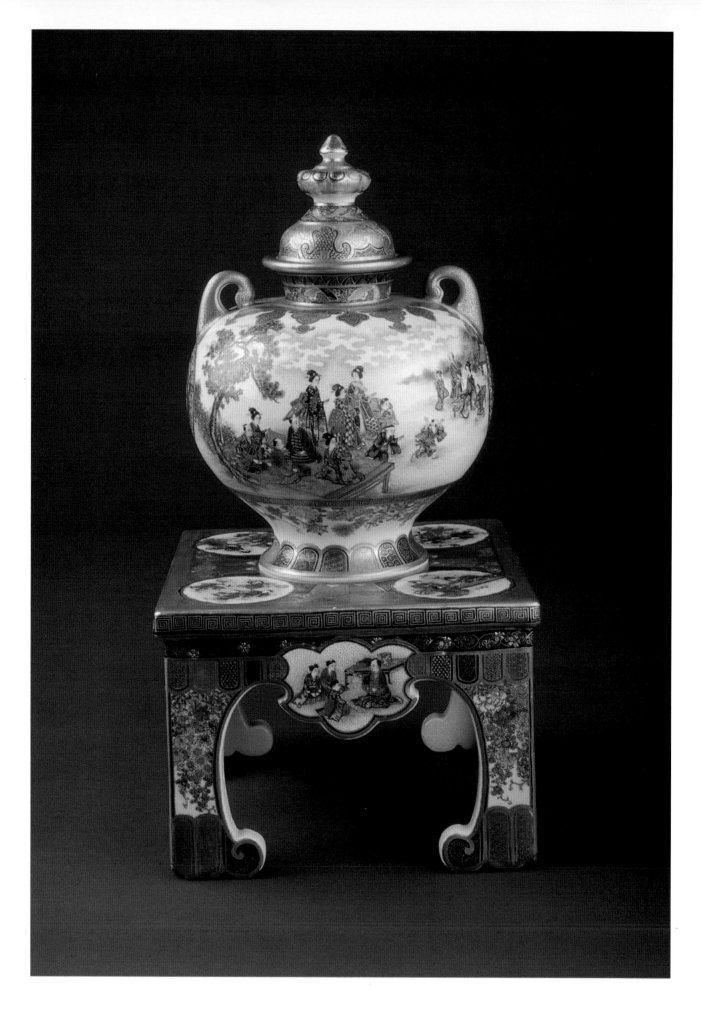

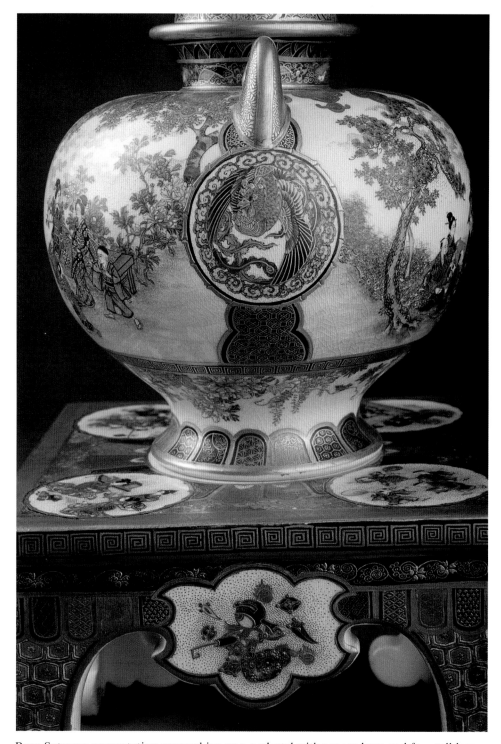

Rare Satsuma presentation covered jar on a pedestal with square base and four tall legs.
The painted decoration is extremely refined including people in a landscape. Signed Kyoto
Tojiki Goshi Gaisya Ryozan  and Ysuda mark. 11-3/4" h. *Courtesy of Marvin Baer, The Ivory
Tower, Inc.* $20,000-25,000.

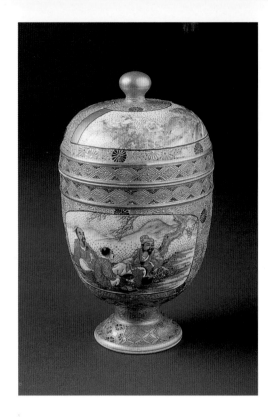

Satsuma covered and footed egg box with unusual turquoise enamel in the finely painted floral decoration. 6" h. $3000-3500.

Satsuma koro with cutout lid in a petal-shaped design and teardrop finial. The two gilded dragon handles are applied. The circular base has a flared pedestal decorated on the foot with six vignettes of women, landscape, precious objects, and noble men. Signed by Kozan. 5" h. *Harry & Carol Willems.* $1200-1500.

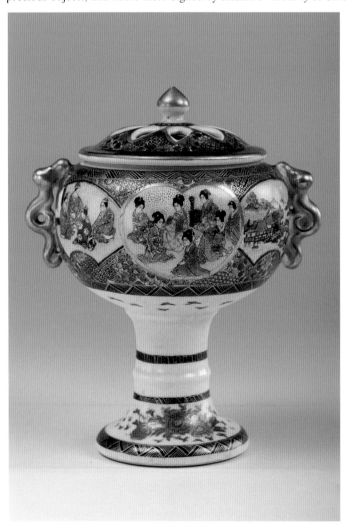

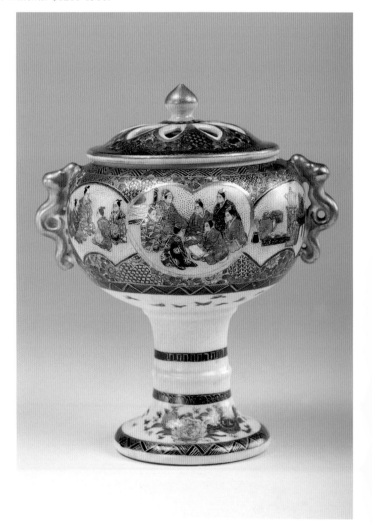

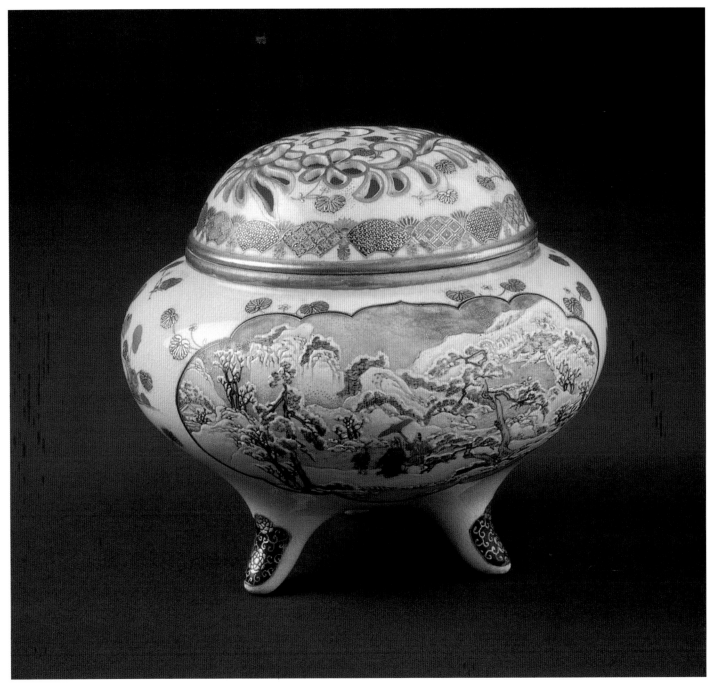

Satsuma koro with pierced lid and round body on three-feet. Fine winter landscape painted decoration. 4-1/4" d. $3500-4000.

Pumpkin-shaped bowl on three legs with an iron wire top designed as a chrysanthemum. The side decoration includes enameled sages on a gold background. Signed Hodota. 8" d. $4000-5000.

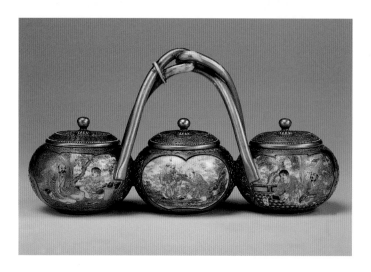

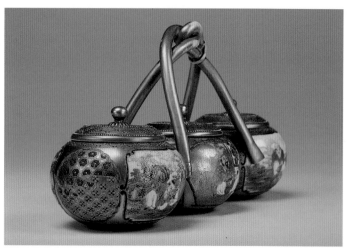

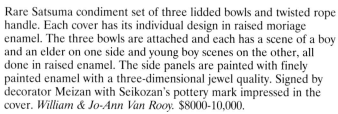

Rare Satsuma condiment set of three lidded bowls and twisted rope handle. Each cover has its individual design in raised moriage enamel. The three bowls are attached and each has a scene of a boy and an elder on one side and young boy scenes on the other, all done in raised enamel. The side panels are painted with finely painted enamel with a three-dimensional jewel quality. Signed by decorator Meizan with Seikozan's pottery mark impressed in the cover. *William & Jo-Ann Van Rooy.* $8000-10,000.

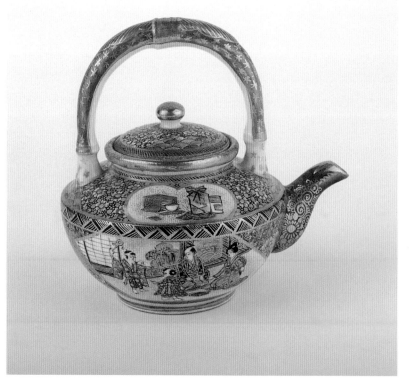

Satsuma individual teapot in the shape of a traditional teacup at the base. Decorated in enamels with packages in the rim and people in a room in the body. 3" d. *Courtesy of H. Walker Nowell.* $1800-2000.

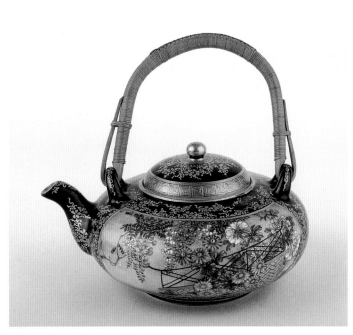

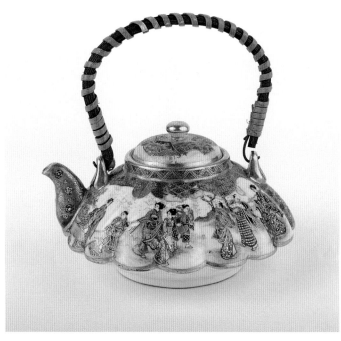

Fine small Satsuma individual teapot with cobalt blue background with gold floral decoration and enameled floral design in the side panels. Label of the decorator S. Kinkozan, Kyoto, Japan is attached. 4" d. *Courtesy of H. Walker Nowell.* $1000-1200.

Satsuma individual teapot with scalloped sides decorated with fine gold borders and painted groups of people in a landscape. 4-1/4" d. *Courtesy of H. Walker Nowell.* $1500-1800.

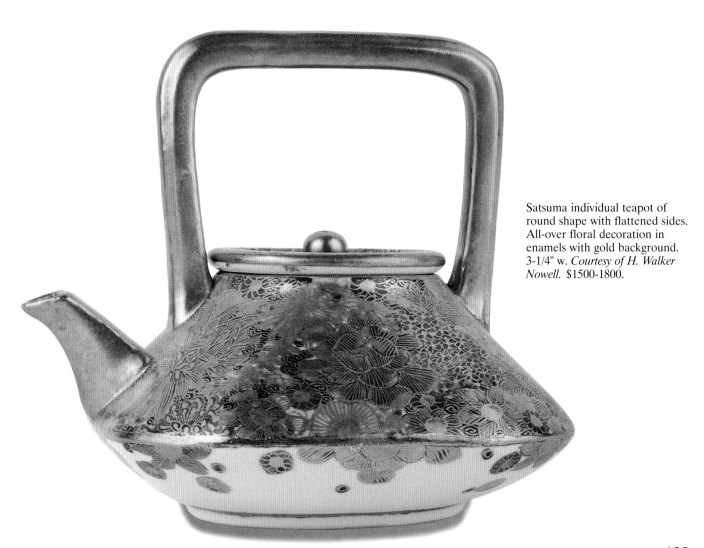

Satsuma individual teapot of round shape with flattened sides. All-over floral decoration in enamels with gold background. 3-1/4" w. *Courtesy of H. Walker Nowell.* $1500-1800.

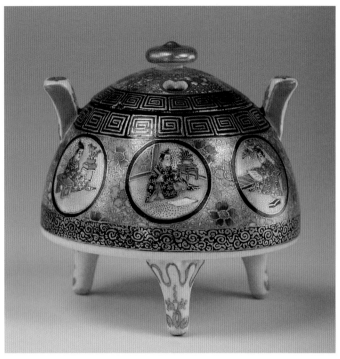

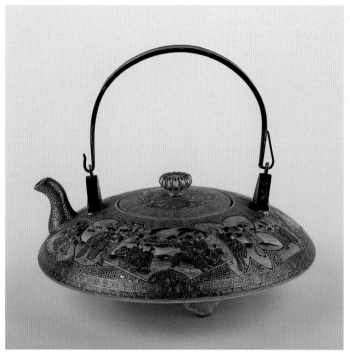

Satsuma two-handled sensor on three tapering legs with a domed lid and mushroom button finial. A Greek-key border rims the lid and base. Six circular reserves depict individuals, including students and men, and alternate with floral decoration. Signed Kozan. 2-3/4" h. *Harry & Carol Willems.* $800-1200.

Satsuma individual teapot of flat round shape with metal handle. Small lozenges are beautifully decorated with people standing in groups. *Courtesy of H. Walker Nowell.* $1500-2000.

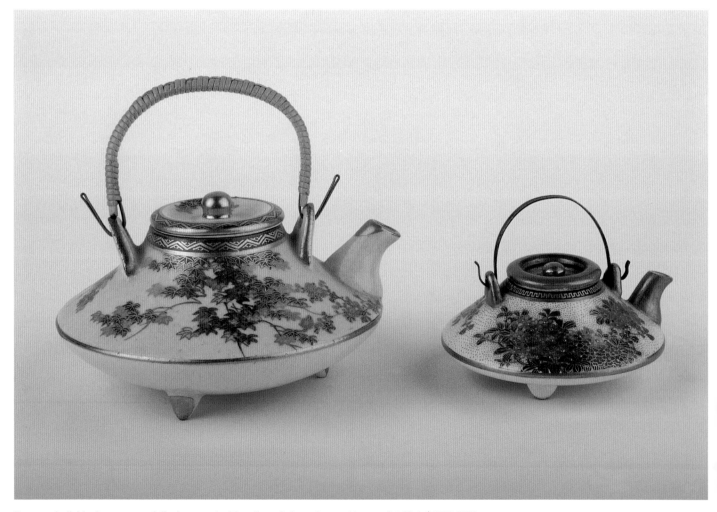

Satsuma individual teapot carefully decorated with red maple branches and leaves. 3-1/2" d. $1000-1200.
Small Satsuma individual teapot with blue and red floral bouquets on a gold stippled background. 2-1/2" d.
*Courtesy of H. Walker Nowell.* $800-1000

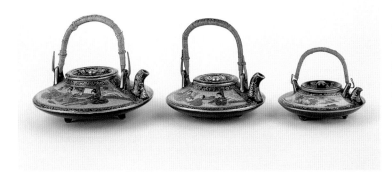

Three Satsuma individual teapots with cobalt blue backgrounds and gold floral sprays. All signed by decorator Kinkozan. Large one decorated with people in a room. 5-1/4" d. $1000-1200.

Center individual teapot decorated with people in a room. 3-1/2" d. $800-1000.

Smallest individual teapot decorated with landscape with a building. Kinkozan, Kyoto paper label. 3" *Courtesy of H. Walker Nowell*. $600-800.

Three Satsuma individual teapots. Large one with men and women seated. Signed by Kinkozan. 3-3/4". $2000-2500.

Center, decorated with people inside a room, three men seated. 3" d. $1500-2000.

Right, decorated with landscape with grass, cranes, and a mountain. 2-1/4" d. *Courtesy of H. Walker Nowell*. $1200-1500.

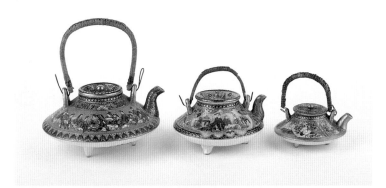

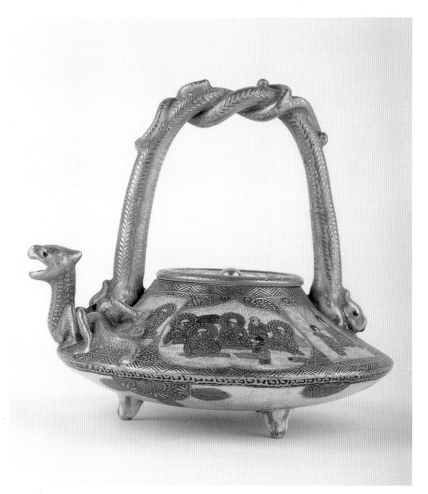

Satsuma individual teapot with dragon handle and spout, recessed lid, decorated with painted groups of people, body 5" d. *Courtesy of H. Walker Nowell*. $1000-1200.

127

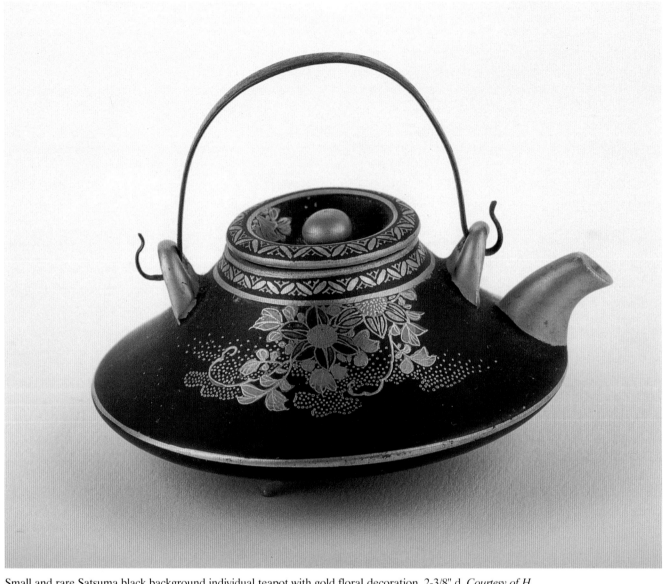

Small and rare Satsuma black background individual teapot with gold floral decoration, 2-3/8" d. *Courtesy of H. Walker Nowell*. $800-1000.

Small covered Satsuma round box with interior and exterior polychrome decoration on pink background and figures in landscape with dragons. Decoration by Tokhaken. 3" d. *Courtesy of the L. Robbins Collection*. $4500-5000.

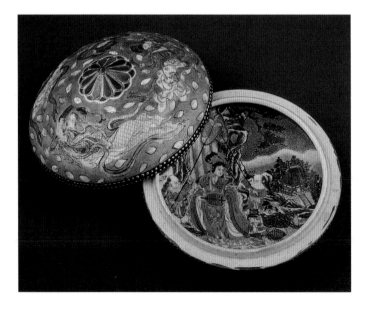

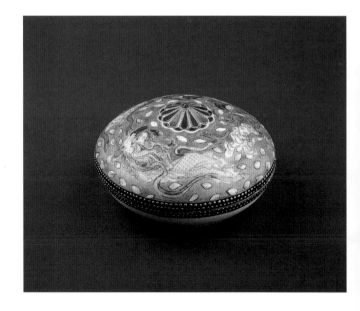

Silver buckle in two round parts with Satsuma plaques painted with iris in a cobalt and gold detailed border. *Courtesy of Marvin and Nina Vida.* $100-150.

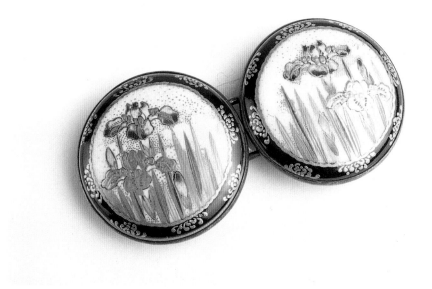

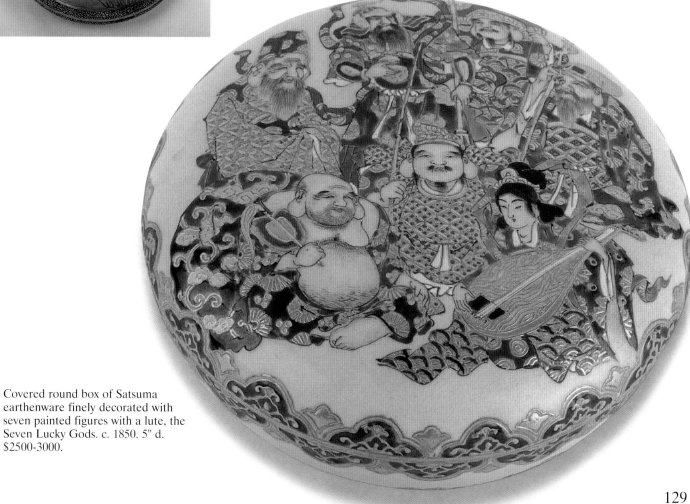

Round Satsuma kogo, covered box. Domed lid decorated with women and children on a raised patio with a lake scene behind and hanging wisteria vines. The gold and enamel work is partially raised. The inside lid contains a spray of peonies and the bottom interior has painted butterflies. The border has a floral and black painted design. Signed by Yozan with the Satsuma mon in raised white enamel. 3" d. *William & Jo-Ann Van Rooy.* $1200-1500.

Covered round box of Satsuma earthenware finely decorated with seven painted figures with a lute, the Seven Lucky Gods. c. 1850. 5" d. $2500-3000.

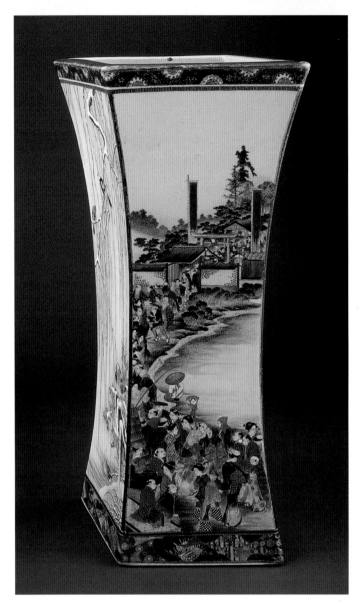
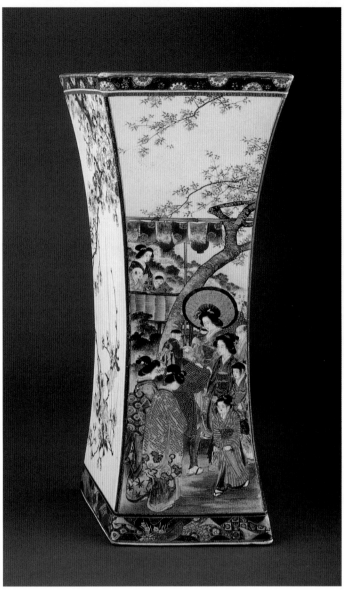

Satsuma large diamond-shaped vase with four panels. Decoration includes a procession in polychrome and winter landscape with snow and birds. Signed by Ryozan and Ysuda factory mark. 15" h. *Courtesy of the L. Robbins Collection.* $6000-8000.

# Vases

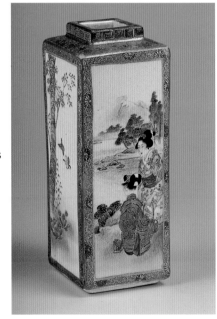

**Rectangular Shapes**
Satsuma vase with gold borders and four panels decorated in enamels, two with two women in landscapes and two with flowers, a bird, and a tree. Signed by Kozan. 6" h. *William & Jo-Ann Van Rooy.* $1200-1500.

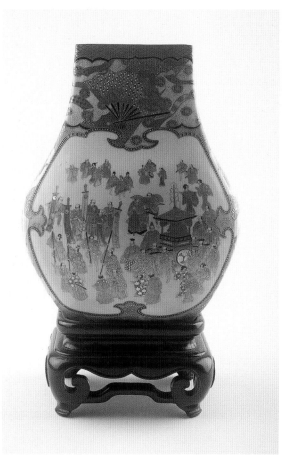

Satsuma vase of bulbous square shape decorated with a procession of people, with banners, bearing a Buddha. *Courtesy of the Hilco Collection.* $1500-1800.

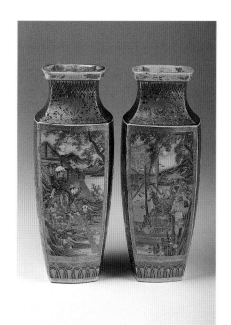

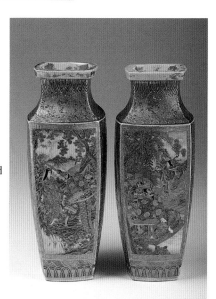

Pair of four-sided square, Satsuma vases. Each side has decorated panels of birds of paradise in landscapes, a family fishing, folklore tales of a Samurai and goddess, and heavy gilt brocade borders. Three sides of each vase shown. c. 1860-1870. 14.25" h. *William & Jo-Ann Van Rooy.* $5000-7500 the pair.

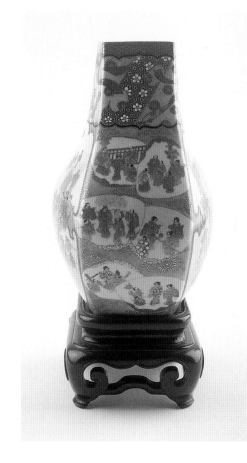

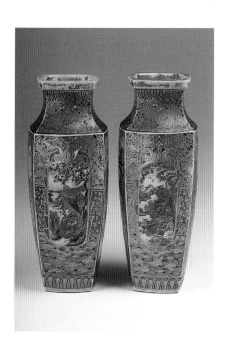

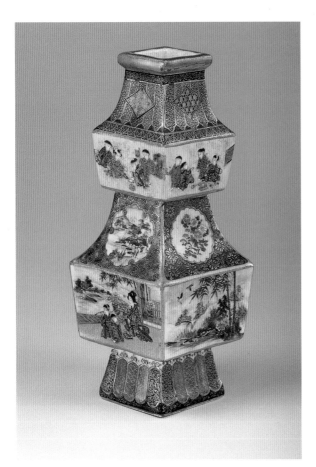

Square double gourd vase, the straight sides painted with groups of boys at play on the upper level, and on the lower level two groups of people, ceremonial objects, and landscape with two birds. Signed by Kozan. 6" h. *William & Jo-Ann Van Rooy.* $ 4000-5000.

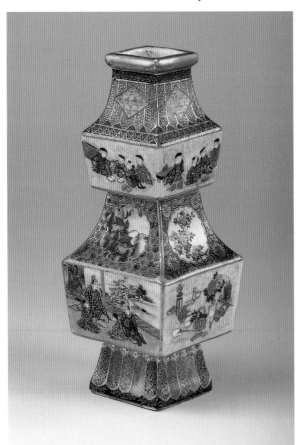

Tapered rectangular vase with narrow neck and four rectangular panels decorated in enamels and gold, one with women, one with men, one with a landscape, and one with flowers. Signed by Kozan. 5-3/4" h. *William & Jo-Ann Van Rooy.* $1000-1200.

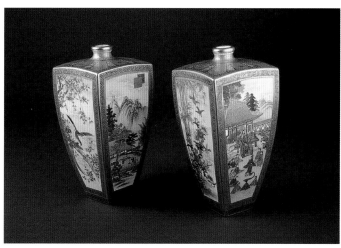

Pair of Satsuma square flaring vases with four sides beautifully painted with landscapes including buildings and people. The borders have incised gold frames. Signed by Unzan. c. 1880-1890. *Courtesy of Marvin Baer, The Ivory Tower, Inc.* $18,000-20,000.

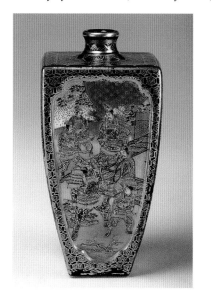
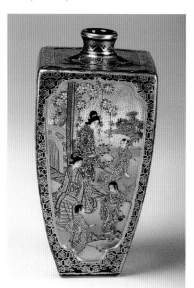

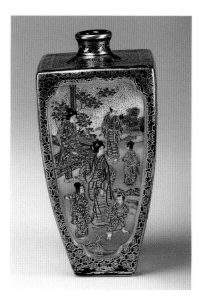
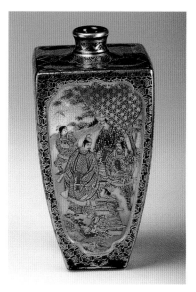

Tapered square vase with small round neck in the widening flat top with cobalt blue background and gold overlaid borders. The sides are each painted with embossed raised gold work and enamel scenes, two of men and two of women in groups. Signed by Kinkozan. 4-3/4" h. *William & Jo-Ann Van Rooy.* $2500-3000.

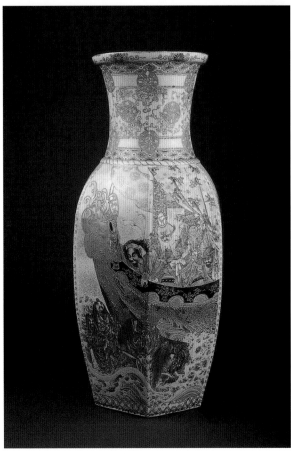

**Geometric Shapes**
Satsuma hexagonal vase decorated with polychrome enamels including a ship and fire. Transitional period c. 1867. 16-3/4" h. *Courtesy of the L. Robbins Collection.* $5000-6000.

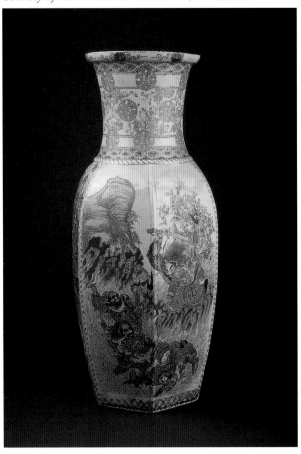

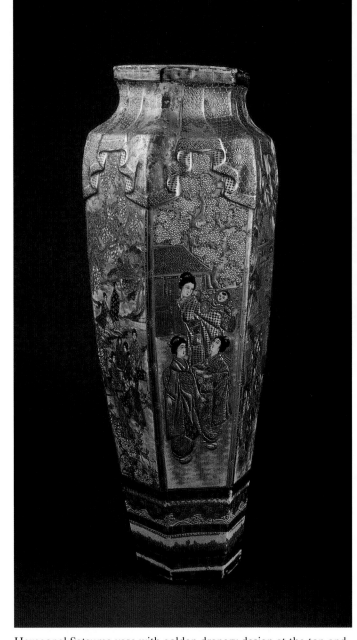

Hexagonal Satsuma vase with golden drapery design at the top and carefully painted with geishas, a shrine, and courtesans in a garden. Signed by Choshuzan. 16-1/4" h. *Courtesy of the L. Robbins Collection.* $6000-8000.

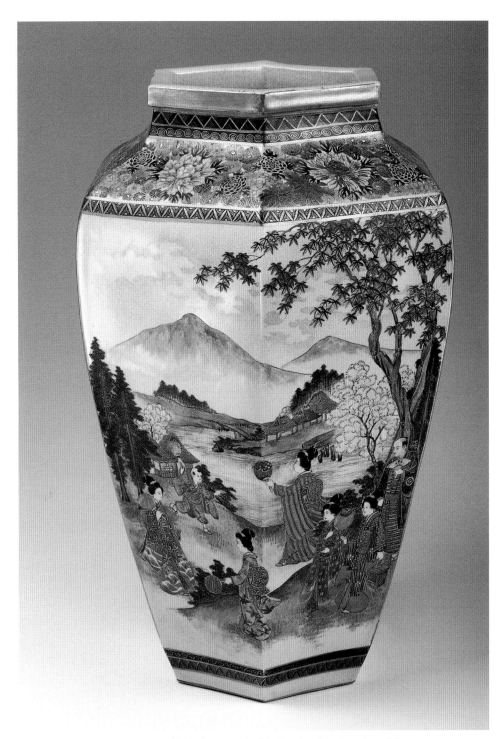

Satsuma hexagonal vase beautifully decorated with floral painted neck and four panels: two double panels decorated with landscapes of Lake Biwa and Mount Fuji; maple, pine and cherry decoration; and courtesans in gardens. Each of the side panels has flowers, including wisteria and peonies, and a bird on a bamboo branch. Signed by Kozan in the style of Ryozan. c. 1915-1920. 15-3/4" h. *William & Jo-Ann Van Rooy.* $7500-8500.

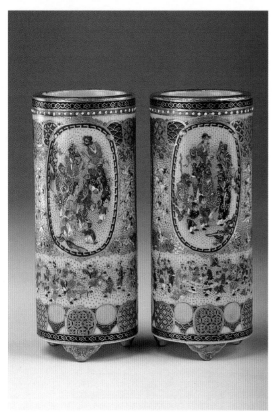

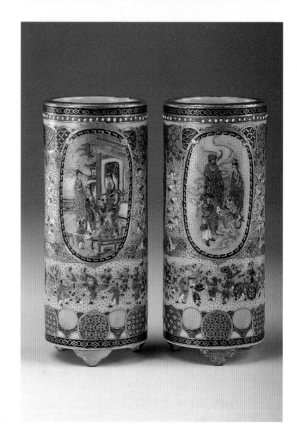

**Round Shapes**

Pair of straight-sided brush pots on three triangular feet decorated in fine detail, each with three major oval reserves decorated with heavy brocade work of wise men, women, and children and below them a band of children at a Boys Day parade. The colorful enamels are outstanding. Signed Meizan. 4-1/2" h. *William & Jo-Ann Van Rooy.* $8000-12,000.

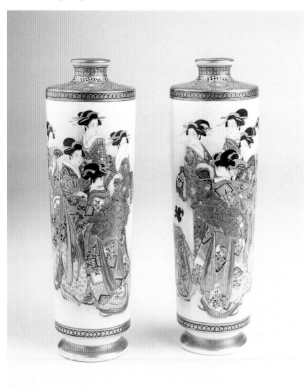

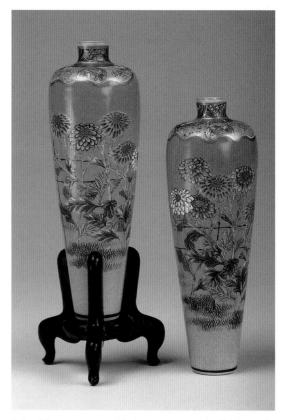

Pair of Satsuma tapered baluster vases, decorated in polychrome enamels with groups of standing women and girls. Signed by Kinkozan. 8-1/2" h. *Courtesy of MPL and BL collection*. $3000-3500.

Pair of Satsuma tapered baluster vases, each with brocade shoulder and mouth with large peony decoration on a trellis. Mustard yellow background. Together with original carved wooden stands. Signed by Taizan. Taisho period. *William & Jo-Ann Van Rooy.* $500-600.

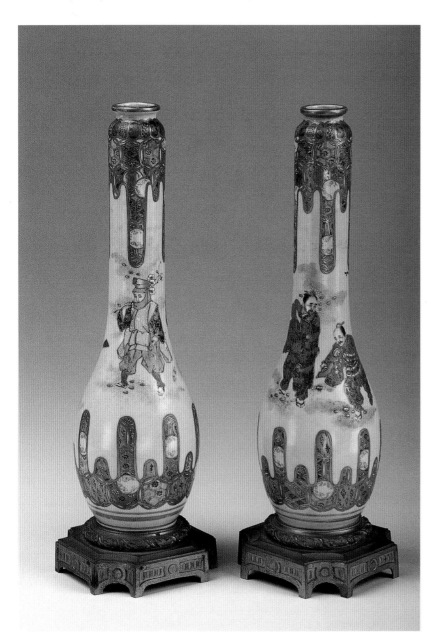

Pair of Satsuma saki bottles with borders of staggered tapestry decoration and a white field with detailed men in elaborate clothing. Lids missing and mounted on European bronze ormolu square bases. Vases 12" h. *William & Jo-Ann Van Rooy.* $1200-1500.

Pair of Satsuma cabinet vases of dinner bell shape. Each has a narrow neck with octagonal brocade design and circular scene of women and children in a landscape with pagoda. The painting is finely applied. Greek key border at the base. 3" h. Signed by Shozan. *William & Jo-Ann Van Rooy.* $1500-2000.

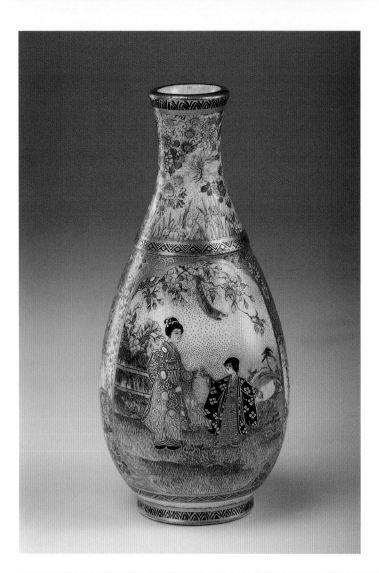

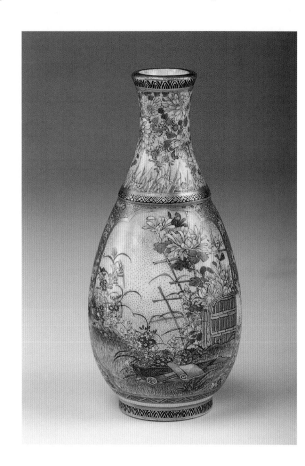

Teardrop vase with enamel and gold decoration of floral design and two primary reserves, one with a woman and child in a landscape and the other with a garden gate and flowers. Signed by Kinkozan. Meiji period. 4-4/5" h. *William & Jo-Ann Van Rooy.* $1200-1500.

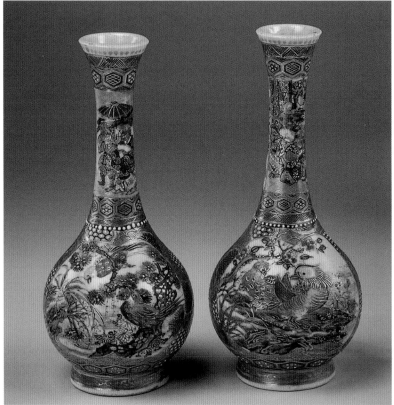

Pair of tall-necked Satsuma vases with major reserves on the sides of enamel and gold decoration of people and birds on each. Some of the enamel is in raised moriage form. Impressed Taizan signature. Meiji period. 5-3/4" h. *William & Jo-Ann Van Rooy.* $800-1200.

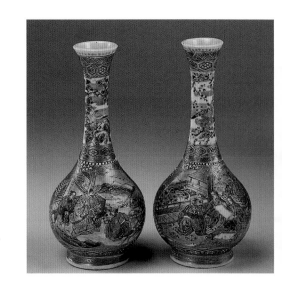

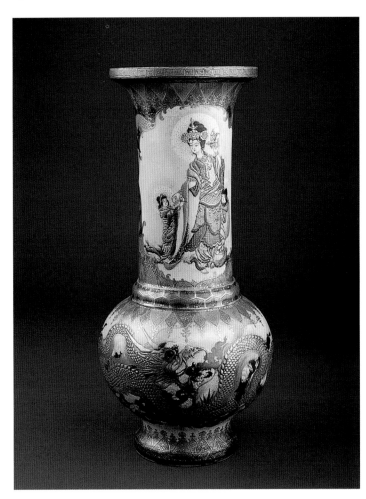

Satsuma vase of bulbous shape with dragon decoration around the base and figures in the neck. Signed by Kozan. *Courtesy of the L. Robbins Collection.* $5500-6500.

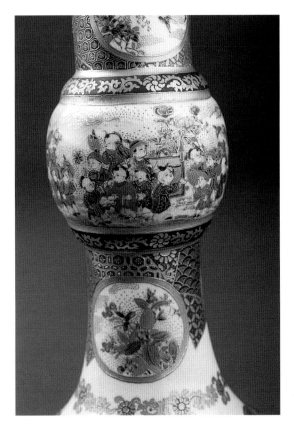

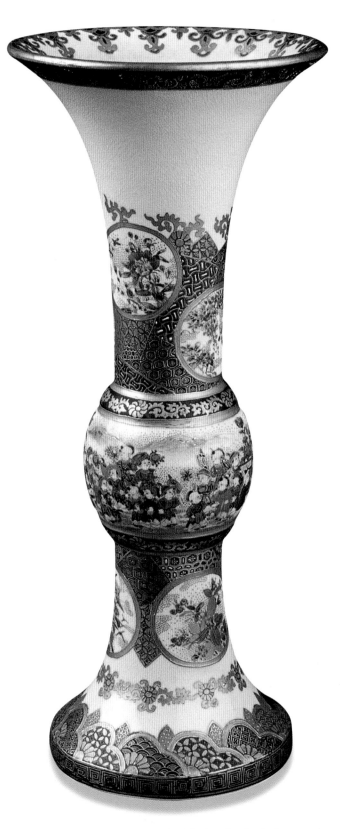

Satsuma vase with bulbous center and flaring rim finely decorated with floral medallions and borders and many children in the swelled center. Signed by Yozan. 9-1/2" h. $5000-6000.

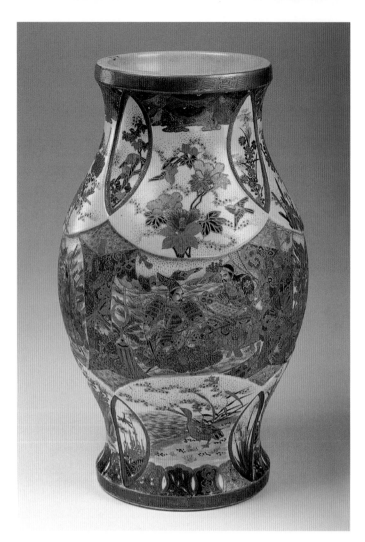

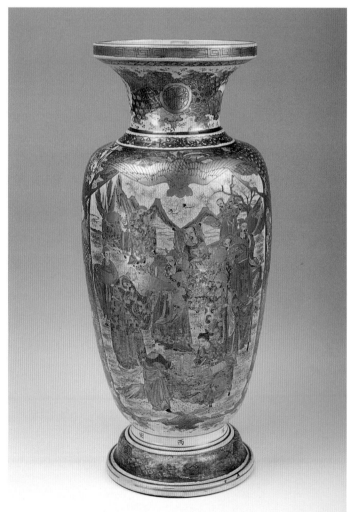

Pair of vases with the Prince of Satsuma's marks on the base and the Tokugawa seal of hollyhock on the throat and sides. Baluster shape with a flared base and mouth. Turquoise is an unusual color detailing the painted figures and in the floral neckband. Decoration is in raised enamel and gilt and many interesting vignettes of birds, Greek key band around the top rim. Legendary and mythical figures in the side panels. A potter's mark is on the base with the impressed oval of decorator Kozan. c. 1860-1865. 21-3/4" h. *William & Jo-Ann Van Rooy.* $10,000-12,000.

Pair of Satsuma vases with golden Greek key design on rim and raised deep scalloped borders on the top and bottom with white background and floral enamel decoration. Detailed court scenes with the Emperor decorate the center. Oval recessed separations are between the scalloped borders. 15" h. *William & Jo-Ann Van Rooy.* $10,000-12,000 the pair.

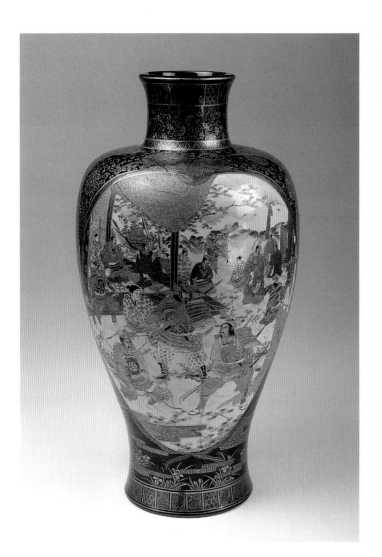

Tall Satsuma baluster shape vase made for the Western market with dark cobalt blue background and gilt phoenix in iron red bodice and wingspread in repose gilt. Large panel scenes with Samurai on one side and courtesans in a garden on the reverse, by Kozan Tsukuru, Kyoto, c. 1890, 22" h. *William & Jo-Ann Van Rooy.* $25,000-30,000.

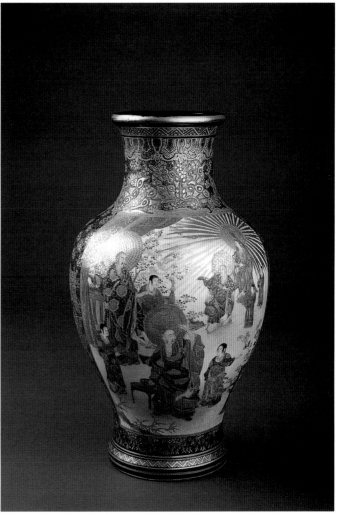

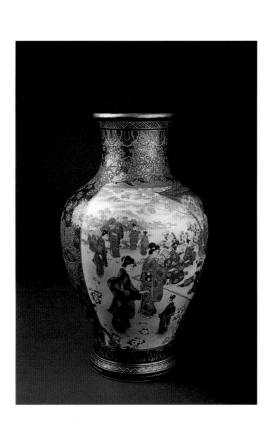

Satsuma vase of round baluster shape with cobalt blue background and gold decoration interrupted by two reserves painted with a sunburst and men and women in a garden. Signed by Kinkozan. 12-1/8" h. *Courtesy of Marvin Baer, The Ivory Tower, Inc.* $2800-3000.

141

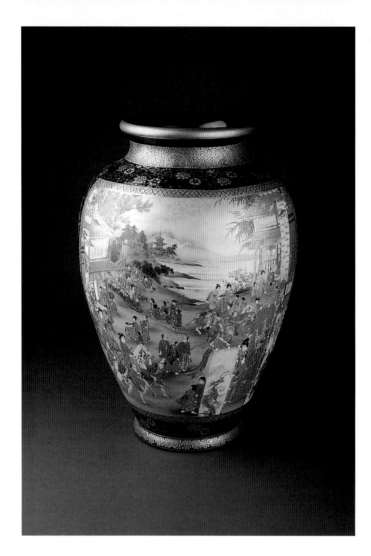

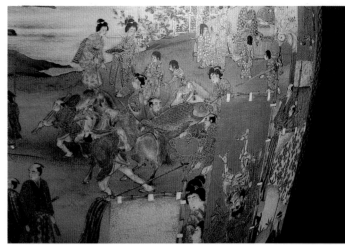

Satsuma baluster urn finely decorated with figures in a landscape, scroll and garden scene, and cobalt blue background with gold raised floral and geometric decoration. Signed Matsumoto Hozan. 18" h. *Courtesy of Marvin Baer, The Ivory Tower, Inc.* $15,000-18,000.

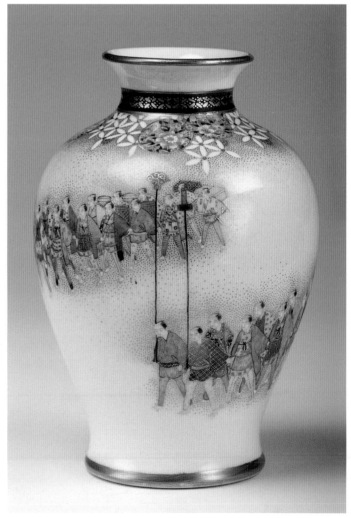

White Satsuma vase with carefully painted floral decoration of excellent quality in shibui colors on the shoulder and a spiral procession of men carrying the shogun around the body. Signed by Kinkozan. 4.65" h. *William & Jo-Ann Van Rooy.* $3500-4000.

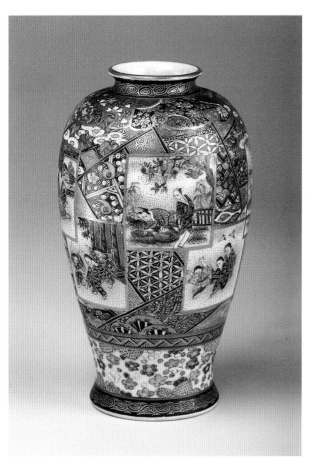
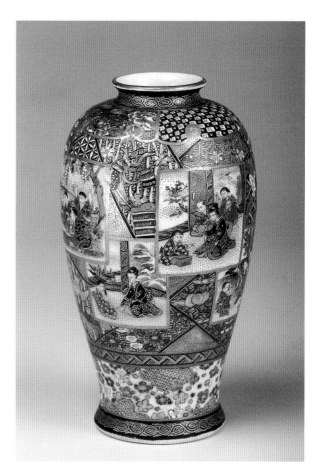

Satsuma baluster vase decorated with six overlapping panels showing people, over flowers and tapestry background designs. Signed by Kozan. 5" h. *William & Jo-Ann Van Rooy.* $ 2500-3500.

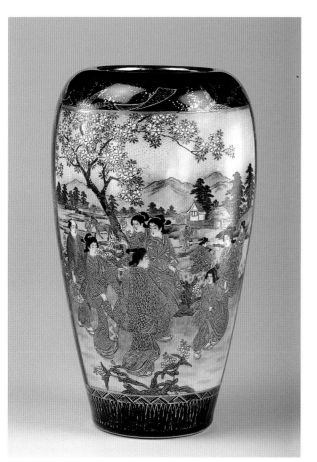
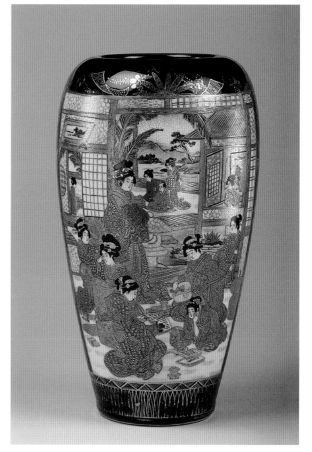

Ovoid Satsuma vase with cobalt blue background and gold details. Two large rectangular panels are decorated with women in a landscape setting on one side and a series of room interiors on the other. Signed by Hodota. 9.25" h. *William & Jo-Ann Van Rooy.* $4000-5000.

143

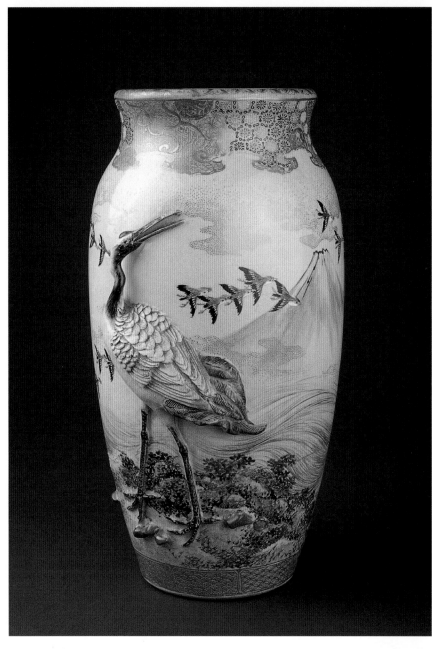

Unusual Satsuma ovoid vase with relief decoration of a crane on the body and painted flying geese in a landscape. 13-1/2" h. *Courtesy of Marvin Baer, The Ivory Tower, Inc.* $1500-1800.

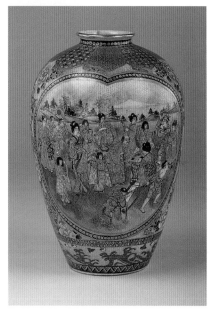

Ovoid Satsuma vase with enamel and raised gold decoration of floral and tapestry design, and a fan-shaped reserve decorated with a group of people seated, and a nearly heart-shaped reserve with a large group of women in a landscape. Signed by Hozan. 5.125" h. *William & Jo-Ann Van Rooy.* $7500-8500.

Finest quality Satsuma ovoid vase with cobalt blue background and gold decoration interrupted by two large rectangular panels, one with exquisitely painted floral landscape and the other with women and children in a garden. Signed by Kinkozan. 12" h. *William & Jo-Ann Van Rooy.* $10,000-12,000.

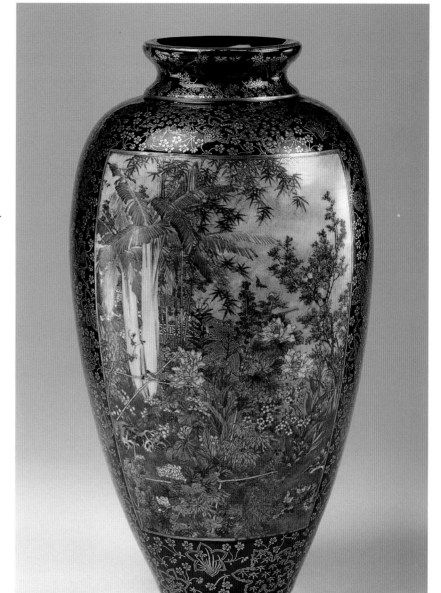

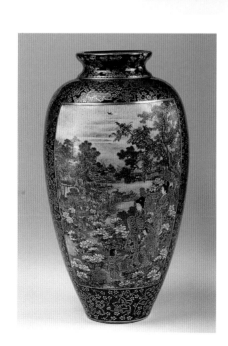

145

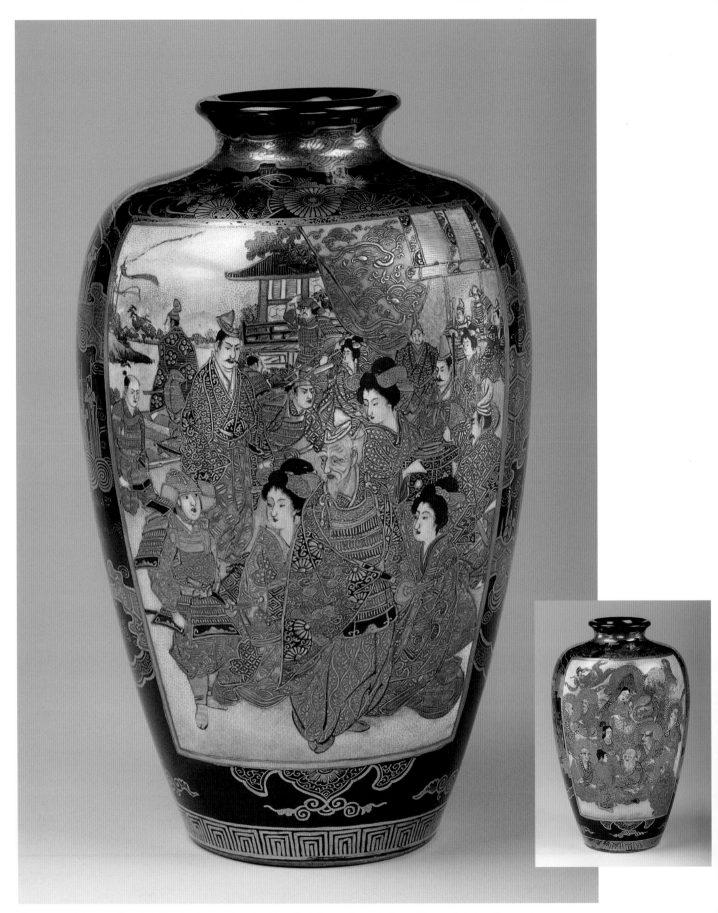

Satsuma ovoid vase with cobalt blue background and gold applied decoration including a lily pond design. Two rectangular panels are beautifully painted, one with Rakons (the 18 followers of Buddha, usually represented as skinny old men) and Kannon (deity of mercy) and the other with a variety of people gathered in an outdoor setting. Raised enamel gold work. Signed by Kinkozan. 9-3/4" h. *William & Jo-Ann Van Rooy.* $6000-8000.

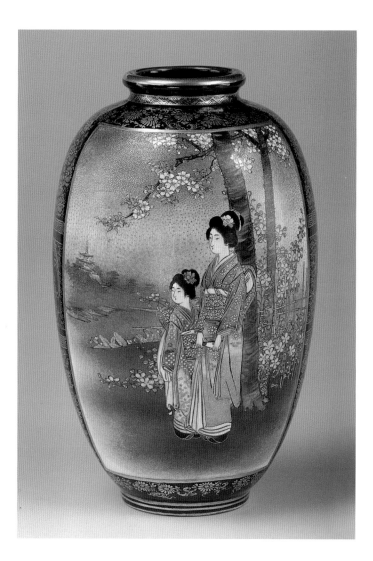

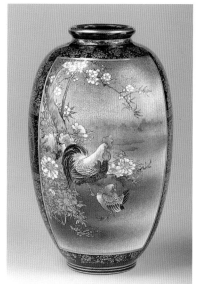

Ovoid Satsuma vase with cobalt blue background and applied gold floral and scroll design in three sections on each side panel. Two rectangular reserves are finely painted in enamels with landscapes, one with a woman and a girl and the other with a cockerel and chicken. Signed by Kinkozan. c. 1890-1900. 7.5" h. *William & Jo-Ann Van Rooy.* $4000-5000.

Satsuma vase decorated with a processional of people on one side and gold mountain landscape on reverse. Signed by Ryozan. 14-1/2" h. *Courtesy of the L. Robbins Collection.* $12,000-15,000.

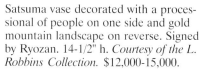

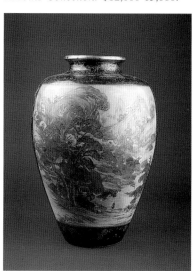

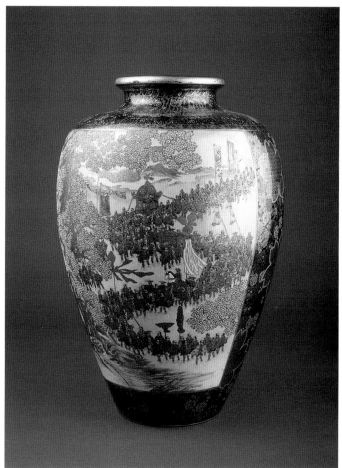

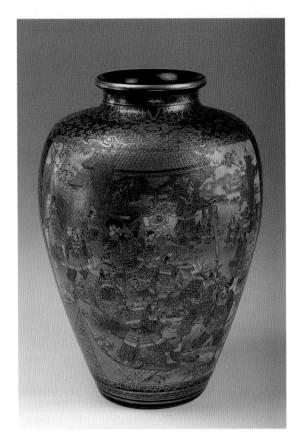
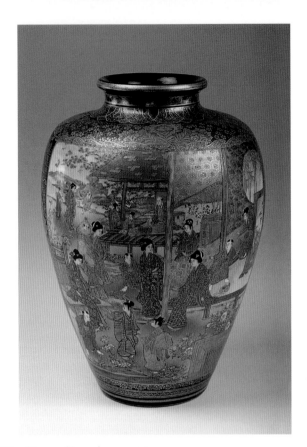

An unusually fine Satsuma ovoid vase decorated with raised repousse gilt. The side panel has a large peony head surrounded by a gold foulard pattern. A Samurai scene on one side includes a building with a gold roof (the emperor's?) Reverse side is embossed raised repousse gold of women (Bijin of the court) and children in a palace garden setting, with wonderful detail to the faces and each kimono is decorated in its own pattern. Signed by Kinkozan. c. 1880. 15-1/2" h. *William & Jo-Ann Van Rooy.* $20,000-25,000.

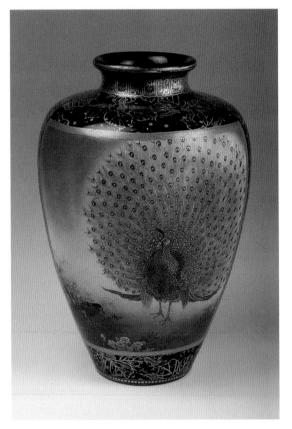
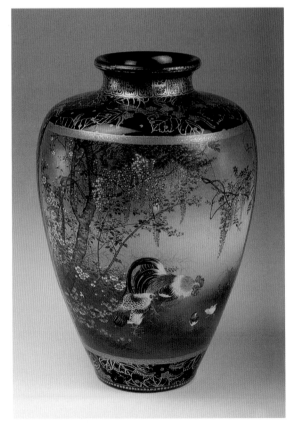

Ovoid Satsuma vase of cobalt blue background the re-touched gold leaf decoration. Side panels with a rooster and chickens on one side and a peacock and mockingbird on the reverse. Signed by Kinkozan. 14.25" h. *William & Jo-Ann Van Rooy.* $8500-10,000.

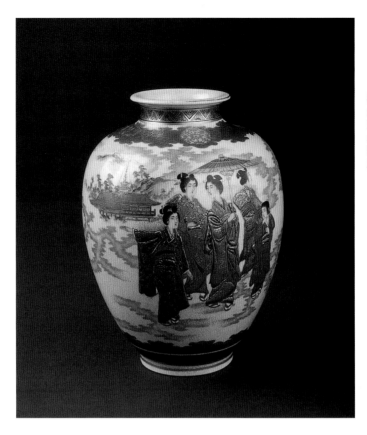

Small Satsuma vase with three rectangular panels painted with landscapes, a group of women, and bridge crossing a river. Signed by Kinkozan. 3-3/8" h. $3500-4000.

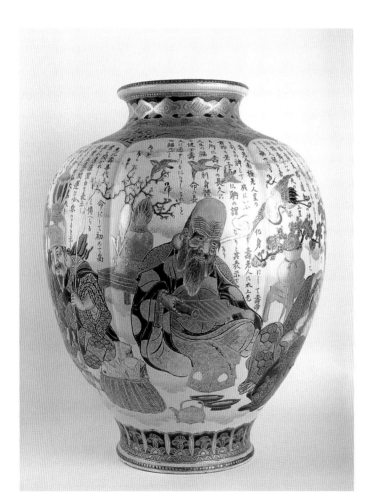
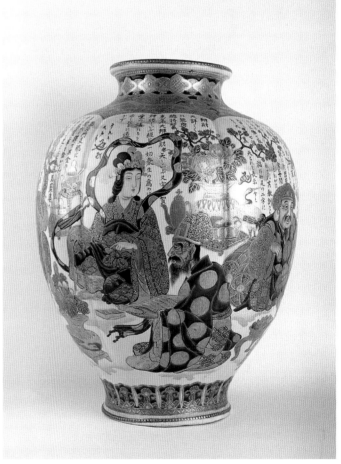

Early and rare Satsuma ovoid vase with six raised vertical panels and decoration of the Seven Lucky Gods. The background is filled with columns of Japanese calligraphy. Gosu blue is included in the decorations. Signed by Matanobu. c. 1840. 18" h. $15,000-18,000.

Pair of vases decorated in enamels and gold with wisteria background and overlapping reserves. A round reserve on each shows two generations of parents and grandparents and a young boy. Each also has a fan-shaped reserve with floral decoration. Signed Kozan and Ysuda factory mark. 6.25" h. *William & Jo-Ann Van Rooy.* $15,000-18,000.

Tapered ovoid vase with cobalt blue background and applied gold floral and scroll design. Two nearly heart-shaped panels are decorated with raised dimensional gilt work in gold and silver landscape scenes of people gathered, one with a roofed porch extending into the scene. Impressed Kinkozan mark on side of base. 7.25" h. *William & Jo-Ann Van Rooy.* $2500-3000.

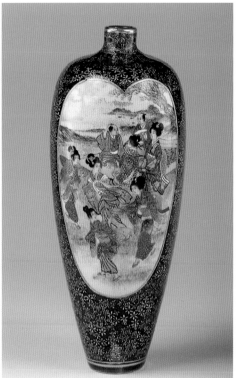

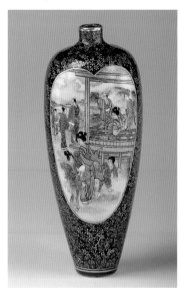

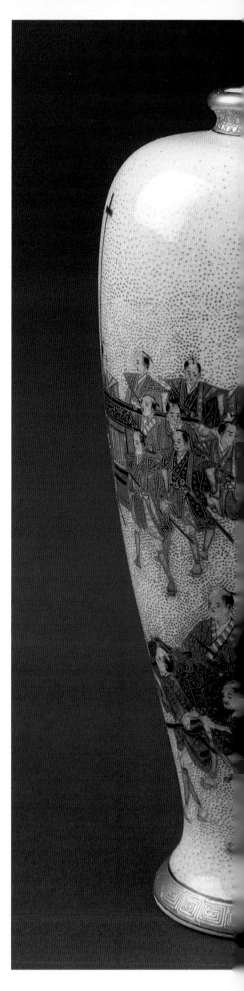

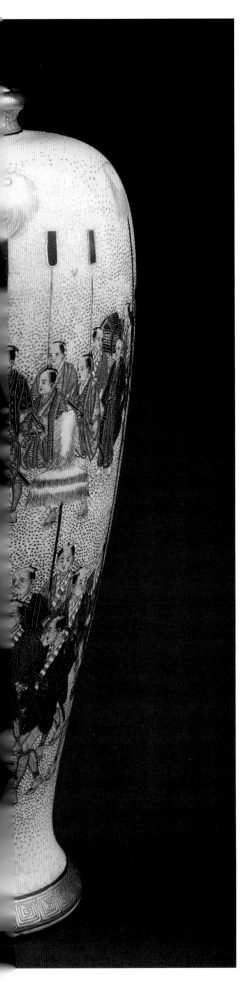

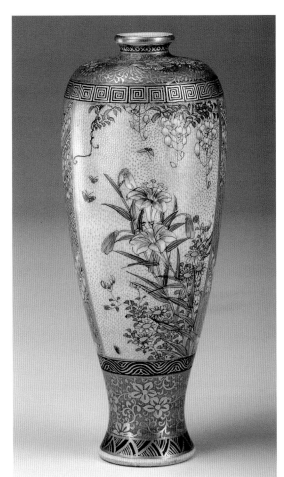

Tapered cabinet size baluster vase with enamel and gold decoration with two rectangular reserves, one of two women and the other of flowers. Signed by Kozan. 4-3/4" h. *William & Jo-Ann Van Rooy.* $600-800.

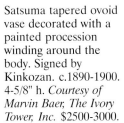

Satsuma tapered ovoid vase decorated with a painted procession winding around the body. Signed by Kinkozan. c.1890-1900. 4-5/8" h. *Courtesy of Marvin Baer, The Ivory Tower, Inc.* $2500-3000.

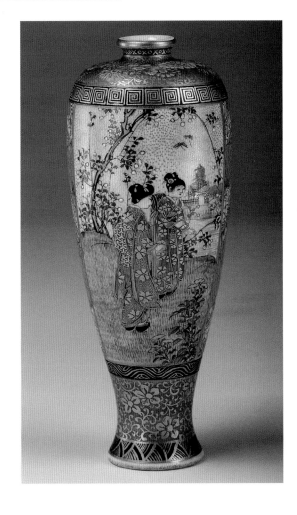

151

Small tapered ovoid Satsuma vase with gray and stippled gold background and a group of children finely painted. Signed by Kinkozan. 3-3/4" h. *Courtesy of MPL and BL collection.* $1000-1200.

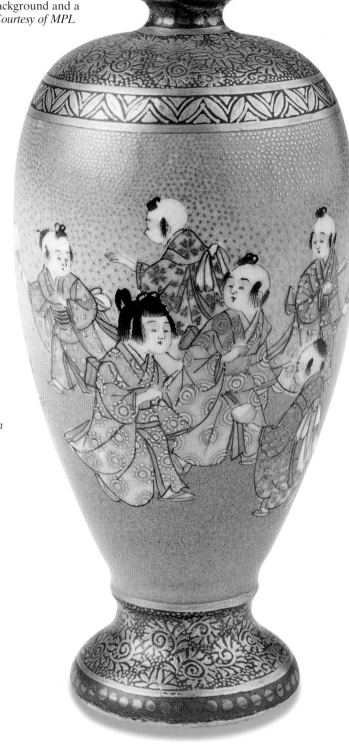

Tall Satsuma footed globular vase with floral garden and birds decoration. Signed by Kinkozan. 11-3/8" h. *Courtesy of The Marvin Baer - Bonnie Boerer Alliance Collection.* $6000-7500.

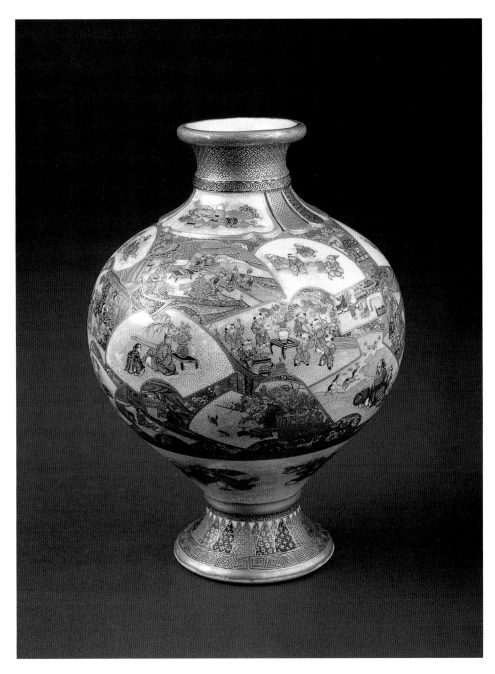

Satsuma footed globular vase with many overlapping fan-shaped panels decorated with finely painted scenes of people. Signed by Kinkozan. 6" h. *Courtesy of Marvin Baer, The Ivory Tower, Inc.* $7000-7500.

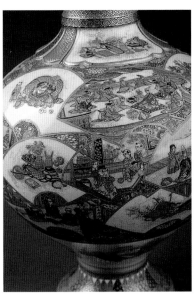

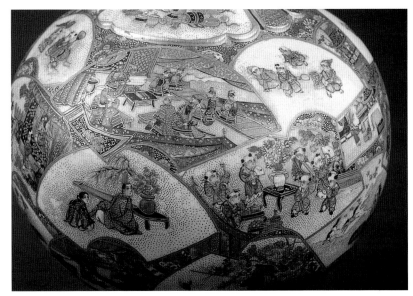

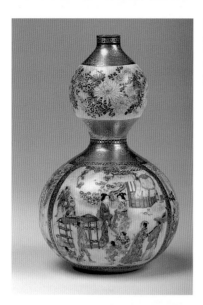

Satsuma double gourd vase with raised gold and enamel floral decoration and in the lower bulb reserves of people in outdoor activities. Side panels of wisteria and peonies. Signed by Kinkozan. 5-1/2" h. *William & Jo-Ann Van Rooy.* $1800-2000.

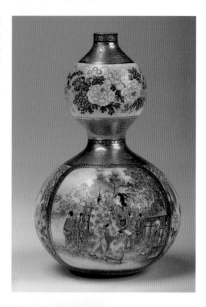

Satsuma oval vase with small neck and allover diaper pattern against a red background with two fanciful birds painted in polychrome. 5-1/2" h. *Courtesy of Marvin Baer, The Ivory Tower, Inc.* $3500-4000.

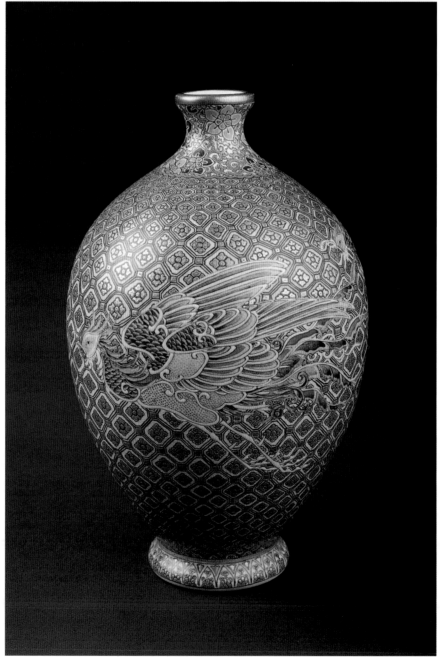

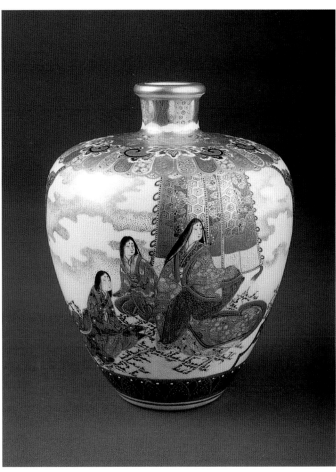

Satsuma vase of flaring oval shape decorated with paintings of three women against a background of gold clouds. 6" h. *Courtesy of Marvin Baer, The Ivory Tower, Inc.* $3000-3500.

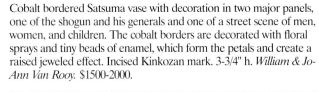

Cobalt bordered Satsuma vase with decoration in two major panels, one of the shogun and his generals and one of a street scene of men, women, and children. The cobalt borders are decorated with floral sprays and tiny beads of enamel, which form the petals and create a raised jeweled effect. Incised Kinkozan mark. 3-3/4" h. *William & Jo-Ann Van Rooy.* $1500-2000.

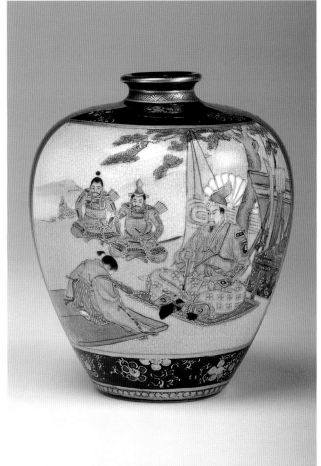

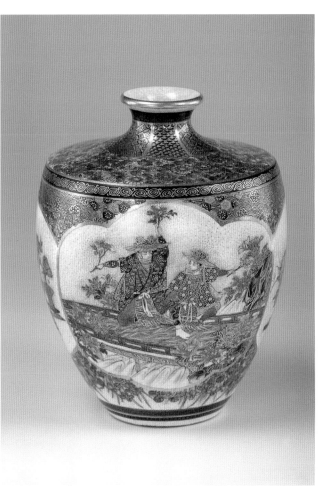

Satsuma vase with narrow neck and beautiful enamel in gold tapestry and floral decoration. The sides have four reserves, two with groups of men in a landscape and two with ceremonial objects. Signed by Kozan. 5.125" h. *William & Jo-Ann Van Rooy.* $2500-3500

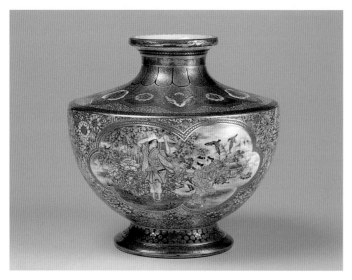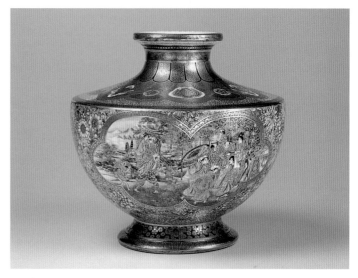

Best quality tapered squat Satsuma vase with flared base with allover, elaborate gold and enamel decoration. The sides have floral decoration with scalloped cartouches painted with people and a light blue banner in a landscape setting. Signed by Kiowa. 8-1/8" h. *William & Jo-Ann Van Rooy.* $18,000-20,000.

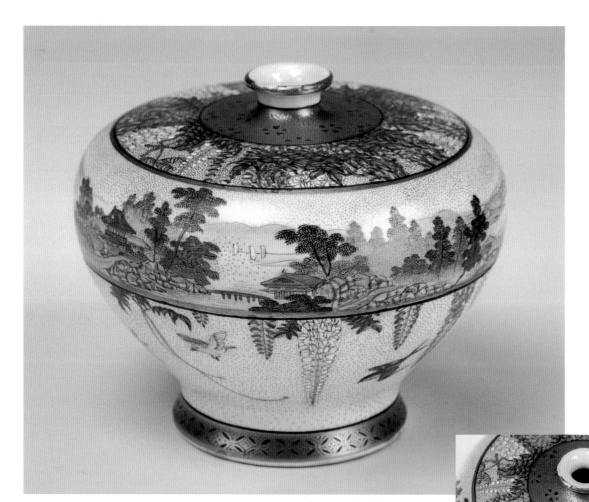

Tapered squat Satsuma vase with a narrow neck and wonderfully enameled wisteria shoulders and a circular scene consisting of Lake Biwa, Mt. Fuji, forests, and villages. The lower portion is decorated with hanging wisteria vines and various species of birds. Signed by Kinkozan. 3-1/2" d. *William & Jo-Ann Van Rooy.* $6000-7500.

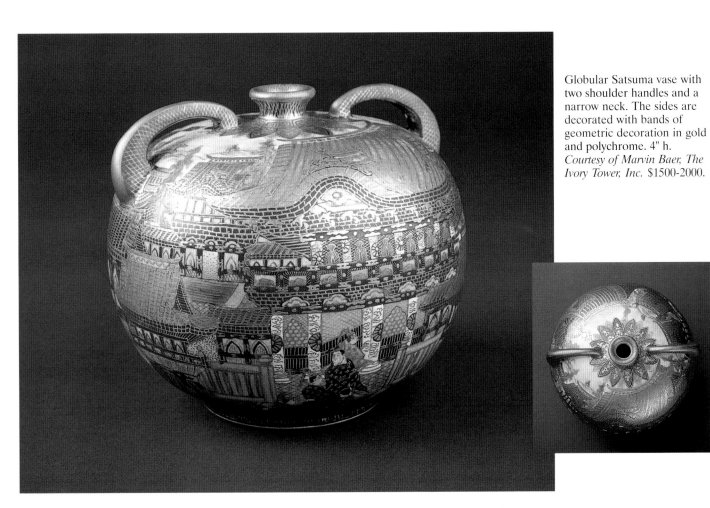

Globular Satsuma vase with two shoulder handles and a narrow neck. The sides are decorated with bands of geometric decoration in gold and polychrome. 4" h. *Courtesy of Marvin Baer, The Ivory Tower, Inc.* $1500-2000.

Globular Satsuma vase with very fine enamel and gold decoration in bands. Sages, children, and the goddess Kannon standing on a dragon illustrate a folk tale. Double signed by Suigetsu. 6" h. *William & Jo-Ann Van Rooy.* $8000-10,000.

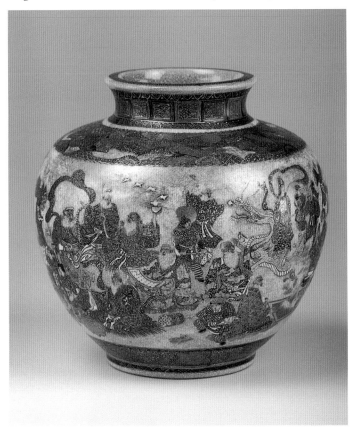

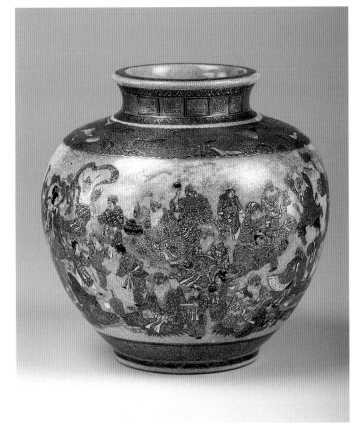

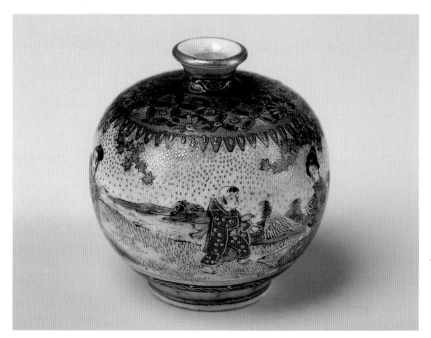

Miniature globular Satsuma vase, whose form was used to demonstrate the shape only. The circular scene depicts women and children in an outdoor setting. The shoulder of the vase has a floral and brocade design. Signed Kozan.1-3/4" high and 1-3/4" wide. *William & Jo-Ann Van Rooy.* $250-300.

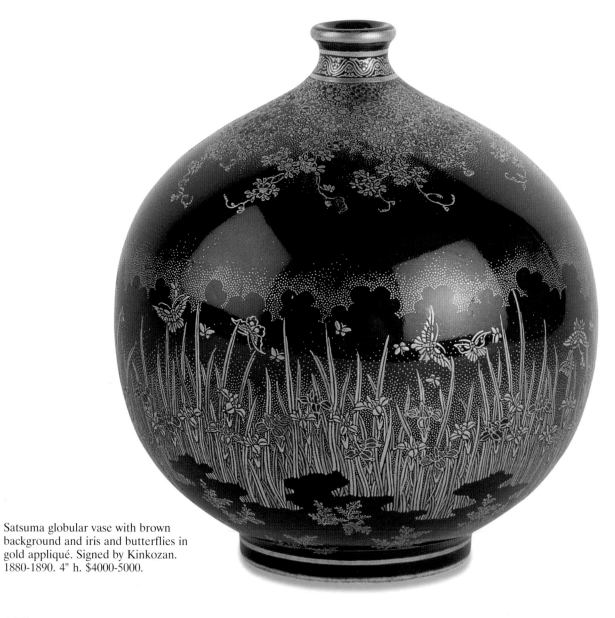

Satsuma globular vase with brown background and iris and butterflies in gold appliqué. Signed by Kinkozan. 1880-1890. 4" h. $4000-5000.

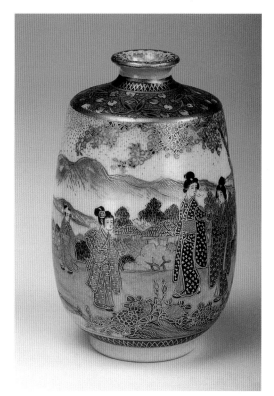

Satsuma ovoid vase with a floral and gold brocaded decorated flat shoulder, which is followed by a circular scene consisting of Bijin, Lake Biwa, and Mt. Fuji. 3-3/5" high, Impressed and signed by Kinkozan. *William & Jo-Ann Van Rooy.* $1000-1500.

## Oval Shapes

Satsuma tall ovoid vase with dark green background and gold appliqué and wisteria decoration. c. 1880-1890. Signed by Kinkozan. 7" h. $3000-4000.

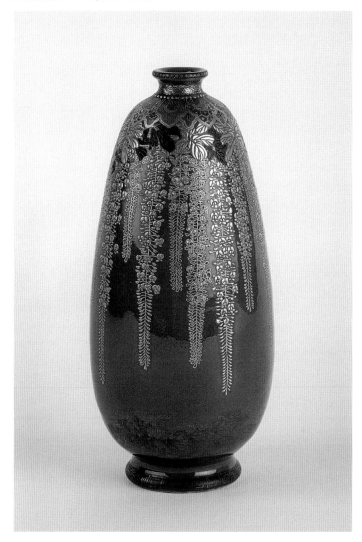

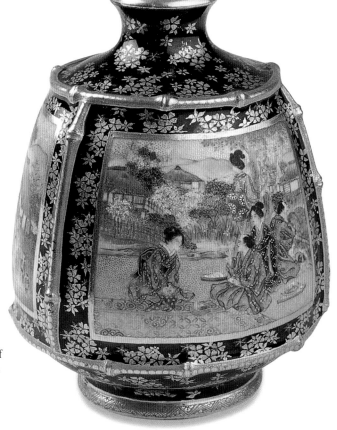

Satsuma ovoid vase with cobalt blue background, gold floral details, and two rectangular panels on the sides of white background painted with a landscape and people. Signed by Kinkozan. 7" h. *Courtesy of Marvin Baer, The Ivory Tower, Inc.* $5000-5500.

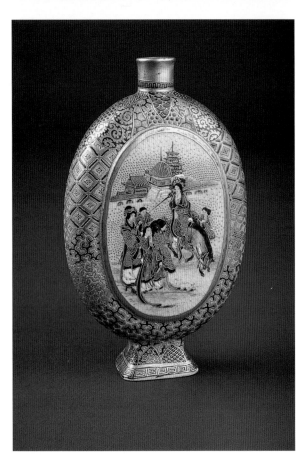

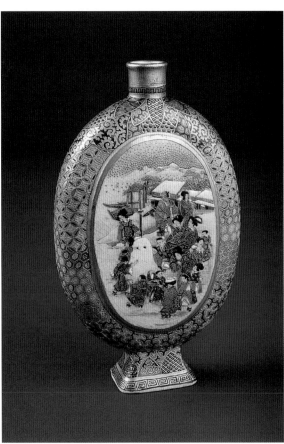

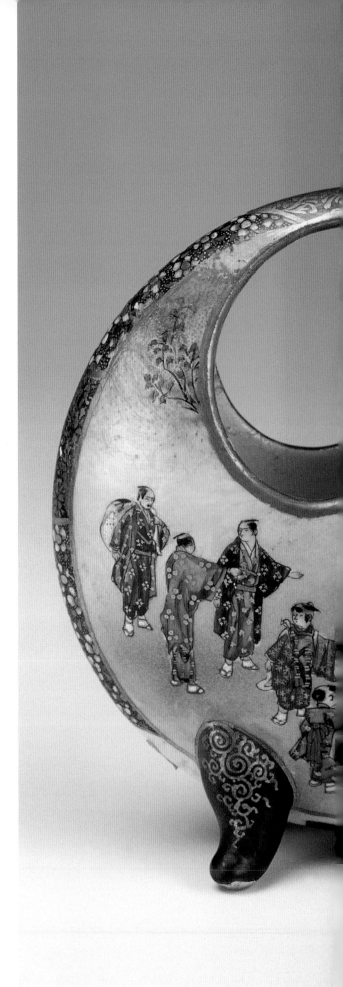

Small flat Satsuma saki flask on a rectangular base with gold geometric and tapestry borders and two side oval panels painted in polychrome with summer and winter landscape scenes. Signed by Meizan. c. 1875. $4000-4500.

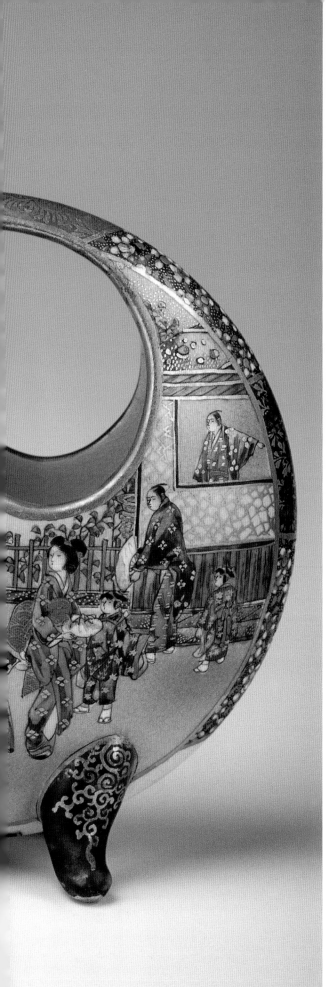

Satsuma flat saki flask on a round base with two side scenes, one of women and children in a landscape and the other of men seated on a draped platform. Signed by Kozan. 7-1/2" h. *Courtesy of the L. Robbins Collection.* $3500-4000.

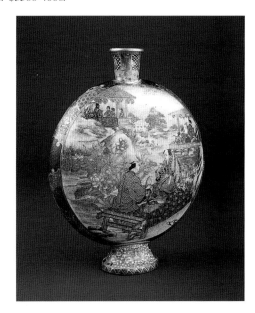

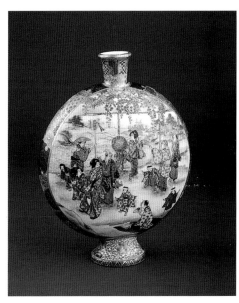

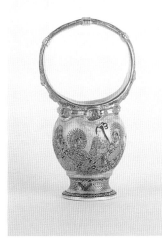

Small Satsuma vase of basket form with gold decorated handle and borders and painted people on both sides. Signed Dai Nihon, and Satsuma gold cross mark. 5-3/4" h. $1000-1200.

Convex flat round vase with continuous handle and resting on four legs, painted with enamel and gold scenes: one of many people gathered outside a house and the other with two birds in a garden setting. Signed by Kinkozan. 4.25" h. *William & Jo-Ann Van Rooy.* $1200-1500.

# Bowls

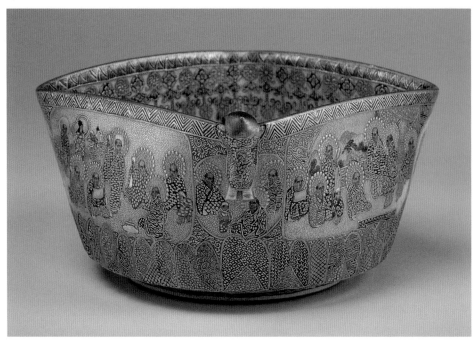

## Rectangular Shapes

Satsuma square deep bowl decorated on the inside and outside with raised enamel and gold designs. Outside are four major panels and four small panels with scalloped and fluted rim. Inside, a border of stylized hanging brocaded tassels running from the perimeter to the center of the bowl surrounds a landscape scene of Rakons proceeding over a bridge, from a Shinto temple, with raised gold work on the roof and Rakons themselves. In one corner of the bowl a relief figure of a boy with a hat is shown peering over the rim. Signed by Hodota. 5.-1/2" w. and 3-1/2" h. *William & Jo-Ann Van Rooy.* $2500-3000.

Hexagonal Satsuma bowl decorated inside and outside with allover enamel and gold mille fleur design of peonies and chrysanthemums and on the outside base tiny butterflies are near the foot. Signed by Kozan. Taisho period (1912-1926). 7" d. *William & Jo-Ann Van Rooy.* $800-1200.

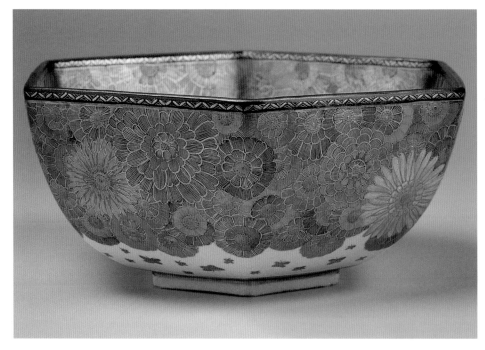

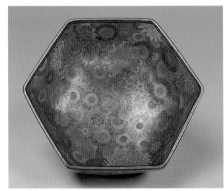

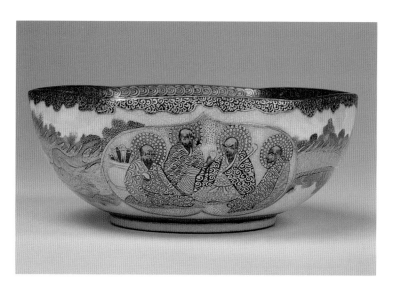

Hexagonal Satsuma bowl with raised gold and enamel decoration inside and outside of sages and dragons. The detailed embossed gold work on the dragons and Rakons is exceptional. The imperial Satsuma cross is on the inside and outside and an embossed phoenix bird appears on the exterior. The outside has an embossed gold dragon, which circles the perimeter and a heart-shaped scene of four Rakons, which are well decorated in raised gold work. The signature is very stylized. Signed by Hodota Shozan. 6" w. and 2-1/2" h. *William & Jo-Ann Van Rooy.* $3500-4000.

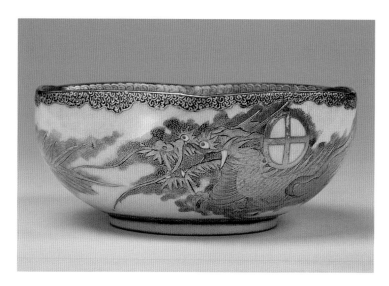

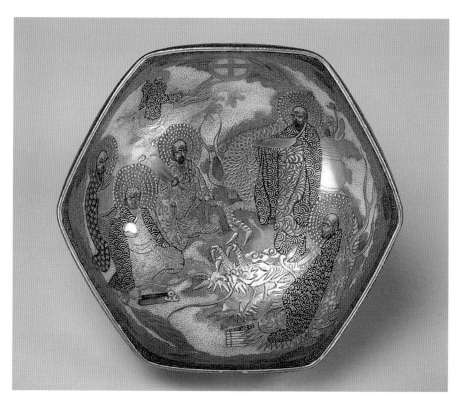

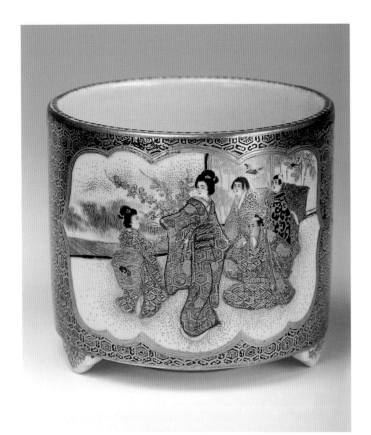

**Round Shapes**

Round Satsuma *chawan* (ceremonial tea bowl) with nine wavy panels inside, each with floral and striped décor in raised gold and enamel. In the center, in a maple leaf shaped panel, is a painted scene of a family, which includes parents, a son, and a daughter. The exterior has two maple leaf and two circular panels containing painted scenes of various family members at different times in their home. Peonies and chrysanthemums separate these. There is a small pedestal foot. Signed by Hozan. Meiji period. 4" d. *William & Jo-Ann Van Rooy.* $1500-2000.

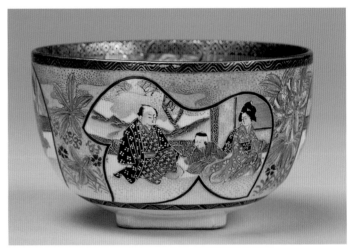

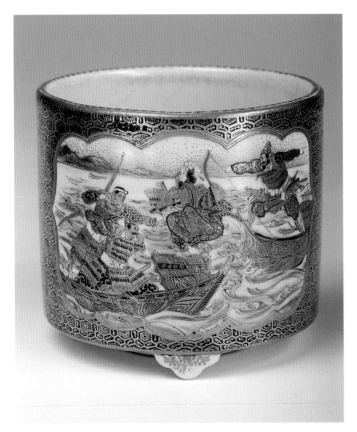

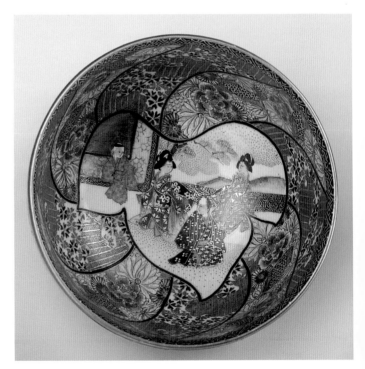

Cylindrical Satsuma cup with three flat legs and a gold work background around two scenic panels with scalloped edges: one of Samurai and boats on the water and the other with noble man and woman in a palace scene. The diaper work consists of meticulously painted geometric gold brocade design. Meiji period. Signed by Kinkozan. 2-3/4" d. and 2-3/4" h. *William & Jo-Ann Van Rooy.* $1800-2000.

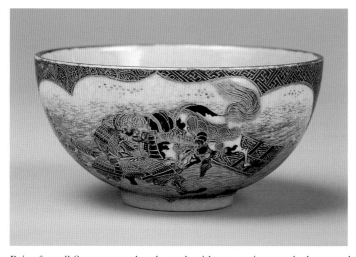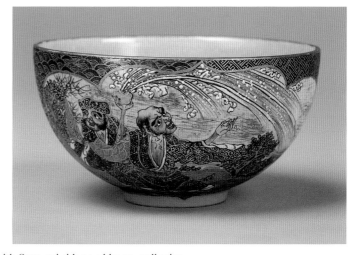

Pair of small Satsuma tea bowls, each with two major panels decorated with Samurai rider and horse, galloping and dismounted, seashore in the background. The opposite panel on each has a folklore scene with some rather unusual looking sages, both have scenic landscape backgrounds. The reserves have a gold and iron red geometric design separating the panels. Both are unsigned. 3" d. *William & Jo-Ann Van Rooy.* $800-1200 the pair.

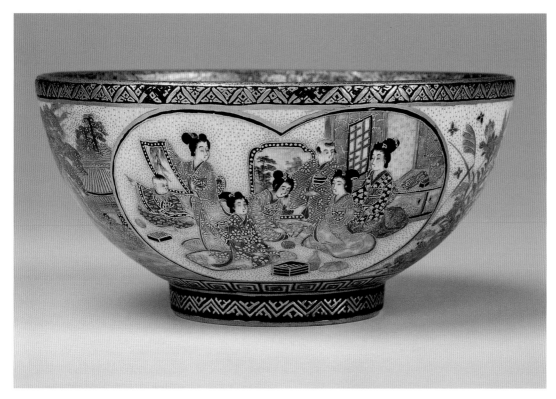

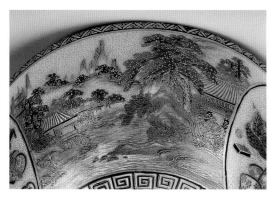

Round Satsuma bowl with floral interior decoration of iris, peony, and chrysanthemum. The outside has two panes, one of Bijin and the other of Bijin and attendants. Separating the scenes is a landscape with water, flowers, and butterflies. A Greek key design is above the pedestal foot. Signed by Kyokaen. 5-1/4" d. x 2-1/2" h. *William & Jo-Ann Van Rooy.* $5000-6000.

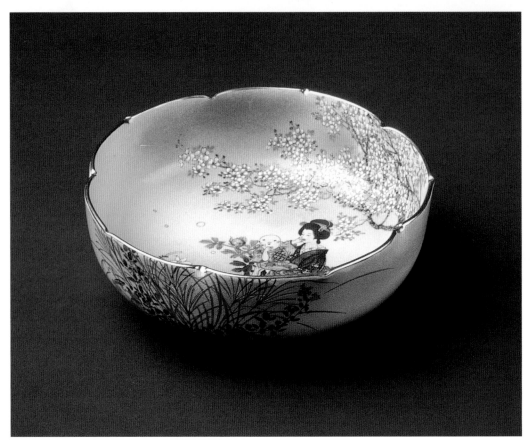

Satsuma bowl with straight sides and gently shaped 5-lobe top edge outlined in gold. The interior is painted with a woman and child. c. 1890-1900. Signed by Kensan. 7" d. *Courtesy of The Marvin Baer - Bonnie Boerer Alliance Collection.* $2000-2500.

Satsuma bowl with 5-lobed rim outlined in gold. The interior is painted with a scene depicting a family of five people, each dressed in a kimono of different patterns. The outside of the bowl has five individuals: three women, a boy, and a girl. Very rare shading appears in the decoration. Signed by Kinkozan Sozan. Meiji period. 1-3/4" h. x 5" d. *Harry & Carol Willems.* $6000-8000.

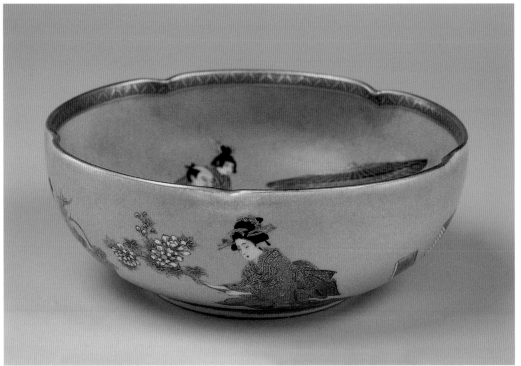

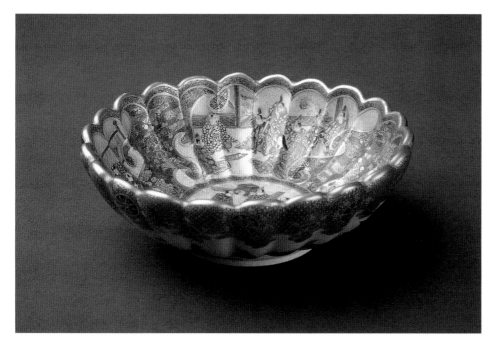

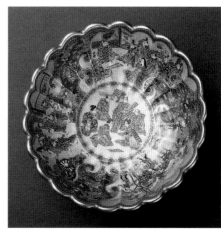

Satsuma bowl with ribbed sides and scalloped rim. The interior and exterior are both heavily decorated with painted decoration: flowers on the outside and people inside. Signed by Kozan. 5" d. *Courtesy of Marvin Baer, The Ivory Tower, Inc.* $3500-4500.

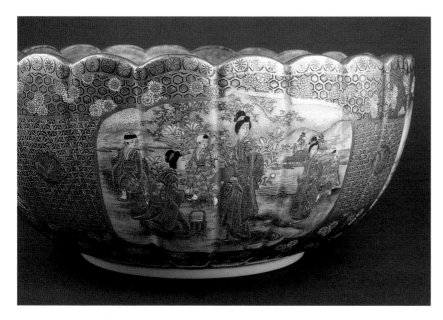

Large and elaborate Satsuma bowl with ribbed sides and a scalloped rim. The decoration is continuous over the entire surface, with a tiny processional of people spiraling from the center against a background of gold lines on the inside. The exterior has four reserves with floral and people scenes representing the four seasons against a background of geometric tapestry designs. Signed by Ryozan in open signature. 12-1/4" d. *Courtesy of the L. Robbins Collection.* $8000-10,000.

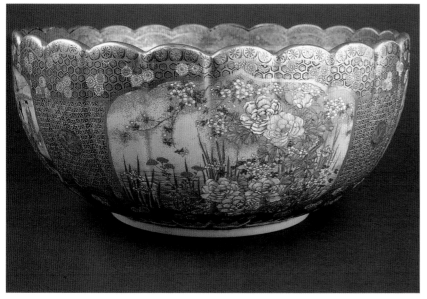

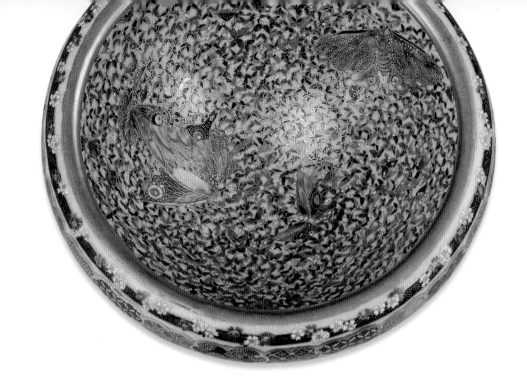

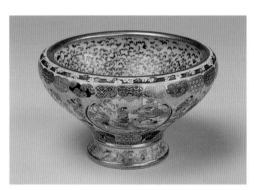

Satsuma convex lipped bowl on a pedestal with an interior covered with thousand butterflies decoration and three large and finely detailed butterflies. The exterior has four circular scenes with people in market and countryside views. Between the scenes is a myriad of people milling about. The bottom rim of the pedestal is comprised of flowers, fish, animals, and frogs. Signed by Meizan. *William & Jo-Ann Van Rooy.* 5" d. x 3" h. $8000-10,000.

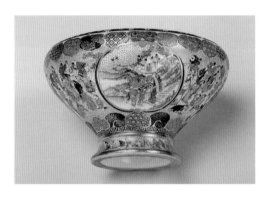

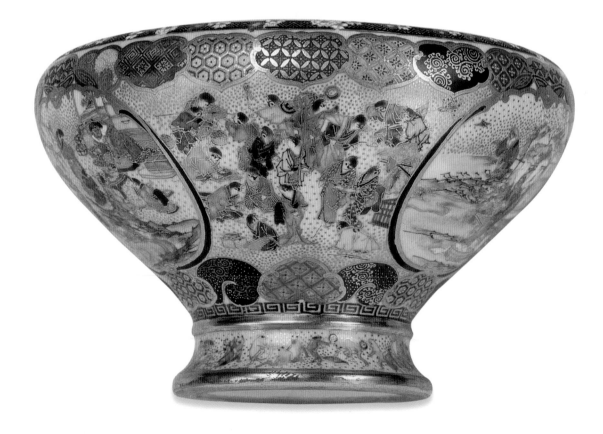

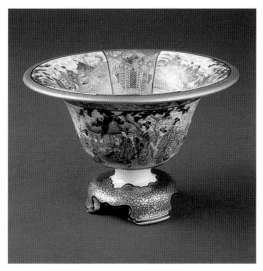

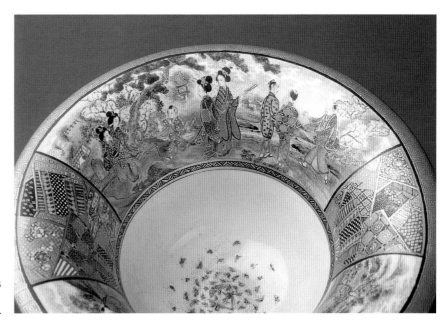

Satsuma flaring bowl on a pedestal decorated with panels of figures in landscapes on both the interior and the exterior. Signed by Kinkozan. 4" d. x 5-3/4" h. $5000-6000.

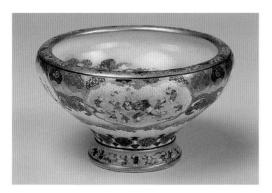

Satsuma convex lipped bowl on a pedestal with an interior painted decoration of butterflies, birds, and a center medallion of people. The exterior has four oval panels decorated with women, Samurai, children, and noblemen, each connected by heavily brocaded medallions and a garland of chrysanthemums, which fall below the four scenes. The pedestal is encircled with a vast number of Kracao boys (indicated with tufts of hair on their heads). Signed by Meizan. 4-3/4" d. x 2-3/4" h. *William & Jo-Ann Van Rooy.* $8000-10,000.

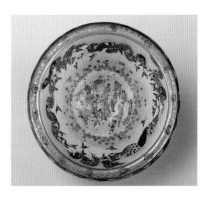

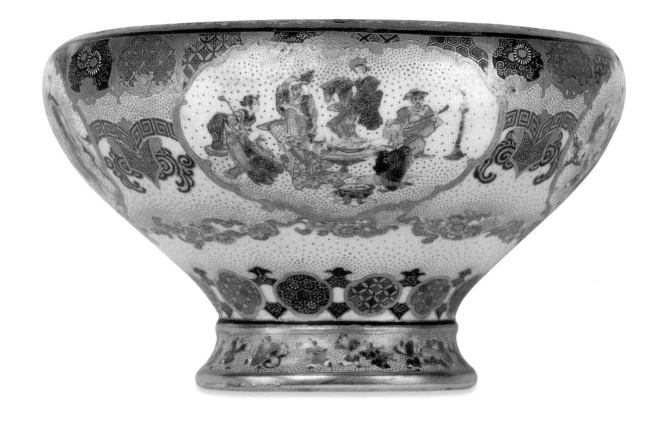

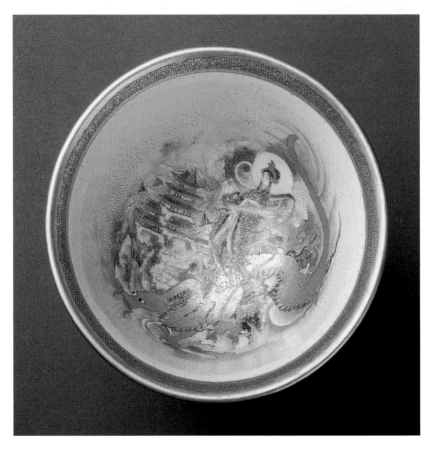

Large Satsuma footed cup beautifully painted with scenes of people and animated beasts in landscapes and floral borders on the exterior. Inside, Kannon and a dragon are depicted within a gold rim border. Signed by Meizan. 6" d. $4000-5000.

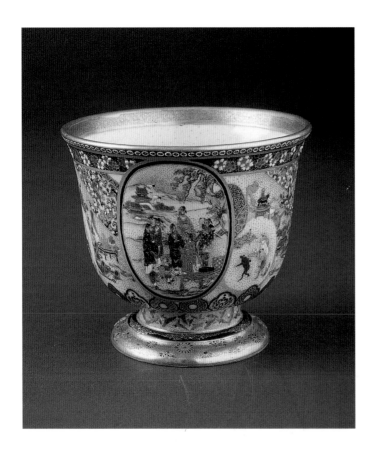

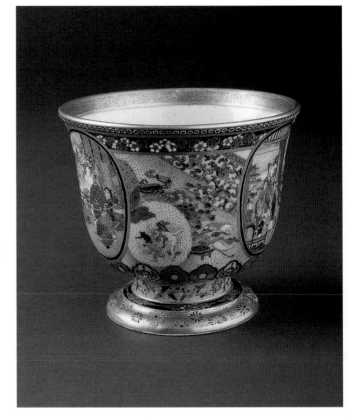

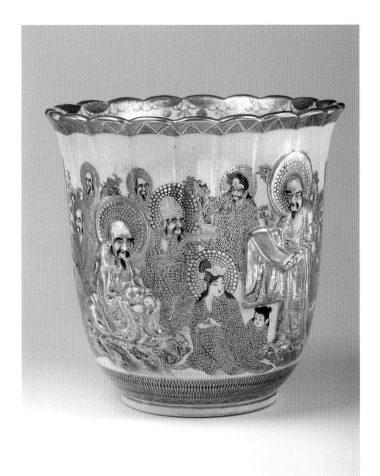
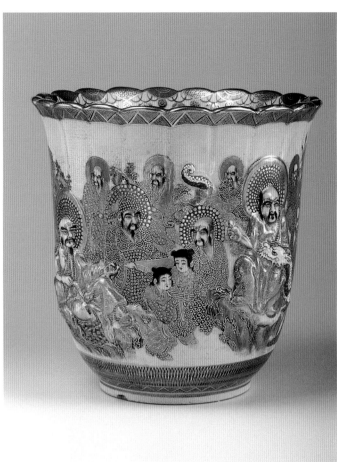

High-sided Satsuma planter with fluted sides and a scalloped rim. The exterior has many raised and flat portrait quality painted sages decorated with enamel and gold. The inside is painted with brocade tassels attached to the scalloped rim. Attributed to Hodota (partially indistinct). 8-1/2" h. *William & Jo-Ann Van Rooy.* $6000–8000.

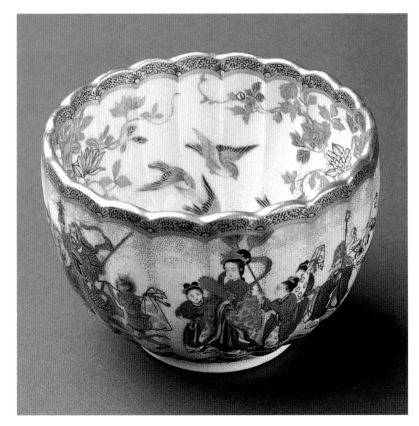
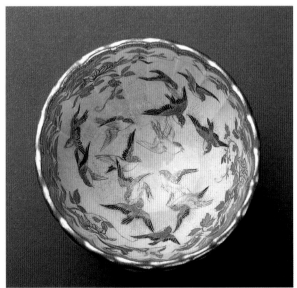

Satsuma tea bowl with ribbed sides and a scalloped rim. The outside is decorated with a painted parade of people. A painted decoration of flying birds and tree branches is inside. Signed by Yozan. 2-1/8" h. *Courtesy of Marvin Baer, The Ivory Tower, Inc.* $5000-6000.

171

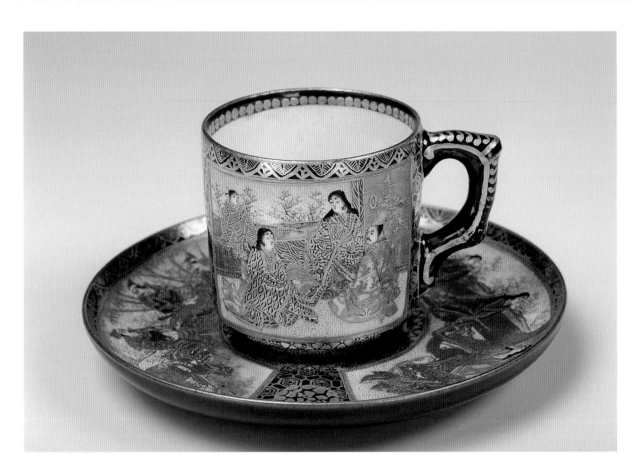

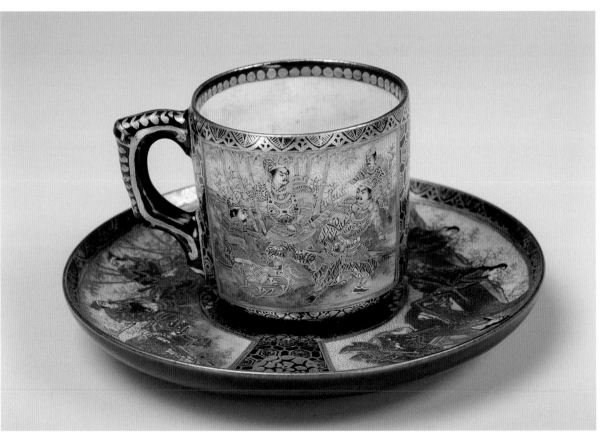

Satsuma teacup with a handle and saucer. Cup has two rectangular scenes, one of Samurai in battle and one of women in the palace. The background is in cobalt blue with geometric gold diaper work separating the two panels. Saucer decorated with two scenes, one of Samurai and one of noble men and women in palace setting. Both scenes separated by a geometric gold and cobalt design. The underside in solid cobalt. Signed by Kinkozan. Cup 2" d. and 3" from handle to edge, 2.25" h. Saucer 4-3/4" d. *William & Jo-Ann Van Rooy.* $800-1000.

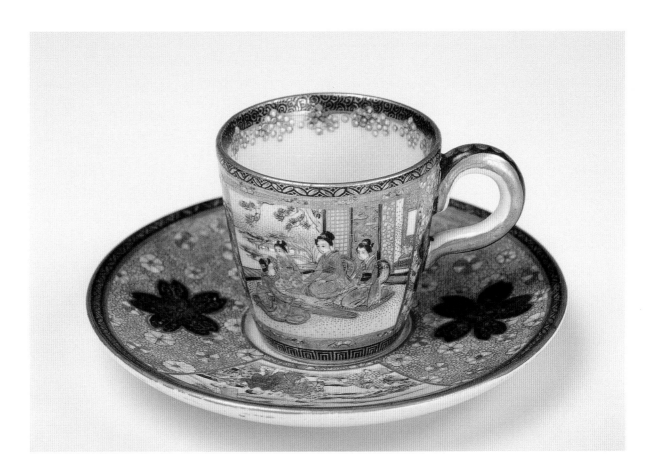

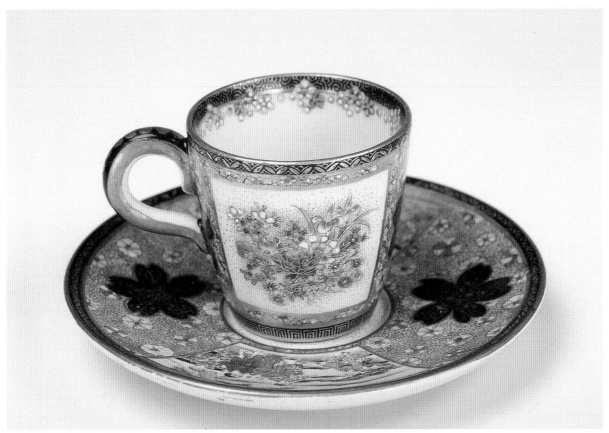

Satsuma demitasse cup with a handle and saucer. Two major panels are decorated, one with four Bijin seated in palace scene and the other with a floral spray of peonies and chrysanthemums. Cobalt background with gold florets separating the panels and on the inside edge of the cup. The inside has a meticulously painted floral spray. The saucer has two scenes, one of Bijin and the other of five boys walking along a path with a mountain in the background. The side panels bordering two scenes consist of a gold brocade background on which a number of pastel colored florets are scattered around a large black and gold peony. Cup signed Kozan and a paper label of Kinkozan, which indicates it was potted at the Kinkozan studio. Cup 1-3/4" d. and 2-1/2" wide and 1.85" h. *William & Jo-Ann Van Rooy.* $600-800.

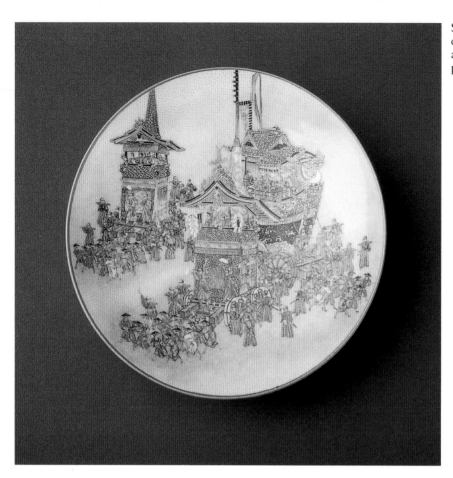

Satsuma round plate decorated with a procession of people pulling three large wheeled carts of architectural temple style that transport important people. Signed by Kinkozan. 4-3/8" d. $4000-5000.

**Oval Shape**

Small oval Satsuma sauce boat with a handle and finely painted decoration inside of butterflies and outside of a group of people. Signed by Hankenzan. 4-3/4" l. x 2-3/4" w. $3200-3600.

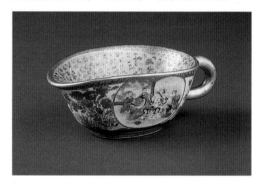

## Plates

Satsuma round plate finely painted with iris decoration within a patterned gold rim band. Signed by Kinkozan. 8-7/8" d. *Courtesy of The Marvin Baer - Bonnie Boerer Alliance Collection.* $2500-3500.

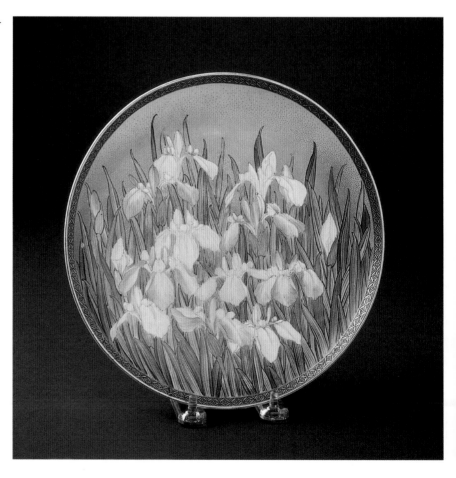

Satsuma round plate with floral rim and center painted with a man and a woman in a garden setting. Signed by Kinkozan. c. 1900. 10-5/8" d. *Courtesy of The Marvin Baer - Bonnie Boerer Alliance Collection.* $2000-2500.

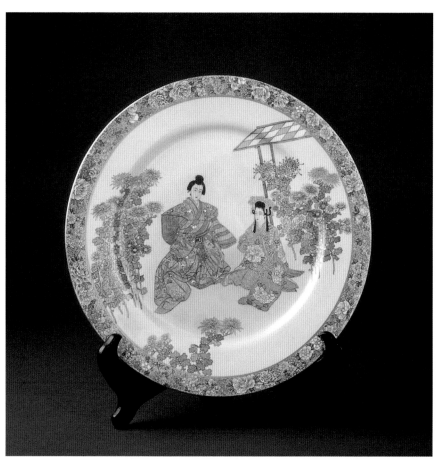

Large Satsuma round platter decorated with a rim band of clustered gold medallions. In the center, painted light rays extend over a small group of men and a raging sea. c. 1867-1875. 15" d. *Courtesy of The Marvin Baer - Bonnie Boerer Alliance Collection.* $4000-4500

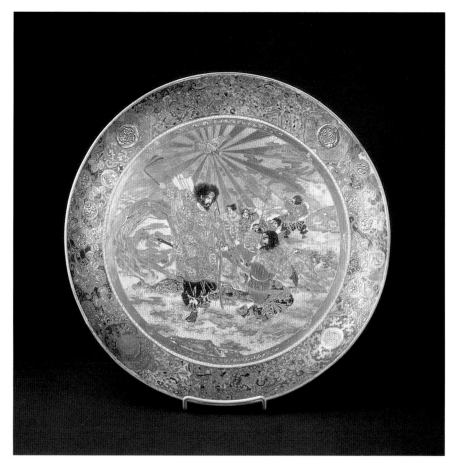

Satsuma round dish with straight sides and a concave center with painted decoration of a group of people within a floral rim border. Signed Koyama Nanpo. 13" d. *Courtesy of Marvin Baer, The Ivory Tower, Inc.* $7500-10,000.

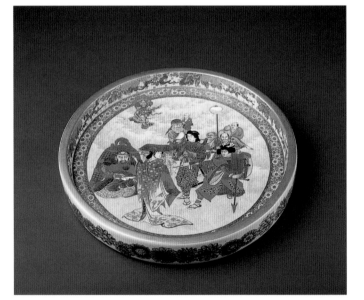

Very unusual large Satsuma round dish resting in an original gilded and carved wooden and canvas frame. The dish is decorated with a painted scene of a room interior where two men are being presented to a lord with attendants. 14-1/2" d. *Courtesy of the L. Robbins Collection.* $6000-7000.

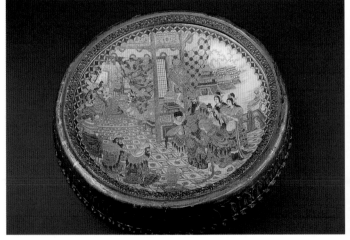

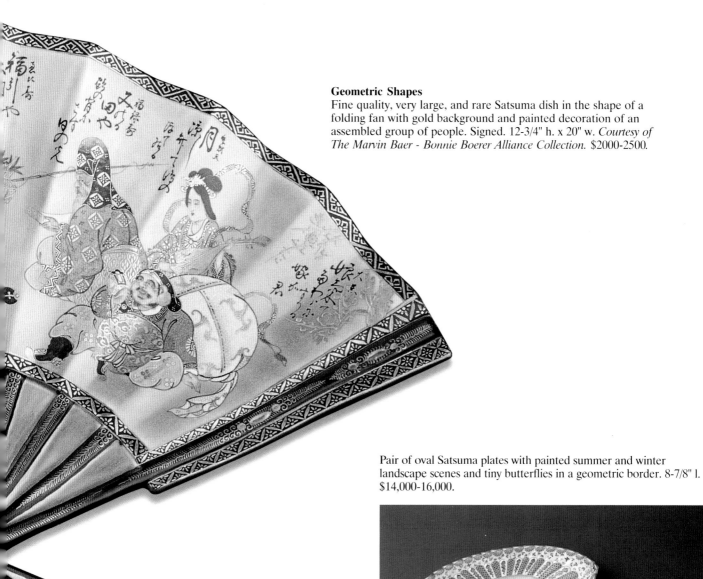

**Geometric Shapes**
Fine quality, very large, and rare Satsuma dish in the shape of a folding fan with gold background and painted decoration of an assembled group of people. Signed. 12-3/4" h. x 20" w. *Courtesy of The Marvin Baer - Bonnie Boerer Alliance Collection.* $2000-2500.

Pair of oval Satsuma plates with painted summer and winter landscape scenes and tiny butterflies in a geometric border. 8-7/8" l. $14,000-16,000.

Very unusual Satsuma fish-shaped dish with painted floral decoration. Signed with Ysuda factory mark. 9-1/2" l. *Courtesy of Marvin Baer, The Ivory Tower, Inc.* $2000-2500.

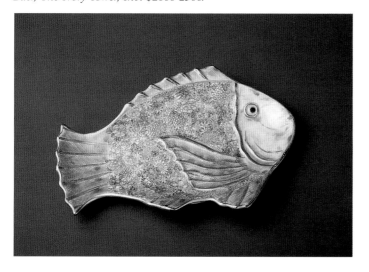

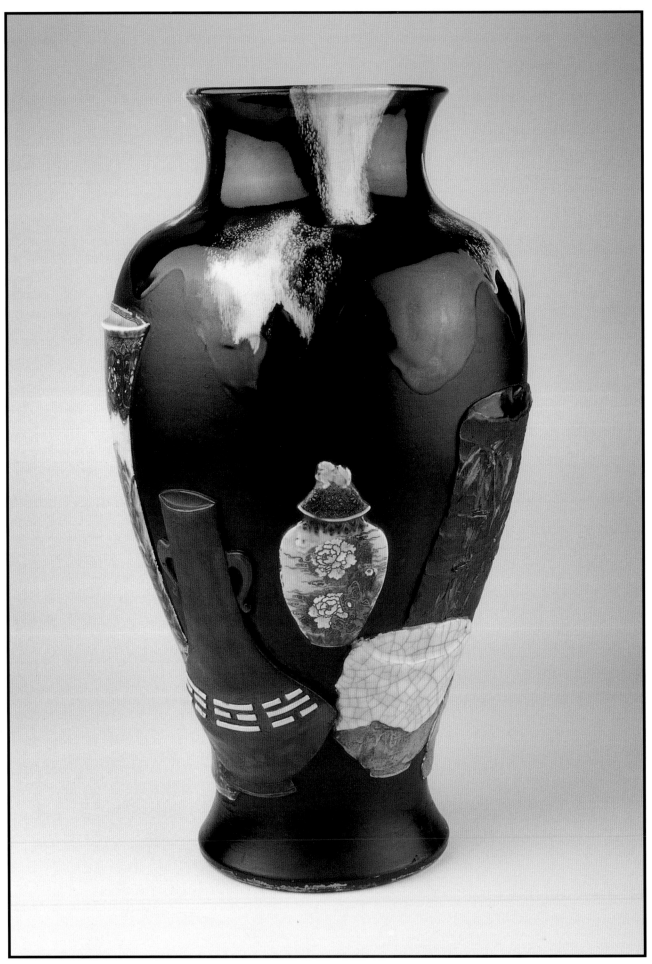

Black Sumida vase of urn shape with a small area of applied relief decoration of various kinds of Japanese ceramic wares appropriately glazed and shaped, truly an unusual subject. The maker's mark of blue underglaze appears on a white gourd relief panel. Signed Inoue Ryosai. 18" h. *R.B. & G. Collection*. $6000-8000.

# Earthenware

Earthenware export ceramics were made with softer and darker clays than the porcelains and are fired at relatively low temperatures. They are usually glazed if they are intended to hold liquids, and the decorations are both applied from the same soft clay and glazed in colors. Tea drinking vessels are commonly made of earthenware and production of them was prolific. The export ceramics in earthenware comprise both utilitarian and ornamental forms.

## Banko

The earthenware clay for Banko export ceramics is usually gray or brown-gray with white and colored glazes. Banko pieces are usually found in small sizes of utilitarian and ornamental forms.

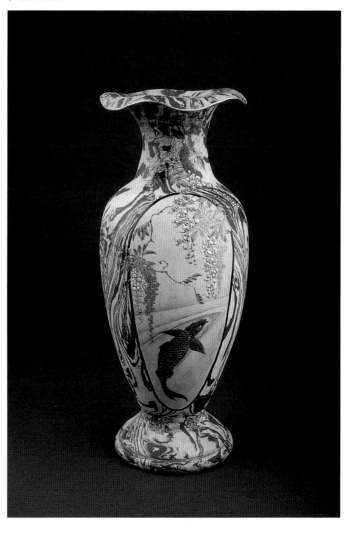

Banko vase with swirled clay interrupted by two clear panels of fish and floral scenes. 12-1/2" h. *Courtesy of the L. Robbins Collection.* $900-1000.

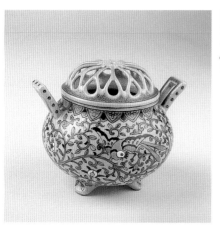

Banko covered potpourri for the Dutch market with floral decoration. c. 1890. *Courtesy of Marvin Baer, The Ivory Tower, Inc.* $400-500.

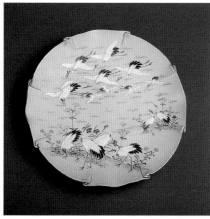

Banko plate with ruffled rim and cranes decoration. 8" d. *Courtesy of the Drick-Messing Collection.*

# Sumida

The term Sumida for earthenware export ceramics refers to forms made from brown, gray, or red clay and usually with colored thick glaze. They were made from the late nineteenth century onward near Tokyo at Asakusa where the Sumida River flows nearby. The forms are both utilitarian and ornamental, often with applied figures of people and animals modeled from the same clay. Many Sumida forms also have painted decoration.

## Sumida decorated by Ryosai

There are three generations of artists who made Sumida ware and used the name Ryosai. Ryosai I (1828-1899) came from Seto and worked in Tokyo, being prominent in the 1890s. Ryosai II (1845-1905) was born Kawamoto Katsusaburo. He worked at Tokyo in a style combining Japanese methods with Western designs. Ryosai III (1888-1971) was named Inoue Ryotaro. He moved the manufacturing to Yokohama in 1914 where he produced export wares until 1941.

## Lidded Forms

### Rectangular Shapes

Sumida flat rectangular teapot and lid with flowing green glaze and two relief figures of children at play on the side. 5-3/4" h. *Courtesy of MPL and BL collection.* $400-600.

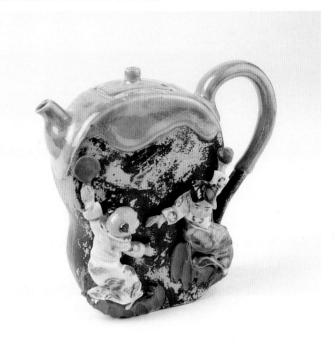

Sumida teapot and lid of unusual rounded rectangular shape with flowing black glaze and typical relief decoration of two figures in green clothing. 4-1/2" h. *Courtesy of Marvin and Nina Vida.* $500-700.

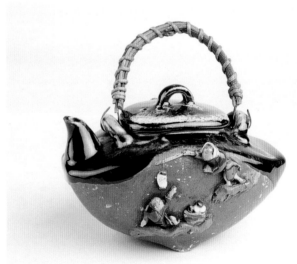

**Left**: The identifying feature of this form of decorative application is that the figures are molded as part of the body. In the earlier forms, the figures were applied in high relief.

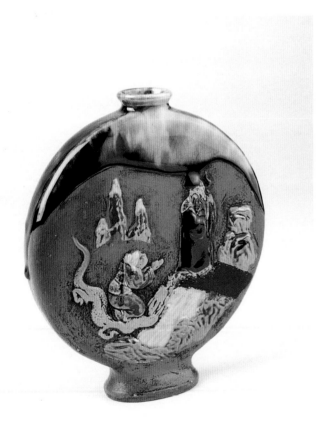

Red Sumida vase with flat sides and mottled flowing glaze on the rim and shoulder. Two relief figures and a dragon on a mountain landscape decorate one side and Mt. Fuji and the sea are on the other side. Late molded style, c. 1920s-1930s. Signed with the impressed Ryosai mark. 8" h. *Courtesy of MPL and BL collection.* $400-600.

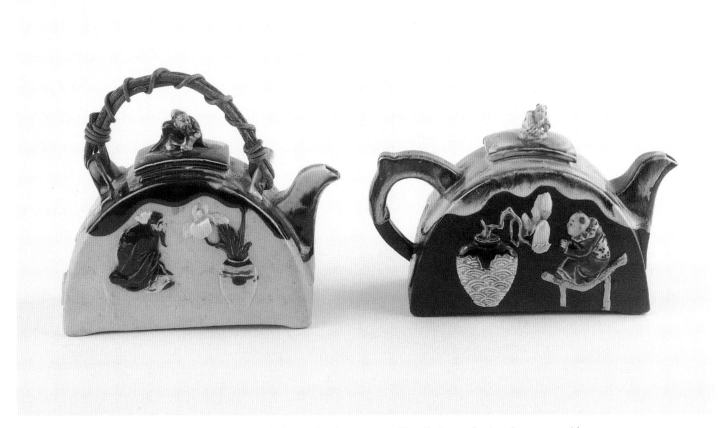

Two Sumida teapots of half round shape with rectangular bases. One has a wrapped handle, brown flowing glaze over tan bisque body, and relief decorations of a man and an iris in a pot on one side and tea implements on the reverse. 4-3/4" h. $600-800. The other teapot has white flowing glaze over a dark brown body and relief decorations of a man seated and plant in vase on one side and tea implements on the reverse, 4-5/8" h. *Courtesy of the Hilco Collection.* $600-800.

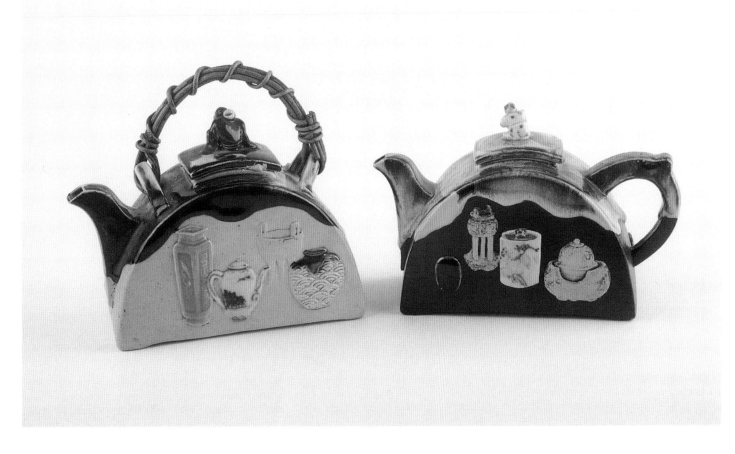

**Round Shapes**
Red Sumida covered cylindrical jar with mottled green/
blue flowing glaze. A seated man with a bird on a stick is
the lid finial. Relief decoration includes a man and a boy
on the side. 8" h. *R.B. & G. Collection.* $1000-1200.

Red Sumida covered cylindrical jar with black
flowing glaze, molded relief tigers decoration around
the body, and lid with a tiger and ball finial. 4-3/4" h.
*Courtesy of MPL and BL collection.* $400-600.

Sumida red covered jar of reverse pear shape with
brown flowing glaze and a relief figure of a woman
as the lid's finial. Two relief figures of a woman and
a boy are on the side. 7-1/4" h. *Courtesy of the Hilco
Collection.* $1000-1200.

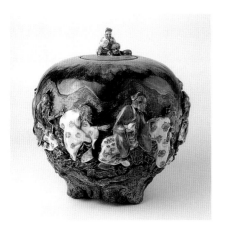 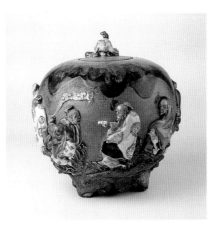 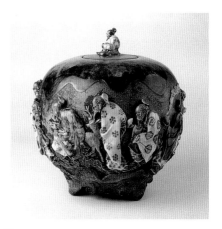

Large globular Sumida covered jar on a four-footed base with scrolls and flowing mottled blue glaze. The round lid has a relief seated man with a bag at his side as the finial. On the sides is a procession of glazed relief figures of scholars with their attributes and a deer. 13-3/4" h. *Krim-Barchanowitz Collection.* $5000-6000.

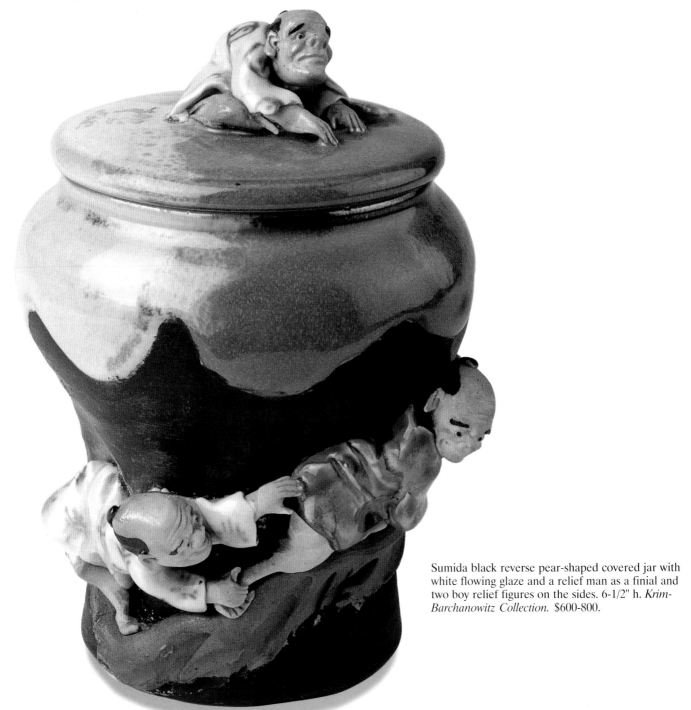

Sumida black reverse pear-shaped covered jar with white flowing glaze and a relief man as a finial and two boy relief figures on the sides. 6-1/2" h. *Krim-Barchanowitz Collection.* $600-800.

183

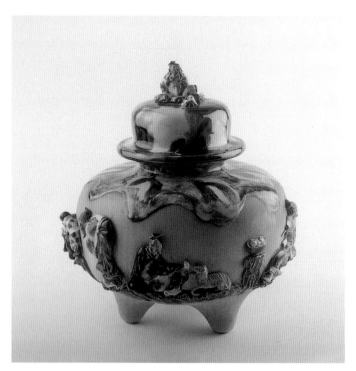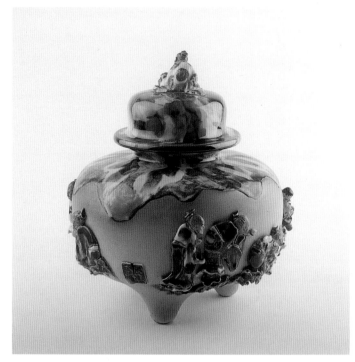

Sumida tan covered jar with brown and blue flowing glaze and a seated sage as the finial on the domed lid. Around the sides are relief figures of sages and their attributes. The jar rests on three peg legs. 12-1/2" h. *Courtesy of the Hilco Collection.* $3500-5000.

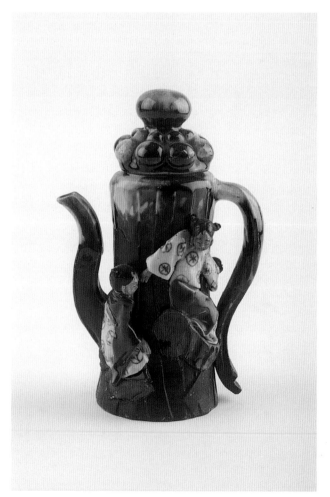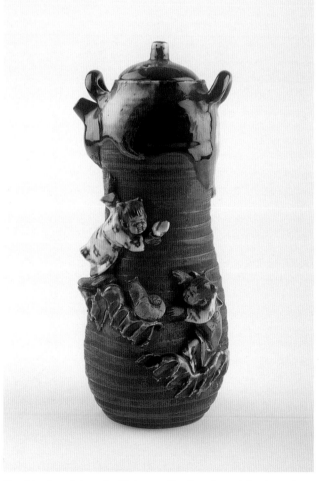

Sumida chocolate pot with flowing glaze over the brown body. The lid is shaped as graduated bubbles. Two glazed relief figures are seated on the side. 8-3/4" h. *Courtesy of the Hilco Collection.* $700-900.

Sumida chocolate pot with brown flowing glaze at the teapot-shaped top. A bail handle attaches to the loops flanking the lid. Two glazed relief figures of children at play are on the red background. 9-1/4" h. *Courtesy of the Hilco Collection.* $800-1200.

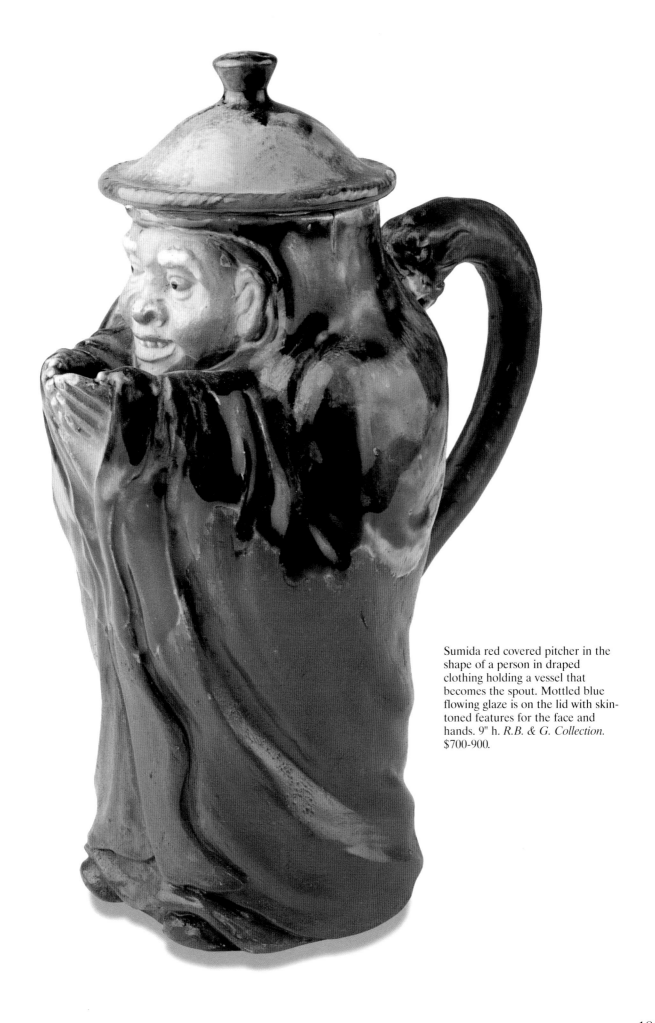

Sumida red covered pitcher in the shape of a person in draped clothing holding a vessel that becomes the spout. Mottled blue flowing glaze is on the lid with skin-toned features for the face and hands. 9" h. *R.B. & G. Collection.* $700-900.

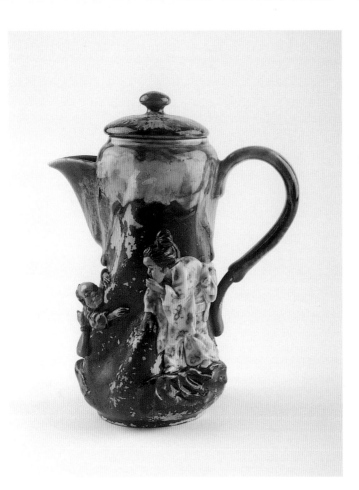

Sumida black chocolate pot with mottled white flowing glaze at the top. Glazed relief figures of a man and a woman are on the side. 8-7/8" h. *Courtesy of the Hilco Collection.* $700-900.

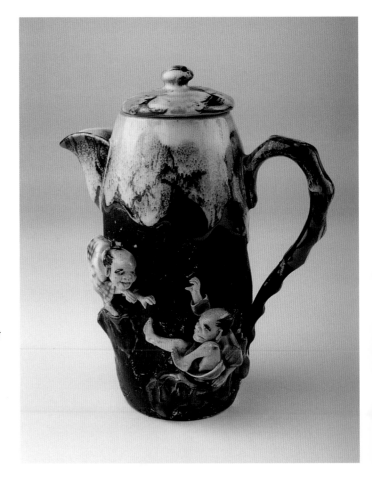

Sumida chocolate pot with brown body, white flowing glaze, and two relief figures of tumbling men. 8.5" h. *R.B. & G. Collection.* $600-900.

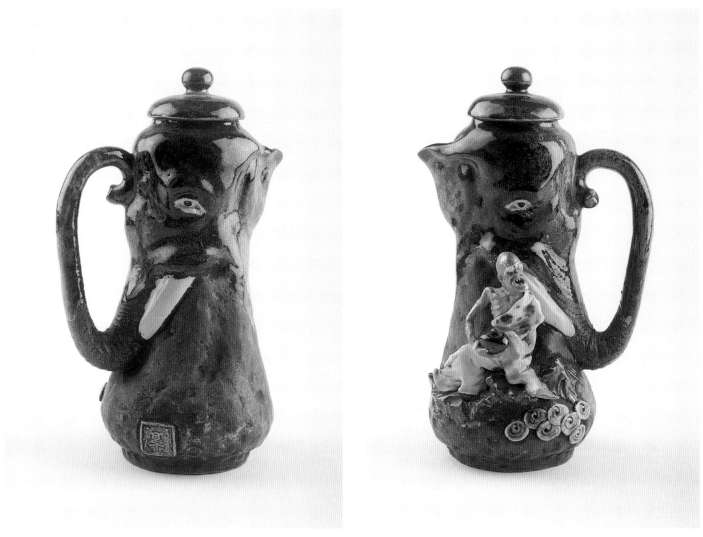

Sumida brown chocolate pot with brown flowing glaze on the elephant-head top. A relief figure of an old man is on the side. *Courtesy of the Hilco Collection.* $700-900.

Sumida covered sugar bowl and cream pitcher with animal head side handles and green glazed lid flowing to the red base, which takes on the form of a person in draped clothing. Signed by Inoue Ryosai. 5.15" h. *R.B. & G. Collection.* $800-1200 the pair.

Red Sumida teapot with blue flowing glaze and flaring body where two glazed figures of people with a bag decorate one side. Bamboo bail handle. 4-1/2" h. *Courtesy of MPL and BL collection.* $600-800.

Red Sumida teapot with flowing mottled brown glaze and two relief frog figures on the side. 4-1/4" h. *Courtesy of the Hilco Collection.* $700-900.

Red Sumida teapot with flowing brown glaze and a white bird as a finial on the lid. Two glazed relief boys decorate the oval body. 5-1/2" h. *Courtesy of the Hilco Collection.* $700-900.

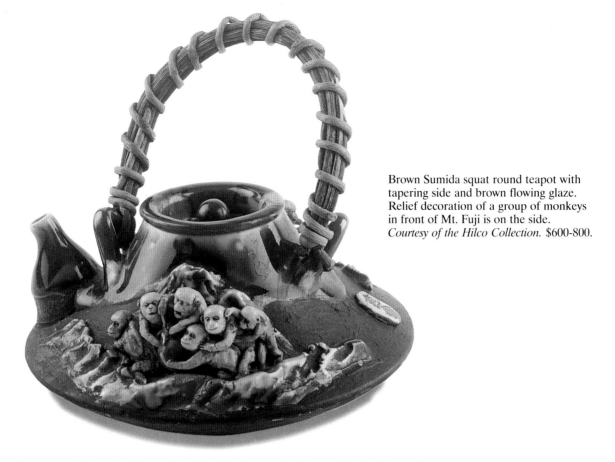

Brown Sumida squat round teapot with
tapering side and brown flowing glaze.
Relief decoration of a group of monkeys
in front of Mt. Fuji is on the side.
*Courtesy of the Hilco Collection.* $600-800.

Two Sumida red squat round teapots with tapering sides. One has mottled brown glowing glaze and
two men in relief on the side. 7" d. $800-1000.
The other has brown and white flowing glaze and a knot of rope as the lid's finial. A dragon in relief
decorates the side. 5-1/2" d. Signed Inoue Ryosai. *Courtesy of the Hilco Collection.* $700-800.

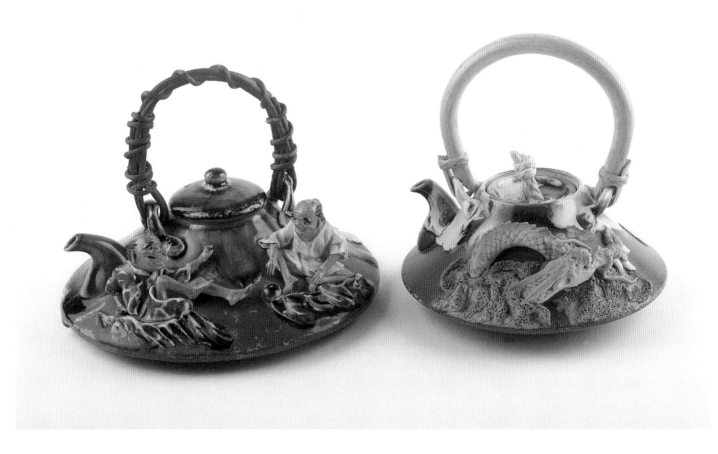

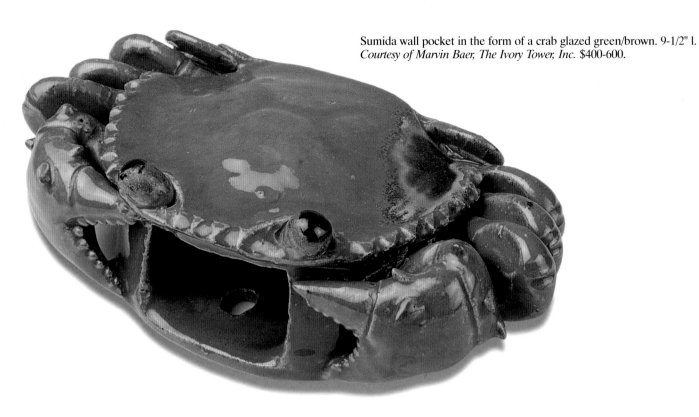

Sumida wall pocket in the form of a crab glazed green/brown. 9-1/2" l. *Courtesy of Marvin Baer, The Ivory Tower, Inc.* $400-600.

## Vases

### Rectangular Shapes
Sumida square red vase with mottled brown flowing glaze and two relief figures of old men on the side. 8-1/4" h. *Courtesy of Marvin and Nina Vida.* $500-750.

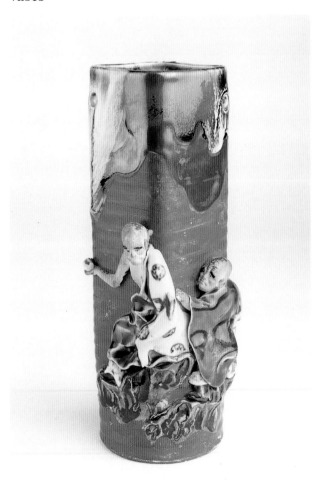

Black Sumida teapot in the squat round shape of a mountain with white flowing glaze. The side is decorated with two relief figures seated. 3-1/4" h. *R.B. & G. Collection.* $700-900.

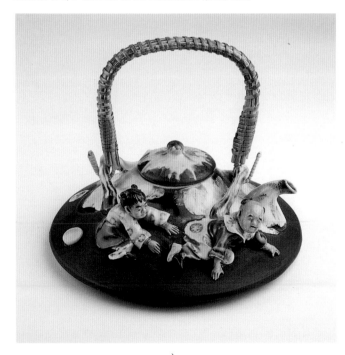

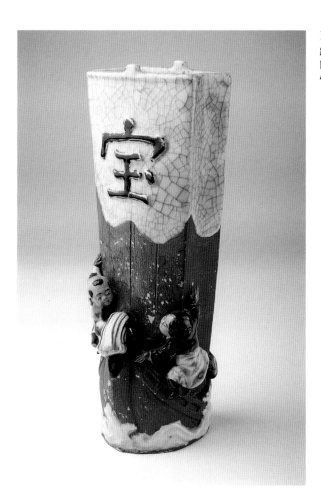

Red Sumida vase of rectangular shape with flowing white crackle glaze and raised black calligraphy. The base is in the shape of the prow of a ship with two relief boys clinging to the sides. 9-1/2" h. *R.B. & G. Collection*. $800-1000.

Red Sumida rectangular flaring vase with four impressed rectangular panes and a relief glazed figure of a woman seated and holding a bowl. 7" h. *Krim-Barchanowitz Collection*. $600-800.

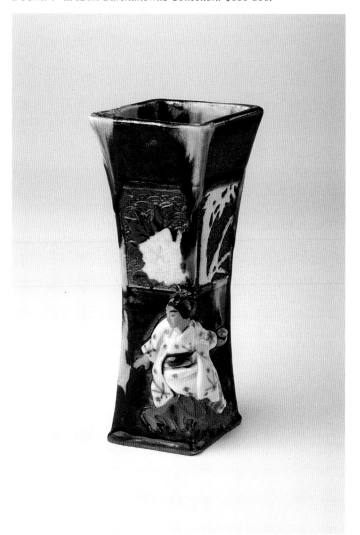

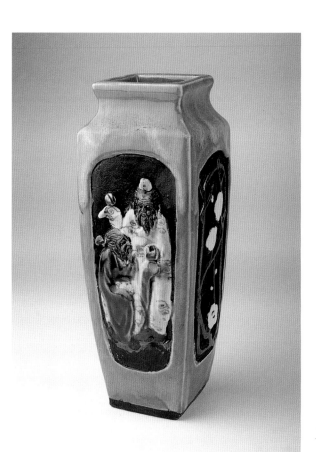

Square blue Sumida vase with two panels decorated with relief men figures and two of floral designs in relief. 12" h. *R.B. & G. Collection*. $1200-1400.

Red Sumida square bulbous vase on a square footed base. The neck has mottled blue flowing glaze and two relief-glazed figures of boys are on the shoulder. 8-3/4" h. *Courtesy of the Hilco Collection.* $1000-1200.

Sumida red square vase with flowing blue glaze and glazed relief figures of an old woman and a child on the side. Signed by Inoue Ryosai. 8-1/2" h. *Courtesy of Marvin and Nina Vida.* $500-600.

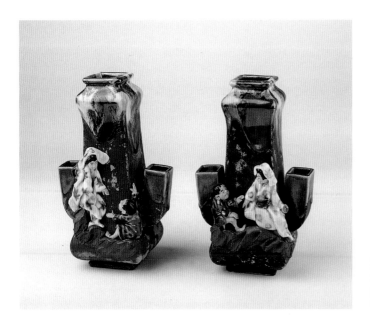

Pair of Sumida vases, each with three square openings. One is red and the other is brown, both with flowing mottled brown glaze. Relief figures of a woman and a child decorate the sides. 8" h. *R.B. & G. Collection.* $1500-1800 the pair.

Brown Sumida basket vase with flowing gray glaze and continuous handle. Two relief figures of children are on the side. 12-1/2" h. *Courtesy of the Hilco Collection*. $1200-1500.

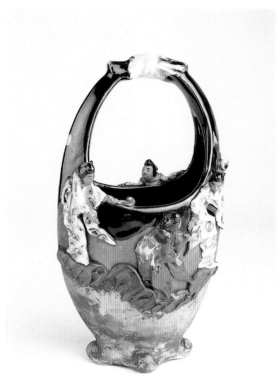

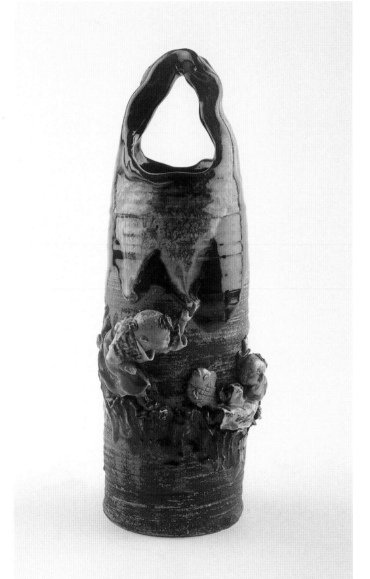

Sumida basket vase with black flowing glaze and continuous handle overlapping and glazed white at the top. The sides have glazed relief figures of people walking along an uneven pathway. Signed by Ryosai. 9" h. *Courtesy of Marvin and Nina Vida.* $600-800.

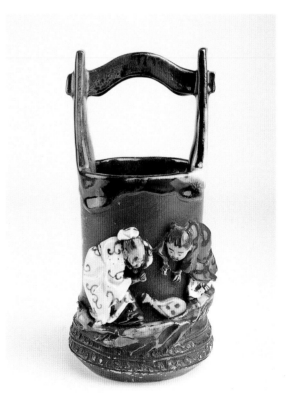

Red Sumida bucket-shaped vase or wishing well with flowing mottled blue/brown glaze at the top. Two glazed relief figures of people with a pouch decorate the side. Signed by Ryosai. 8-1/2" h. *Courtesy of Marvin and Nina Vida.* $600-800.

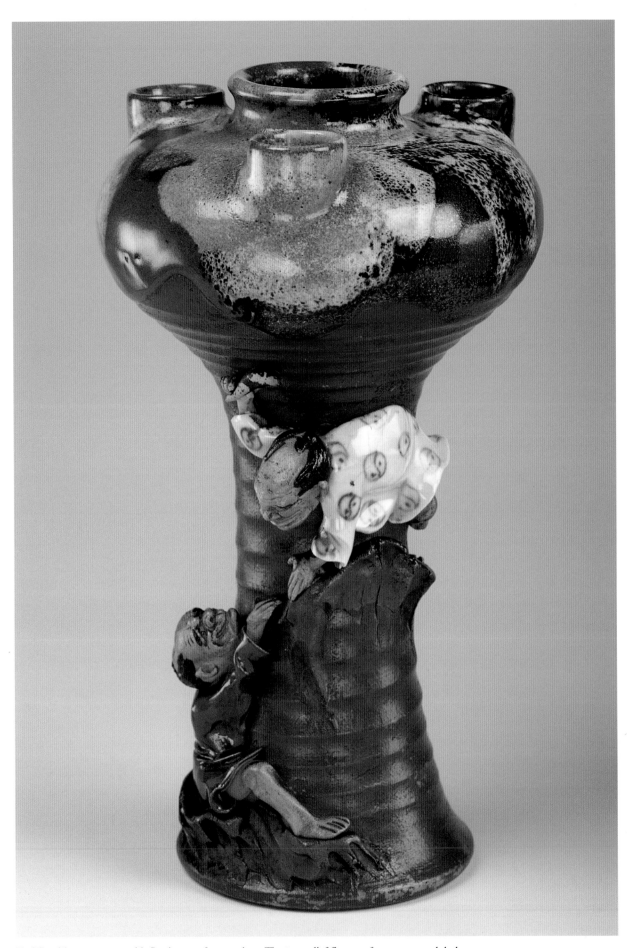

Red Sumida crocus vase with flowing gray/brown glaze. The two relief figures of men on a rock ledge decorate the side. Signed by Koji in a cartouche. Meiji period. 9" high. *Harry & Carol Willems.* $600-800.

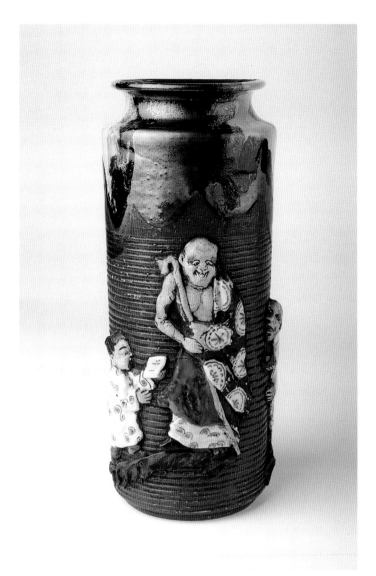

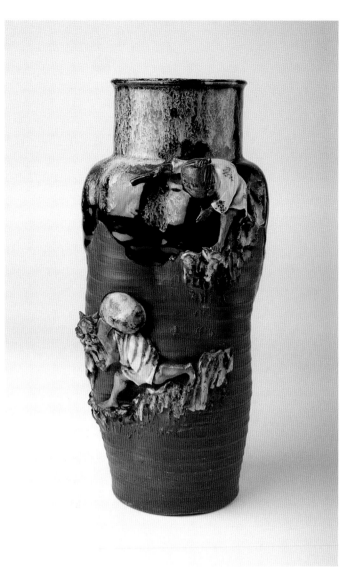

Red cylindrical Sumida vase with flowing mottled black glaze. Relief figures of two old men and a boy in glazed draped clothing decorate the side. 12" h. *Krim-Barchanowitz Collection.* $800-1200.

Red cylindrical Sumida vase with mottled brown flowing glaze. Relief figures of a devil man with a sack and a boy race along the side. 14.15" h. *Krim-Barchanowitz Collection.* $1000-1200.

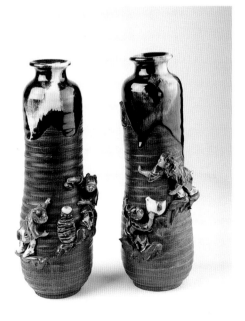

Pair of red Sumida vases with flowing mottled black glaze. Two relief figures on each vase decorate the horizontal ribbed sides. 11-3/4" h. *Courtesy of MPL and BL collection.* $1200-1500.

195

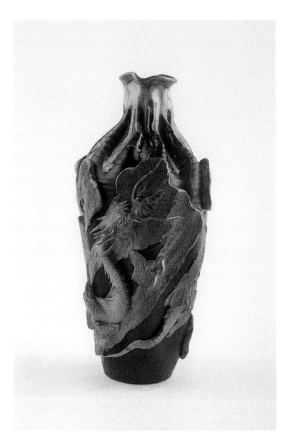

Brown Sumida vase with white flowing glaze on the pinched neck. A tan relief dragon wraps around the body. Signed with the applied white gourd mark of Inoue Ryosai. 12" h. *Courtesy of the Hilco Collection.* $1200-1500.

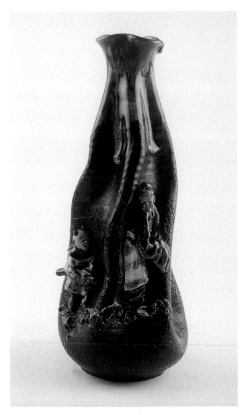

Brown Sumida vase with blue flowing glaze on the pinched neck. Relief figures of a man and a boy decorate the body. 12-1/2" d. *Courtesy of the Hilco Collection.* $800-1200.

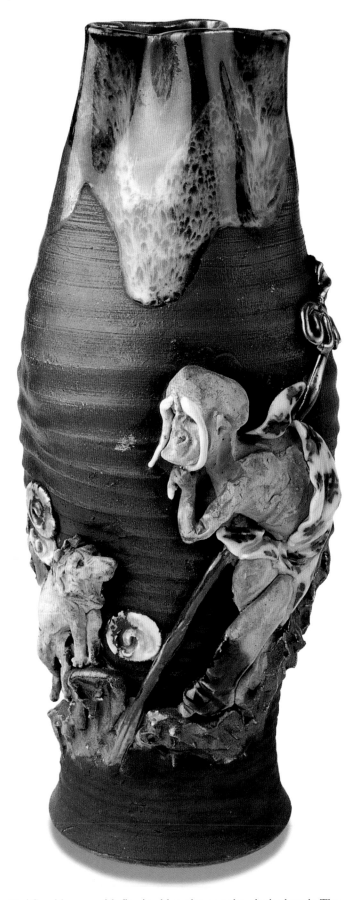

Red Sumida vase with flowing blue glaze on the pinched neck. The sides have relief figures of an old man and a dog. Signed by Inoue Ryosai. 11.25" h. *Krim-Barchanowitz Collection.* $800-1200.

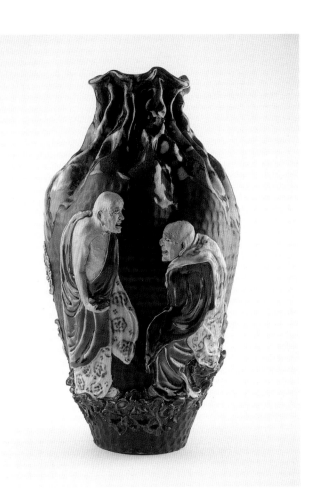

Brown Sumida vase with mottled brown flowing glaze on the pinched neck. Two glazed relief figures of old men decorate the side. Signed by Inoue Ryosai. 18" h. *Courtesy of the Hilco Collection.* $2000-2500.

Red Sumida vase with mottled red flowing glaze on the pinched neck. Relief glazed figures of an old woman and a boy decorate the side. Signed by Ryosai. 14-1/4" h. *Courtesy of the Hilco Collection.* $1200-1500.

Rare red Sumida vase with mottled gray flowing glaze on the pinched neck. Relief lotus flower, bud, and cattail decorate the dot-textured background. Signed in a gourd-shaped cartouche by Ishiguro Koko. 18-1/2" h. *Courtesy of the Hilco Collection.* $3000-5000.

Two red Sumida vases of similar round shape and pinched necks with fluted rims. One has blue flowing glaze and relief decoration of a man and a cloud pattern. The other has green flowing glaze and relief decoration of elephants. Signed by Inoue Ryosai. 8-3/4" h. *Krim-Barchanowitz Collection.* $700-900 each.

Rare red Sumida irregular vase with mottled brown/white flowing glaze representing sea foam. A relief glazed carp emerges from a rough brown surface on the rim. The mark of Inoue Ryosai is in a gourd-shaped cartouche. 18" h. *Courtesy of the Hilco Collection.* $5000-7000.

Sumida vase with overhanging flowing black and white glaze and two relief figures of two old men in a grotto on the body. Signed with a gourd-shaped cartouche and the mark of Gozan. 9-3/4" h. *Courtesy of Marvin and Nina Vida.* $800-1100.

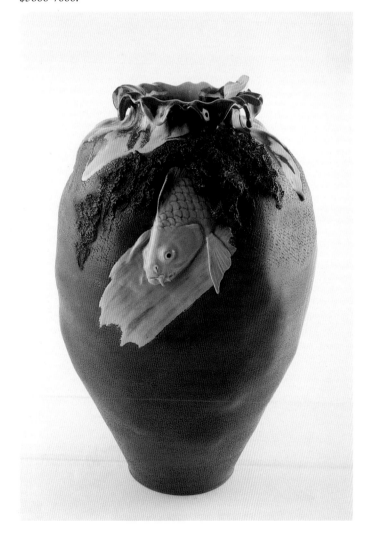

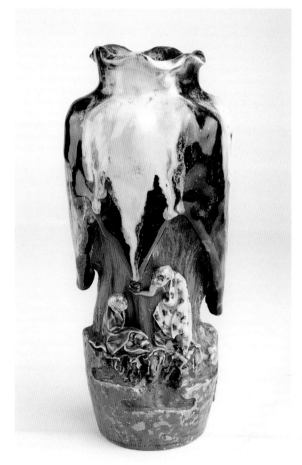

Red Sumida cylindrical tapering vase with mottled flowing glaze and two "bamboo" side handles. Relief decoration of a man with a boy is on the side. Signed by Ryosai. 16-5/8" h. *Courtesy of the Hilco Collection.* $2200-2500.

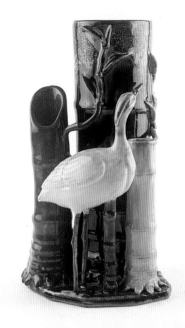

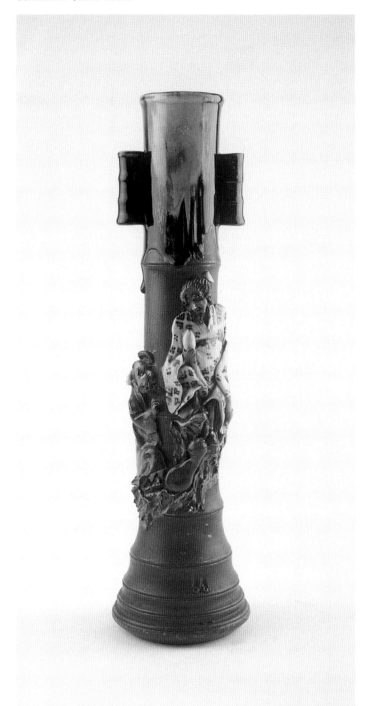

Brown Sumida vase with a white relief crane and three brown bamboo stems. Signed with the impressed mark of Koji. 12-1/4" h. *Courtesy of the Hilco Collection.* $1500-2000.

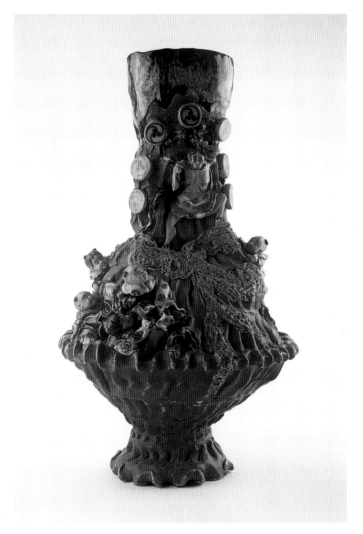

Large and rare red Sumida vase with an irregular pinched surface and black flowing glaze at the top. A relief figure of the god of thunder, Raijin, surrounded by seven discs that represent drum-heads painted with the thunder symbol, scares a group of children who are stealing eggs. A shield-shaped applied cartouche bears the mark of Fuji. 19-1/4" h. *Courtesy of the Hilco Collection.* $6000-7500

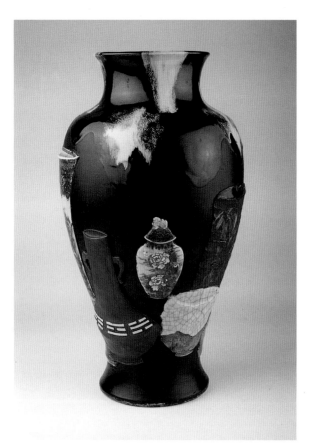

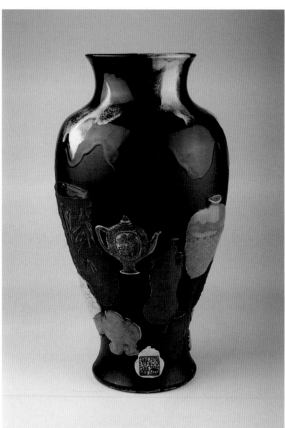

Black Sumida vase of urn shape with a small area of applied relief decoration of various kinds of Japanese ceramic wares appropriately glazed and shaped, truly an unusual subject. The maker's mark of blue underglaze appears on a white gourd relief panel. Signed Inoue Ryosai. 18" h. *R.B. & G. Collection*. $6000-8000.

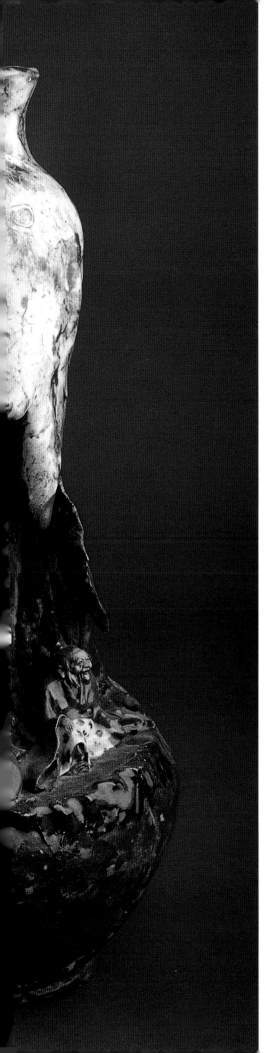

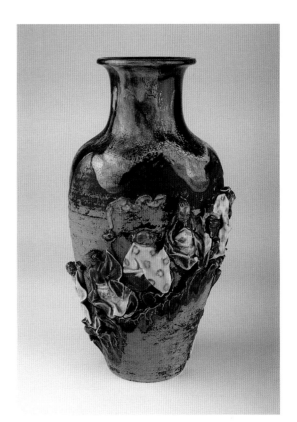

Brown Sumida vase of urn shape with mottled green and blue flowing glaze at the neck and a parade of relief figures in glazed kimonos spiraling around the body. 12.25" h. *R.B. & G. Collection.* $1200-1500.

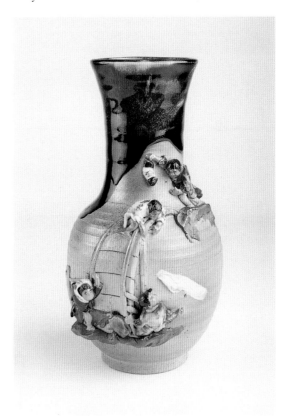

Brown Sumida vase with mottled brown flowing glaze at the neck and relief figures of children in the process of hanging a lantern. Nice quality. 9" h. *Courtesy of Marvin and Nina Vida.* $700-900.

Red Sumida vase with white and blue flowing glaze at the top. The body has a cutout cave and two relief glazed figures of seated scholars. 12" h. *Courtesy of the L. Robbins Collection.* $800-1000.

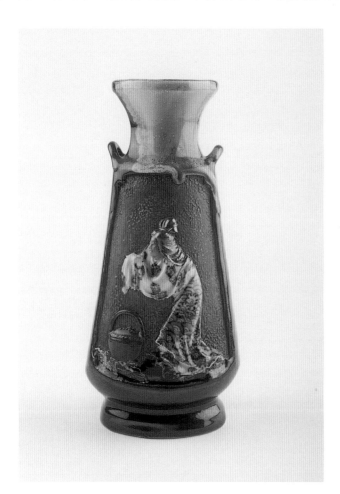

Red Sumida vase with round neck and foot and two recessed rectangular side panels. Relief figures of a woman and boiling pot on one side and two children on the other decorate the body. 8-3/4" h. *Courtesy of the Hilco Collection.* $800-1000.

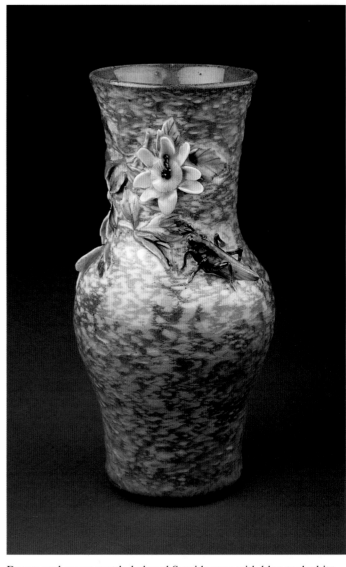

Brown and green mottled glazed Sumida vase with blue and white glazed relief flowers and cricket decorating the neck. Signed on a gourd cartouche mark. 8-1/2" h. $1500-2000.

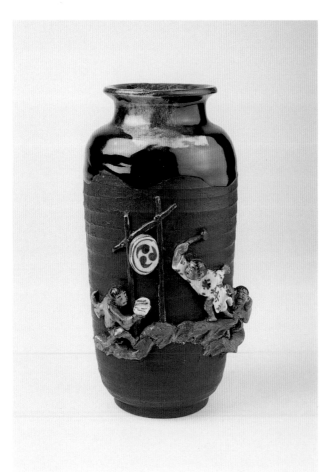

Black Sumida vase with mottled flowing glaze at the neck. Three relief figures and gong in a red frame decorating the body. 8-1/4" h. *Courtesy of MPL and BL collection.* $800-1000.

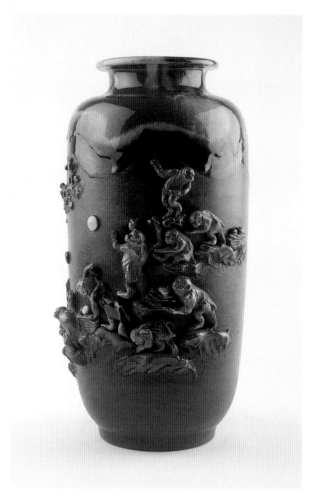

Brown Sumida vase with narrow neck and flaring rim covered in a mottled brown flowing glaze. Relief figures of a group of clothed monkeys climbing on rocks decorate the body. Marked by Inoue Ryosai. 14-1/2" h. *Courtesy of the Hilco Collection.* $1500-2000.

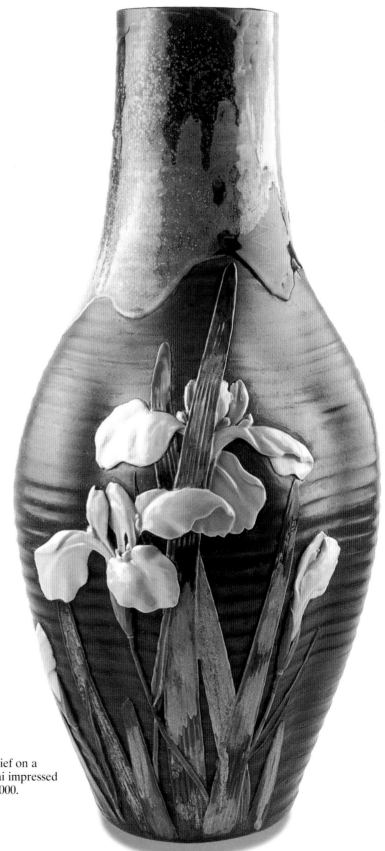

Large and important Sumida vase with white iris group in relief on a red/brown background. Signed with the gourd mark of Ryosai impressed on the base. 29" h. *Courtesy of the Hilco Collection.* $8000-10,000.

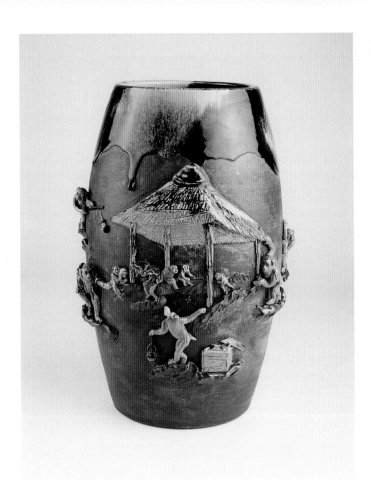

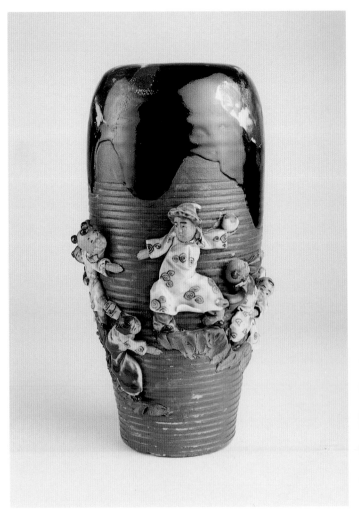

Red Sumida vase with mottled blue flowing glaze on the rim and relief figures of monkeys behaving as humans under a pole shelter with a grass roof. Marked by Ryosai. 13-3/4" h. *Courtesy of Marvin and Nina Vida.* $1000-1200.

Red Sumida vase with black flowing glaze and relief figures of glazed children at play on the ribbed body. Signed by Ryosai. 12-1/2" h. *Courtesy of Marvin and Nina Vida.* $800-1000.

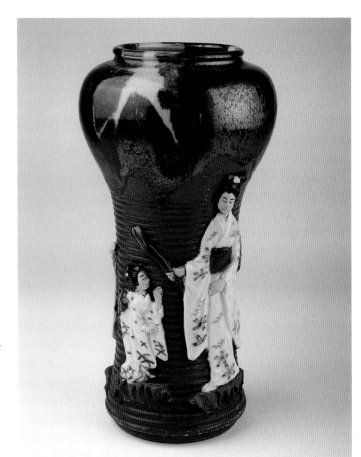

Red, bulbous Sumida vase with flowing black and white glaze. Standing relief figures of ladies and children appear on the body. Signed with the applied cartouche of Koko.11-7/8" h. *R.B. & G. Collection.* $1200-1500.

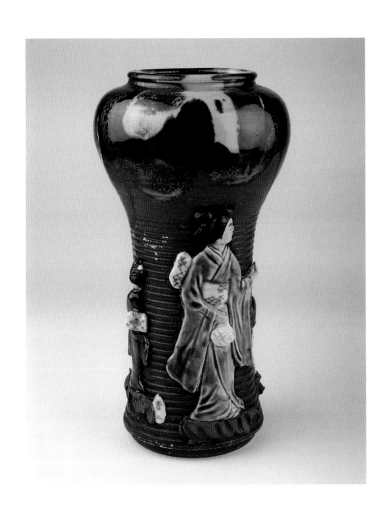

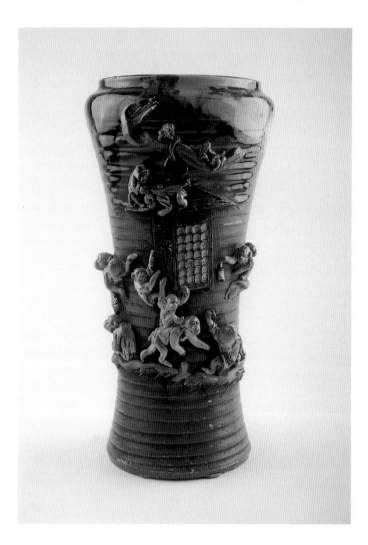

Red Sumida vase with flaring neck and mottled brown flowing glaze. Relief figures of monkeys dressed as children with a lantern decorate the ribbed body. Signed with the mark of Inoue Ryosai. 14" h. *Courtesy of the Hilco Collection.* $2000-2400.

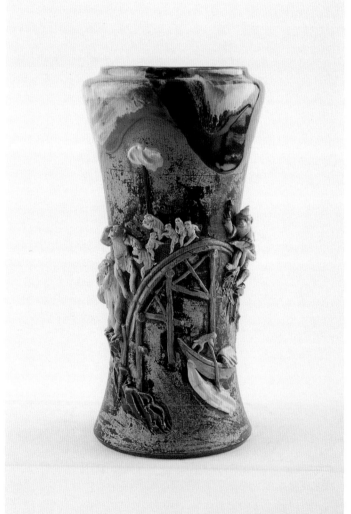

Brown Sumida vase with mottled brown flowing glaze on the rim. Relief figures of monkeys on a red bridge over a boat decorate the body. Signed by Inoue Ryosai. 11-3/4" h. *Courtesy of the Hilco Collection.* $800-1200.

Red Sumida jar with blue/black flowing glaze on the rim. Relief glazed figures of two women and young girls decorate the body. Signed with the mark of Inoue Ryosai. 12-1/2" h. *Courtesy of the Hilco Collection.* $1500-2000.

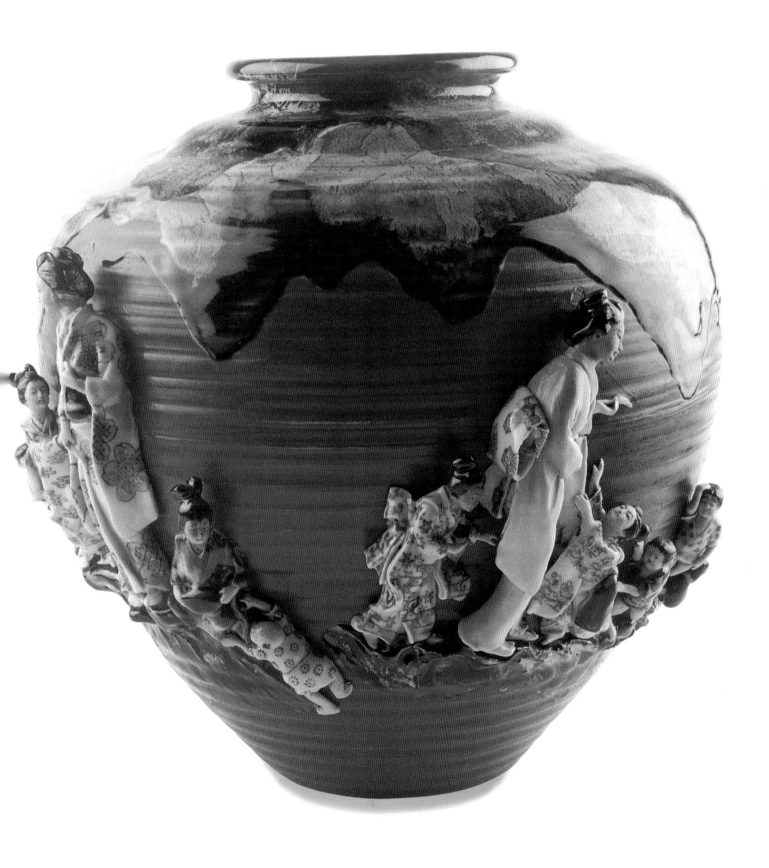

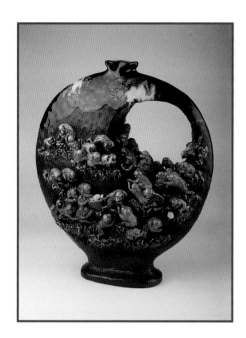

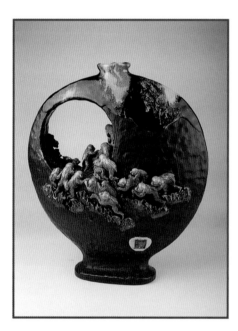

Large brown Sumida moon vase with mottled black and white flowing glaze and relief figures of many monkeys. Signed by Inoue Ryosai. 16-3/4" h. *R.B. & G. Collection.* $4000-4500.

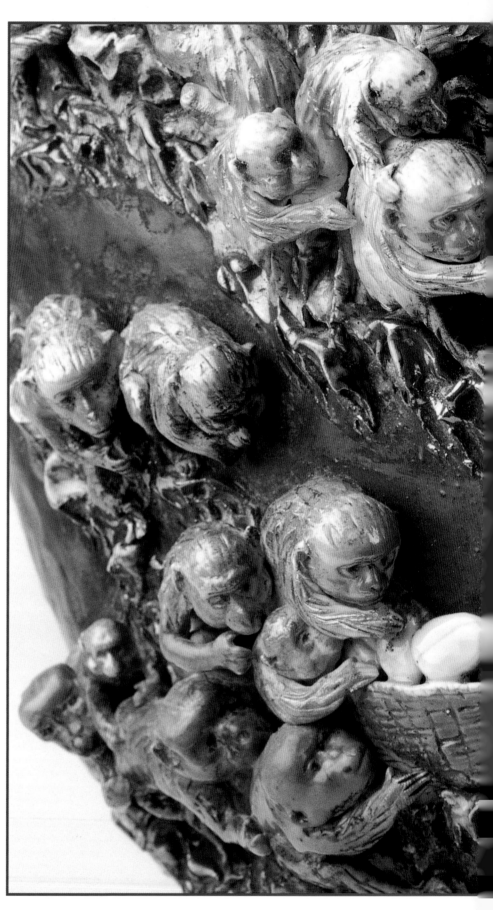

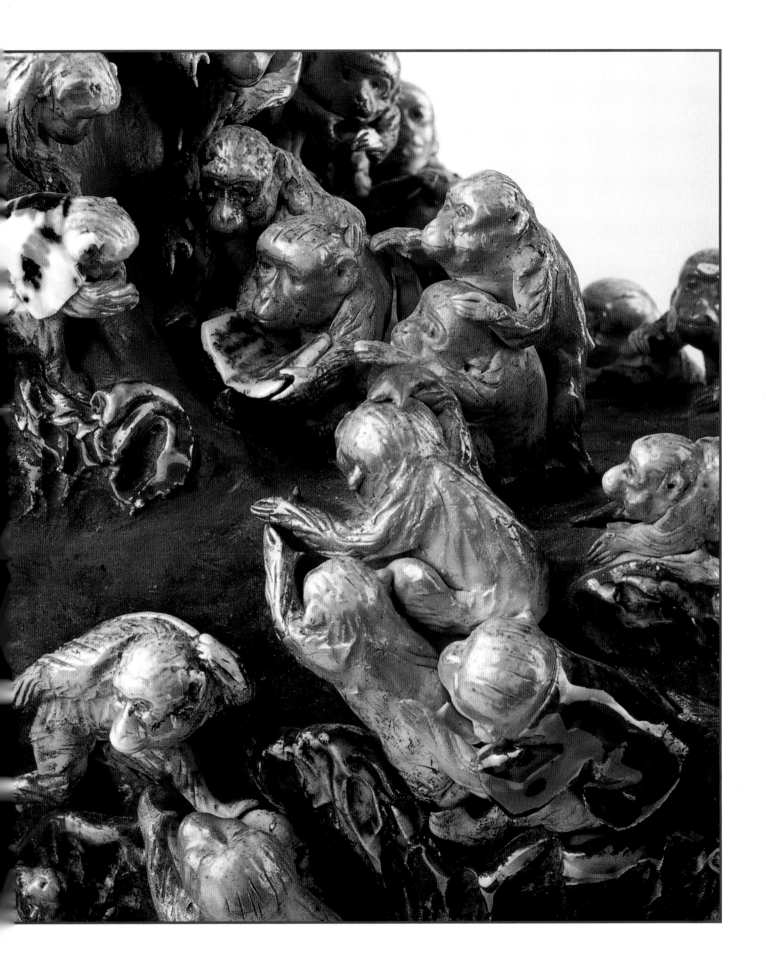

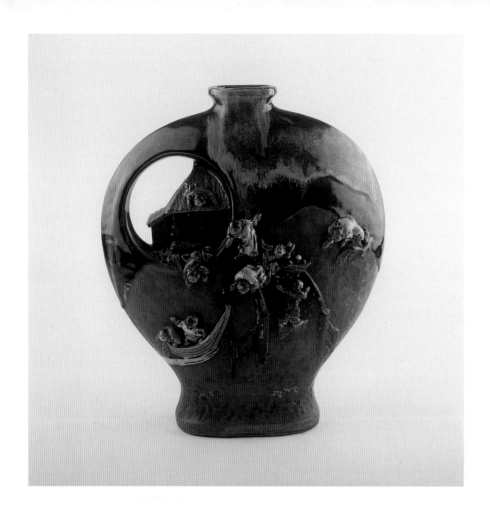

Large brown Sumida molded moon vase with mottled gray flowing family actively engaged at a house and a pier with a small boat. c. 1920s-1930s. 14" h. *Courtesy of the Hilco Collection.* $1500-2500.

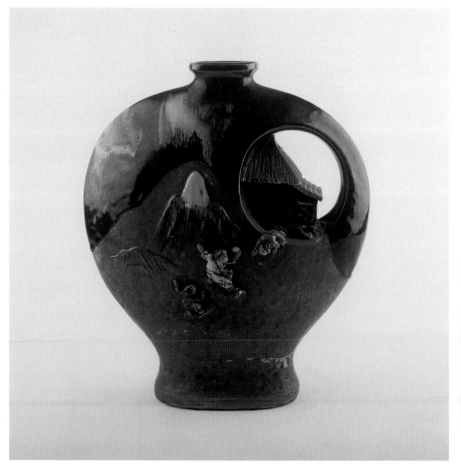

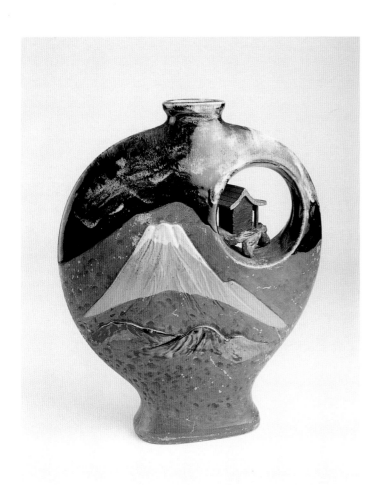

Sumida flat molded moon vase with a building in the cutout.
Three relief figures are on one side and Mt. Fuji is on the other
side. c. 1920s-1930s. 11-1/2" h. *Courtesy of Marvin and Nina Vida.*
$800-1000.

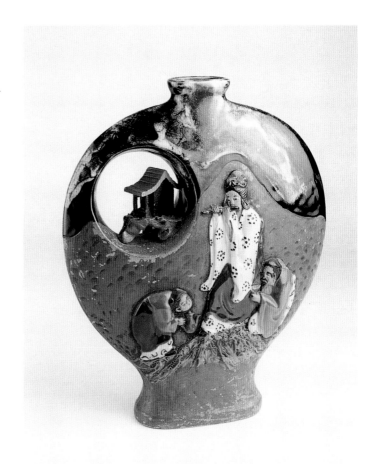

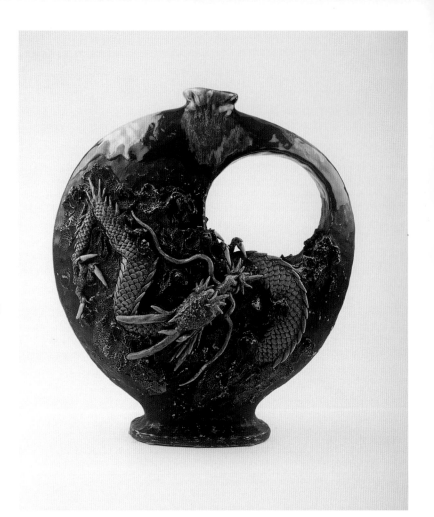

Large brown Sumida moon vase with relief mountains and a dragon decoration in tan on the body. The small spout has purple flowing glaze. Signed by Inoue Ryosai. 17" h. *Courtesy of the Hilco Collection.* $4000-5000.

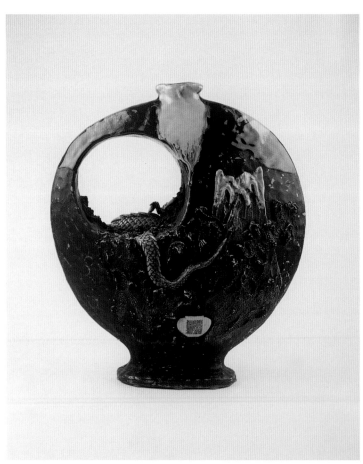

**Pitchers**

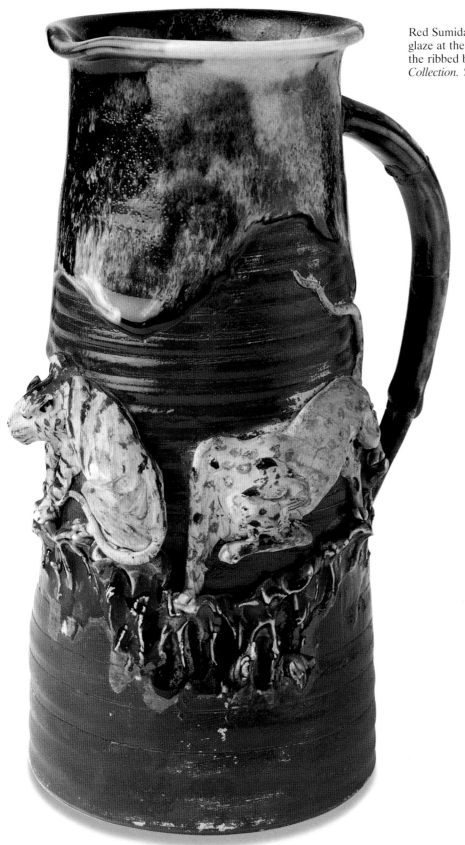

Red Sumida pitcher with mottled blue flowing glaze at the rim and relief figures of tigers on the ribbed body. 8-1/2" h. *Krim-Barchanowitz Collection.* $800-1000.

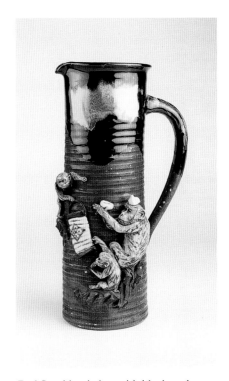

Red Sumida pitcher with black and white flowing glaze and a group of monkeys seated on rocks decorating the ribbed body. Signed by Inoue Ryosai. 13" h. *Courtesy of Marvin and Nina Vida.* $1000-1200.

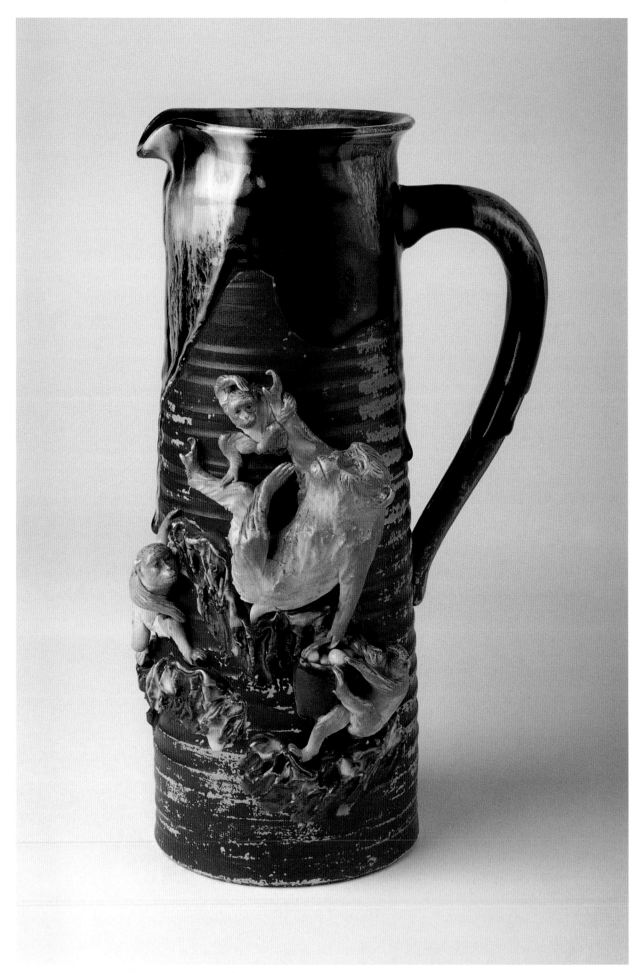

Red Sumida pitcher with brown and cream flowing glaze and relief monkey figures in a rocky landscape on the ribbed body. 12-1/8" h. *Krim-Barchanowitz Collection.* $1000-1200.

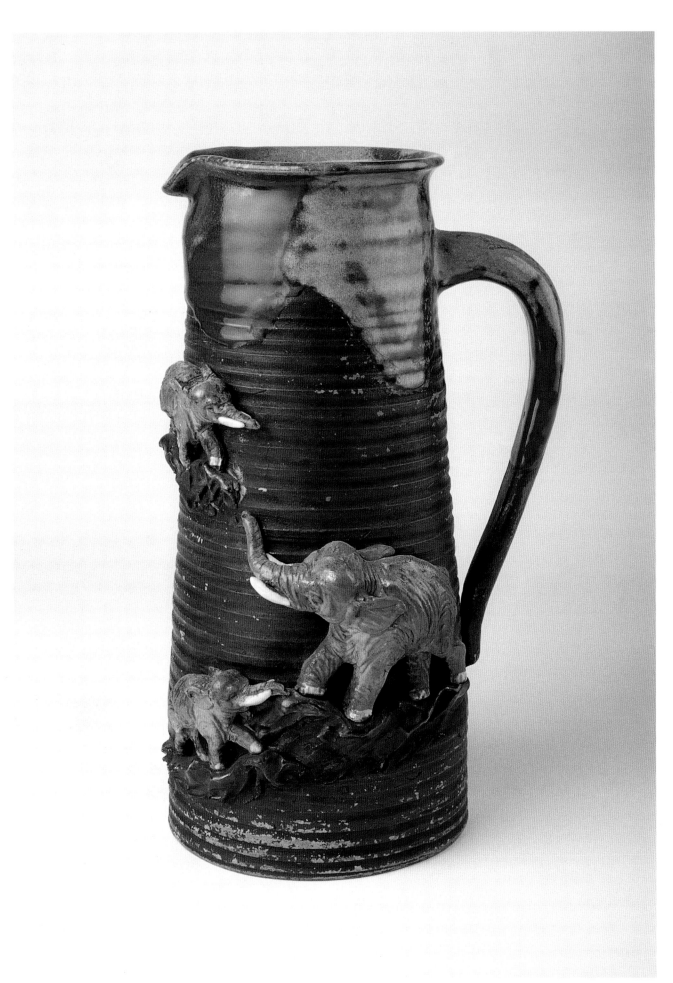

Red Sumida pitcher with flowing blue and green glaze and three relief figures of elephants on the ribbed body. 12-1/2" h. *Krim-Barchanowitz Collection.* $1000-1200.

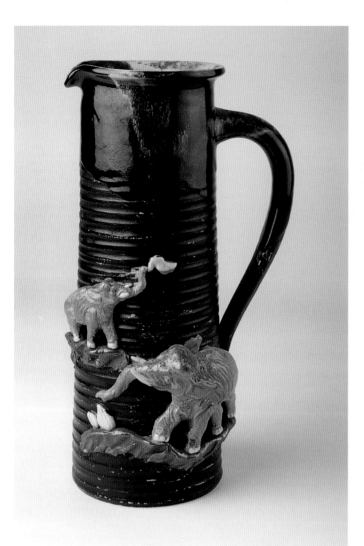

Black Sumida pitcher with black flowing glaze and elephant figures in relief on the ribbed body. Signed by Inoue Ryosai. 12.25" h. *Krim-Barchanowitz Collection.* $1100-1400.

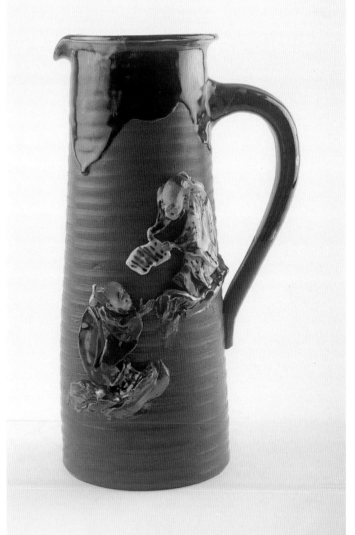

Red Sumida pitcher with brown flowing glaze and relief figures of a man and a boy on the body. 12-3/8" h. *Courtesy of the Hilco Collection.* $1000-1200.

Red Sumida pitcher (12-1/2" h.) and
six mugs (4-1/2" h.) with mottled
dark flowing glaze and relief figures
of children on the ribbed bodies.
*Courtesy of the Hilco Collection.*
$1800-2000 the set.

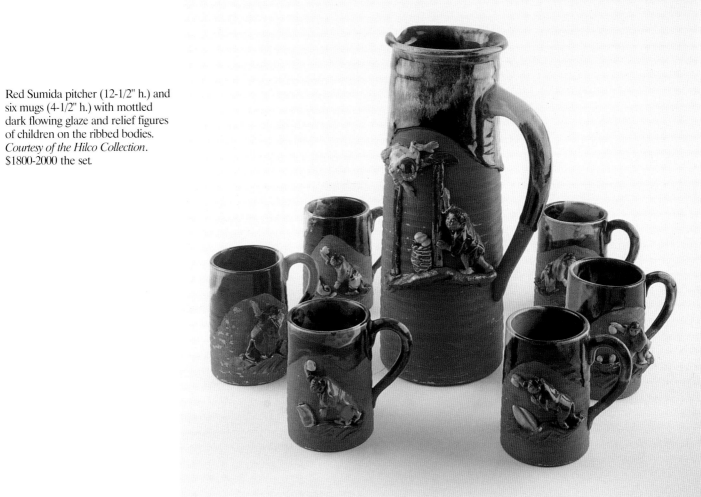

Four red Sumida mugs with flowing glaze, each decorated with a different relief groups: a lady and a cat, a lady
and a child, a man with a shell, and monkeys. 4-1/2" to 4-3/4" h. *Krim-Barchanowitz Collection.* $250-350 each.

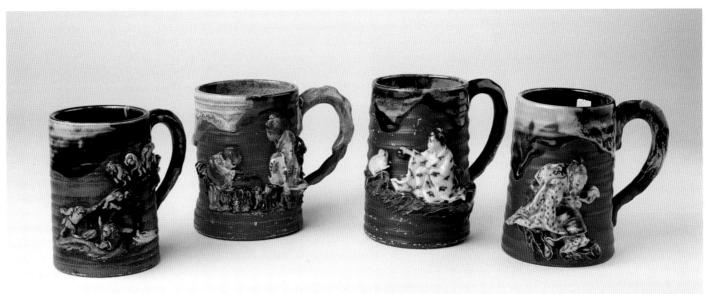

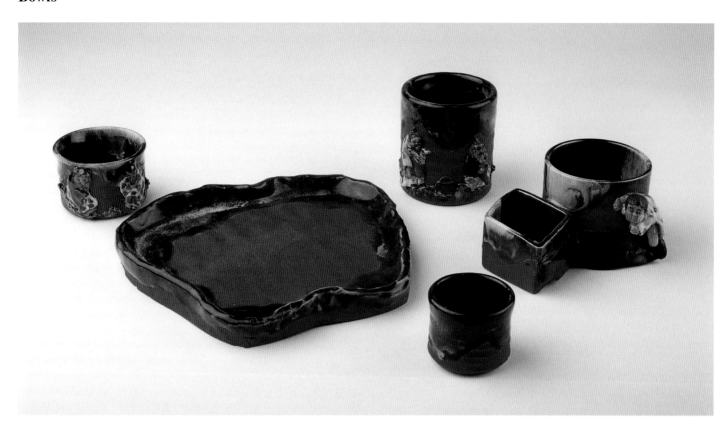

Six-piece red Sumida smoking set with four gradu-
ated cylinders to hold tobacco (lid missing), cigars,
and cigarettes; one square bowl to hold matches; and
a large ashtray that also contains the set. The rims
have mottled gray flowing glaze. Attributed to
Ryosai. Early 20th century. Tallest bowl 3-3/4" h. *R.B.
& G. Collection.* $800-1000.

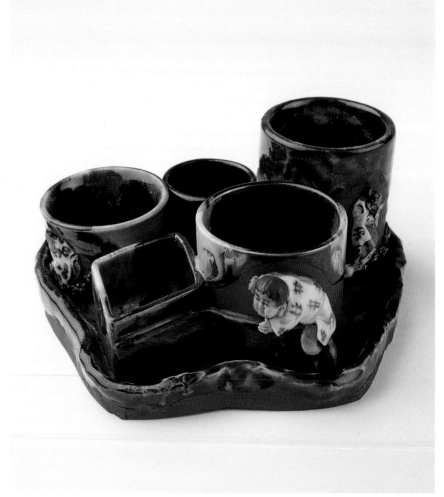

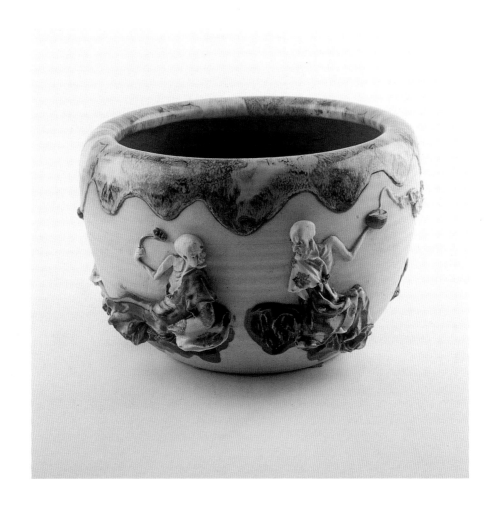

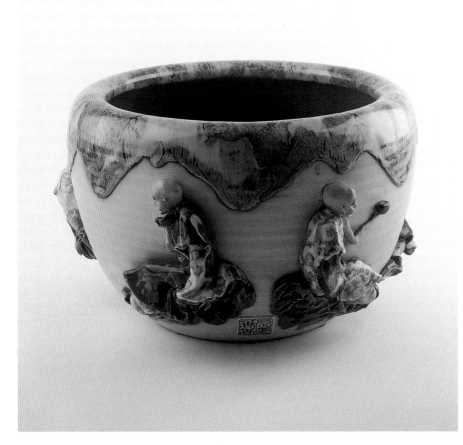

Light brown Sumida bowl with mottled brown/blue flowing glaze at the rim. Four relief figures of Rakan decorate the sides. Marked by Inoue Ryosai. *Courtesy of the Hilco Collection.* 7-3/4" h x 11-1/2" d. $800-1200.

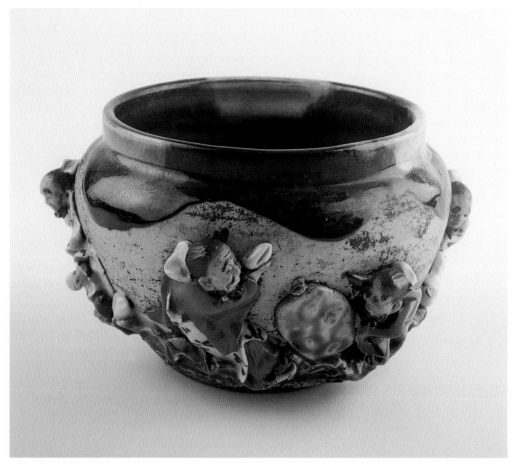

Light brown Sumida bowl with dark brown flowing glaze and four relief figures on the body. 7" d. *Courtesy of the Hilco Collection*. $800-1000.

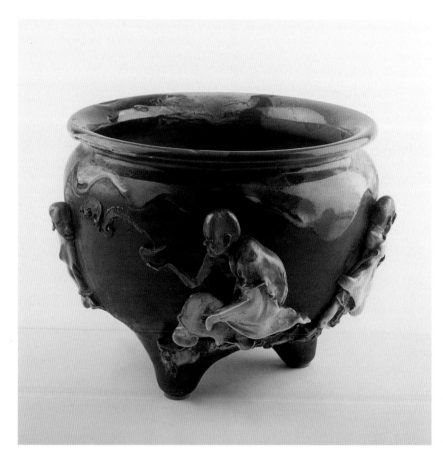

Dark gray Sumida round bowl on three raised feet with mottled flowing glaze at the rim. Decorated with five glazed men in relief on the outside. Signed by Inoue Ryosai. 10" d. x 8-3/4" h. *Courtesy of the Hilco Collection*. $1000-1200.

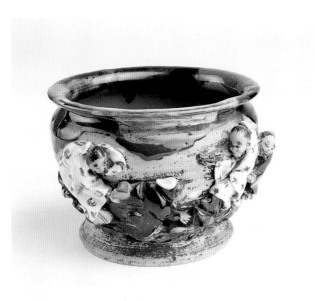

Light tan Sumida footed bowl with mottled flowing glaze and four relief figures in the body. Signed by Ryosai. 3-3/4" h. *Courtesy of Marvin and Nina Vida*. $300-500.

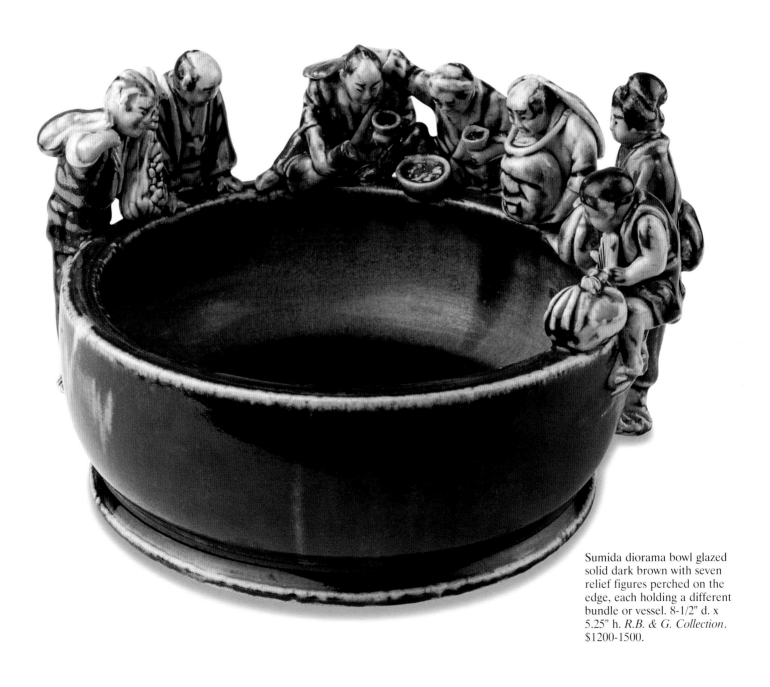

Sumida diorama bowl glazed solid dark brown with seven relief figures perched on the edge, each holding a different bundle or vessel. 8-1/2" d. x 5.25" h. *R.B. & G. Collection*. $1200-1500.

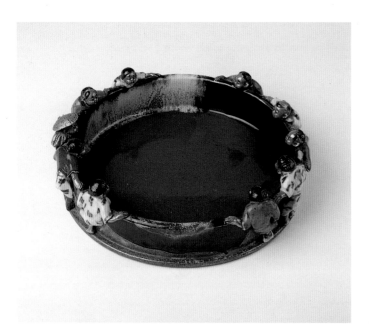

Dark brown Sumida diorama bowl with green mottled flowing glaze on the rim and ten figures of people perched around the rim. 8-1/2" d. x 2-1/2" h. *Krim-Barchanowitz Collection.* $800-1000.

Brown Sumida deep quatrefoil bowl with two scrolled side handles and mottled gray flowing glaze on the rim. Six relief figures of people decorate the outside. 5" h. x 10-1/2" d. *Courtesy of the Hilco Collection.* $800-1000.

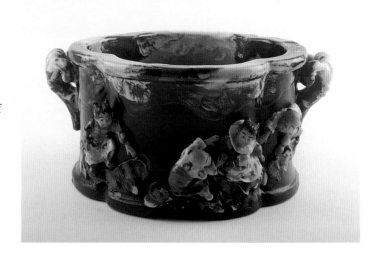

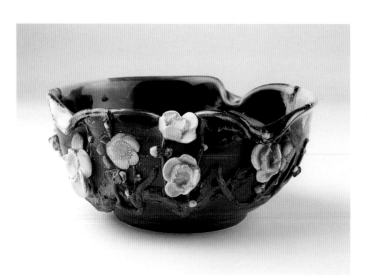

Red Sumida bowl with crimped rim and relief floral blossoms decorating the sides. A dark flowing glaze is on the inside. 7-1/2" d. x 3-1/2" h. *R.B. & G. Collection.* $800-1200.

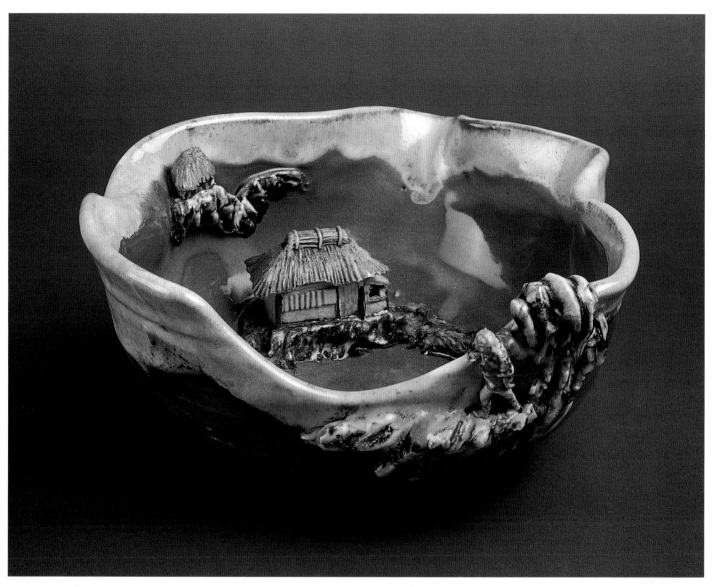

Red Sumida diorama bowl with mottled clear glaze at the crimped rim. A relief figure on the outside is looking in at two huts with thatched roofs on the green glazed interior. Signed by Ryosai, 10" d. *Courtesy of the Drick-Messing Collection.* $1200-1400.

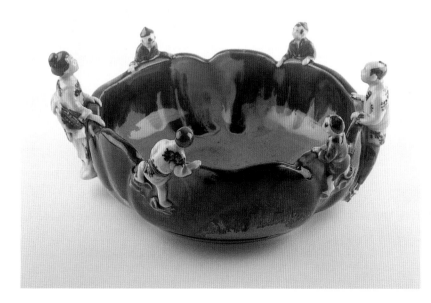

Brown Sumida diorama bowl with crimped rim and six relief figures looking into the green glazed center. Impressed gourd mark. 9-3/4" d. *Courtesy of the Hilco Collection.* $800-1000.

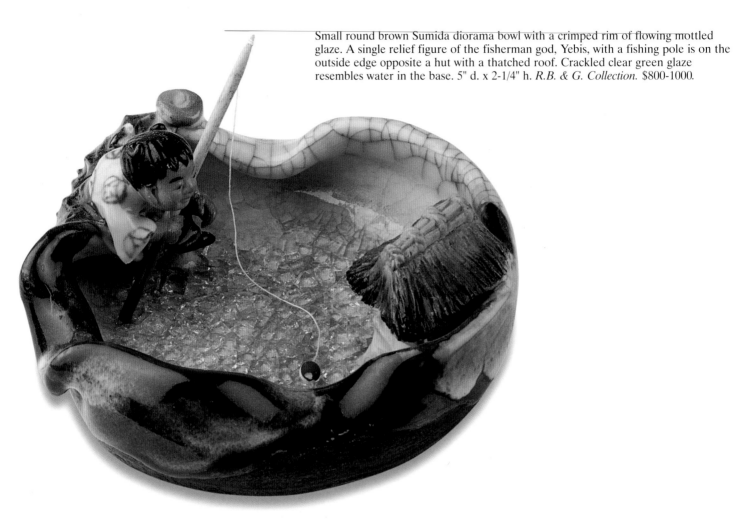

Small round brown Sumida diorama bowl with a crimped rim of flowing mottled glaze. A single relief figure of the fisherman god, Yebis, with a fishing pole is on the outside edge opposite a hut with a thatched roof. Crackled clear green glaze resembles water in the base. 5" d. x 2-1/4" h. *R.B. & G. Collection.* $800-1000.

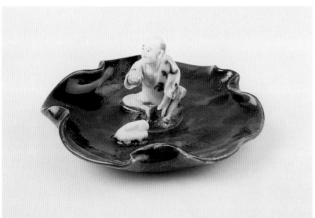

Sumida dish with leaf-shaped base and the glazed figure of a seated man with a white rabbit at the center. 5-1/2" d. *Courtesy of MPL and BL collection*. $500-600.

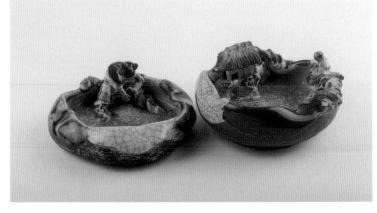

Two round Sumida diorama bowls with mottled flowing glaze at the rims and crackled ice blue glaze resembling water inside. One has a single boy seated on the inside. 5-1/4" d. The other has a hut and a man seated on the rim. 5" d. *Courtesy of the Hilco Collection* $1000-1200 each.

# Marks

## Banko

Impressed Banko

Impressed Banko

## Imari

Old Edo mark

6-character mark Dai Ming Manreki Nen Sei (the company name). Arita.

Made in Arita. Floral design in red indicates overglaze (red) painters in the Edo era, 1615-1868. The paper label reads: "Geo. Neighbour & Sons. London" presumably a retail business.

# Marks

## Imari

E Gami Sei Toh Sho (the company name),
Arita, Izumiyama area, after middle Meiji era.

Fukagawa trademark, Fuka (mountain) Gawa (river)

Eiraku

Special Fukagawa decorated trademark with red river.

Fukagawa Porcelain Manufacturing Company,
Ltd., late Meiji and Taisho, c. 1895-1925.

# Marks

## Imari

Fukagawa Porcelain Manufacturing Co., Ltd. Kan o Some Tsuke (Official Porcelain Underglaze Blue) designed by Iwao Fukagawa since 1977.

Hichozan Shinpo

Fuki Choshun

Ken

Koran Sha Fukagawa, orchid mark of the Company of the Scented Orchid, founded in 1875.

# Marks

## Imari

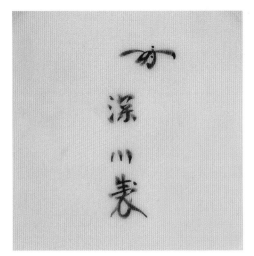

Koran Sha Fukagawa, orchid mark of the Company
of the Scented Orchid, founded in 1875.

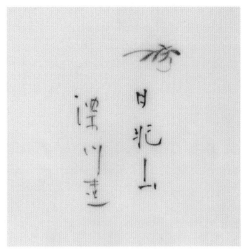

Koran Sha Fukagawa, orchid mark of the Company
of the Scented Orchid, founded in 1875.

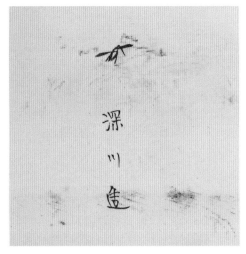

Koran Sha Fukagawa, orchid mark of the
Company of the Scented Orchid, founded in 1875.

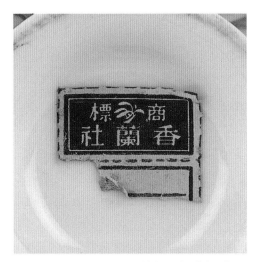

Koran Sha Fukagawa, orchid mark of the Company
of the Scented Orchid, founded in 1875.

Koran Sha Fukagawa, orchid mark of the Company
of the Scented Orchid, founded in 1875.

# Marks

## Imari

Koran Sha Fukagawa, orchid mark of the Company of the Scented Orchid, founded in 1875.

Kotobuki

Sei Ji Kai Sha, the Company of Pure Water, established by the Fukagawa, Tsuji, Fukami, and Tezuka families in Arita, 1879-1883.

## Kutani

Yokohama Genshu

Kutani (Nine Valleys)

# Marks

## Satsuma

Satsu Ma Ko Ryuzan, an export item made in Kagoshima prefecture.

Satsuma Yaki

Chikusai

Choshuzan

Hodota

# Marks

## Satsuma

Hodota

Hodota Shozan

Hodota

Hozan

Hozan

## Satsuma

Matsumoto Hozan

Kinkozan

Kinkozan
Kinkozan IV was the artist name for
Kobayashi Sobei (1824-1884) and another
Kobayashi Sobei (1868-1927) used the artist
name Kinkozan V.

Kinkozan

Kinkozan

# Marks

## Satsuma

Kinkozan

Kiowa

Kinkozan

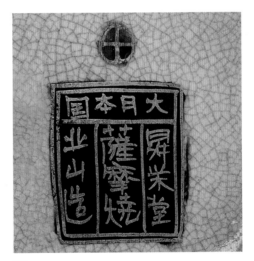

Kitayama

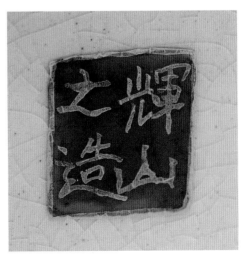

Kizun

# Marks

## Satsuma

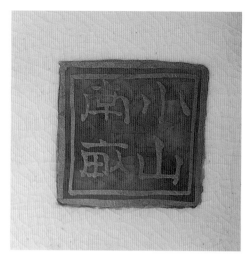

Koyama Nanpo

Kozan

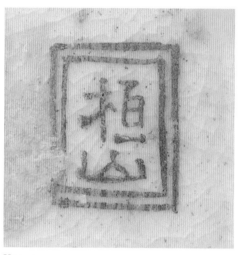

Kozan

Kozan

Kozan

# Marks

## Satsuma

Kozan

Ryozan

Kyokaen

Ryozan

Ryozan

## Satsuma

Kyoto Tojiki Goshi Gaisya Ryozan

Kyoto Satsuma decorated by Shoko Takabe.

Ryugyokuzan

Kyoto Satsuma decorated by Seikozan, late Edo or early Meiji (c. 1850-1870).

Seikozan, c. 1885.

## Satsuma

Kyoto Satsuma decorated by Sozan in the
Kinkozan workshop.

Tani guchi

Suigetsu

Yozan

Kyoto Satsuma decorated by Yabu Meizan
Born Yabu Seishichi (1853-1934) at Osaka, he was a
prolific decorator c. 1880-1916. In the period c. 1880-1890,
he painted primarily Buddhas and Rakons with golden
halos and festivals such as the 100 boys scenes. Circa 1890
he used Japanese themes of Samurai and Hiroshige's
block prints series of the Tokaida Road between Kyoto
and Edo (Tokyo). Also butterflies, flowers, and proces-
sions. He exhibited at the International Exhibitions in
Paris (1900) and London (1910).

## Sumida

Inoue Ryosai

Inoue Ryosai

Ryosai

There are three generations of artists who made Sumida ware and used the name Ryosai. Ryosai I (1828-1899) came from Seto and worked in Tokyo, being prominent in the 1890s. Ryosai II (1845-1905) was born Kawamoto Katsusaburo. He worked at Tokyo in a style combining Japanese methods with Western designs. Ryosai III (1888-1971) was named Inoue Ryotaro. He moved the manufacturing to Yokohama in 1914 where he produced export wares until 1941.

Ryosai

Ryosai

# Marks

## Sumida

Ryosai

Ishiguro Koko

Ishiguro Koko

Ishiguro Koko

Sukari Fuji

# Further Reading

Audsley, George A. and James L. Bowes. *Keramic Art of Japan.* London: Henry Sotheran & Co., 1881.

Cardeiro, C. Philip. *Hirado Ware.* Monterey: Art Asia Museum, 1989.

*Daruma Magazine,* several issues. Higashi, Japan: Daruma Publishing, 1993-2002.

Earle, Joe. *Splendors of Meiji, Treasures of Imperial Japan, Masterpieces from the Khalili Collection.* St. Petersburg, Florida: Broughton International Publications, 1999.

Karp, Herbert and Gardner Pond. *Sumida...according to us.* Atlanta: KarPond. 2001.

Lawrence, Louis. *Hirado: Prince of Porcelains.* Introduction by David Hyatt King. Chicago: Art Media Resources, Ltd. 1997.

_____. *Satsuma, Masterpieces from the World's Important Collections.* London: Dauphin Publishing Limited, 1991.

Levy, Mervyn. *Liberty Style, The Classic Years: 1898-1910.* New York: Rizzoli,1986.

Mew, Egan. *Japanese Porcelain.* London: T. C. & E. C. Jack; and New York: Dodd Mead & Co., no date (about 1915).

Mitsuoka, Tadanari. *Ceramic Art of Japan.* Tokyo: Japan Travel Bureau, 1956.

Schiffer, Nancy N. *Imari, Satsuma, and other Japanese Export Ceramics*, Revised & Expanded 2nd edition. Atglen, Pennsylvania: Schiffer Publishing Ltd., 2000.

_____. *Japanese Export Ceramics 1860-1920.* Atglen, Pennsylvania: Schiffer Publishing Ltd., 2000.

_____. *Japanese Porcelain 1800-1950,* Expanded 2nd edition. Atglen, Pennsylvania: Schiffer Publishing Ltd., 1999.

_____. *Figural Japanese Export Ceramics.* Atglen, Pennsylvania: Schiffer Publishing Ltd., 2002.

Turk, Frank A. *The Prints of Japan.* New York: October House, 1966.

Watson, Eilliam, ed. *The Great Japan Exhibition, Art of the Edo Period 1600-1868.* London: Royal Academy of Arts and Weidenfeld and Nicolson, 1981.

Will, Captain John Baxter. *Trading Under Sail Off Japan, 1860-99, The Recollections of Captain John Baxter Will Sailing-master & Pilot edited with a Historical Introduction by George Alexander Lensen.* Tokyo: Sophia University in cooperation with The Diplomatic Press, Tallahassee, Florida, 1968.

# Index